Tate Liverpool Critical Forum

Series Editor
Jonathan Harris, University of Liverpool

Editorial Board
Lindsey Fryer, Tate Liverpool, Chair
Robin Bloxsidge, Liverpool University Press
Ann Compton, University of Liverpool
Jonathan Harris, University of Liverpool
Anne MacPhee, University of Liverpool
Elisa Oliver, Tate Liverpool
Victoria Pomery, Tate Liverpool
Jemima Pyne, Tate Liverpool

Previously published in this series
American Abstract Expressionism
edited by David Thistlewood, ISBN 0-85323-338-1
Joseph Beuys: Diverging Critiques
edited by David Thistlewood, ISBN 0-85323-349-7
Barbara Hepworth Reconsidered
edited by David Thistlewood, ISBN 0-85323-770-0
Sigmar Polke: Back to Postmodernity
edited by David Thistlewood, ISBN 0-85323-911-8

Cover illustration
Andreas Gursky, *Paris, Montparnasse*, 1993,
photograph on paper on perspex
© DACS, London, 2002

Tate Liverpool Critical Forum, Volume 5

Urban Visions

Experiencing and Envisioning the City

Edited by STEVEN SPIER

Liverpool University Press and Tate Liverpool

First published in 2002
by Liverpool University Press
4 Cambridge Street
Liverpool L69 7ZU
and
Tate LIverpool
Albert Dock
Liverpool L3 4BB

Britsih Library Cataloguing in Publication Date
A Birtish Library CIP record is available

ISBN 0–85323–664–X

Designed and typeset by Isambard Thomas
Printed and bound in the European Union by
Midas Printing (UK) Limited

List of Illustrations

No Place for a Lady MARSHA MESKIMMON

1 George Grosz, *Suicide*, 1916; oil on canvas; Tate Gallery; © DACS, 2002

2 Elfriede Lohse-Wächtler, *Lissy*, 1931; © the Marvin and Janet Fishman Collection, Milwaukee, WI

3 Jeanne Mammen, *Garçonne* (or *Prostitute on a Green Couch*), 1931; Jeanne Mammen Gesellschaft, Berlin; © ADAGP, Paris and DACS, London, 2002

4 Jeanne Mammen, *Masked Ball* (also known as *She Represents*), 1931; Jeanne Mammen Gesellschaft, Berlin; photograph by R. Friedrich; © ADAGP, Paris and DACS, London, 2002

5 Elsa Haensgen-Dingkuhn, *Große Freiheit in St Pauli*, 1929; © Dr Jochen Dingkuhn, Hamburg

6 Elsa Haensgen-Dingkuhn, *Evening in St Pauli*, 1934; © Dr Jochen Dingkuhn, Hamburg

Photo Portfolio: Thomas Struth ANNE MACPHEE

1 Thomas Struth, *Shinju-ku (Skyscapers), Tokyo, 1986*, 1986; photograph on paper, 42.1 x 58.4cm; Tate Gallery, purchased 1995; © Thomas Struth

2 Thomas Struth, *Shinju-ku (TDK), Tokyo, 1986*, 1986; photograph on paper, 34.9 x 59.4cm; Tate Gallery, purchased 1995; © Thomas Struth

3 Thomas Struth, *Via Giovanni Tappia, 1989*, 1989; photograph on paper, 45.8 x 56.8cm; Tate Gallery, purchased 1995; © Thomas Struth

4 Thomas Struth, *Vico Dei Monti, Naples, 1988*, 1988; photograph on paper 58.5 x 41.8cm; Tate Gallery, purchased 1995; © Thomas Struth

5 Thomas Struth, *Hermannsgarten, Weissenfels, 1991*, 1991; photograph on paper, 45 x 58.2cm; Tate Gallery, presented by the artist 1995; © Thomas Struth

6 Thomas Struth, *Schlosstrasse, Wittenberg, 1991*, 1991; photograph on paper, 46.1 x 57.1cm; Tate Gallery, presented by the artist 1995; © Thomas Struth

New York City, 1910–1935 THOMAS BENDER

1 Alfred Stieglitz, *The City of Ambition*, 1910; photogravure, 34 x 26cm; Alfred
 Stieglitz Collection, photograph © 1999 Board of Trustees, National Gallery of Art,
 Washington, DC

2 John Sloan, *The City from Greenwich Village*, 1922; oil on canvas, 66 x 85.7cm; gift
 of Helen Farr Sloan, photograph © 1999 Board of Trustees, National Gallery of Art,
 Washington, DC

3 John Sloan, *McSorley's Bar*, 1912; oil on canvas, 66 x 81cm; Founders Society
 Purchase, General Membership Fund, photograph © 1987 Detroit Institute of Arts

4 John Sloan, *Three AM*, 1909; oil on canvas, 81 x 66cm; Philadelphia Museum of
 Art, given by Mrs Cyrus McCormick

5 Alfred Stieglitz, *The Flatiron Building*, 1903; The Metropolitan Museum of Art,
 Alfred Stieglitz Collection, 1933

6 John Sloan, *Nursemaids, Madison Square*, 1907; oil on canvas, 61 x 81cm; F. M.
 Hall Collection, Sheldon Memorial Art Gallery Association, University of Nebraska

7 Charles Sheeler, *New York (Buildings)*, 1920; pencil on ivory wove paper, 50.5 x
 33cm; gift of Friends of American Art, the Art Institute of Chicago; photograph
 © the Art Institute of Chicago

8 George Luks, *Hester Street*, 1905; oil on canvas, 66 x 92cm; Dick S. Ramsay Fund,
 Brooklyn Museum of Art

9 John Marin, *Movement, Fifth Avenue*, 1912; watercolour with traces of black
 crayon, over charcoal, on off-white watercolour paper, 43.3 x 35cm; Alfred
 Stieglitz Collection, the Art Institute of Chicago; © ARS, NY and DACS, London,
 2002; photograph © the Art Institute of Chicago

10 Georgia O'Keeffe, *City Night*, 1926; oil on canvas, 122 x 76cm; gift of the Regis
 Corporation, W. John Driscoll and the Beim Foundation, the Larsen Fund, and by
 public subscription, the Minneapolis Institute of Arts; © ARS, NY and DACS,
 London, 2002

11 Hugh Ferriss, *The Lure of the City*, 1929; Avery Architectural and Fine Arts Library,
 Columbia University, New York

THE SURREY INSTITUTE OF ART & DESIGN

Las Vegas at Middle Age PAUL DAVIES

Wish You Were Here MALCOLM MILES

The Map is not the Territory ANDREW HUSSEY

Foreword

The Critical Forum series presents papers given at an annual conference jointly organised by Tate Liverpool and the University of Liverpool. The conference and subsequent publication relate to a current gallery display and provide the opportunity to explore both the interaction of art histories and exhibitions, and the latter's theoretical resonance.

The series began in 1993 with the publication of papers from a conference which emerged from the *Myth Making* display, and explored American Abstract Expressionism within its political and theoretical context. Three further conferences and subsequent anthologies followed, each focusing on an individual artist: *Joseph Beuys, Barbara Hepworth* and *Sigmar Polke*. *Urban Visions* relates to the Urban display with which Tate Liverpool reopened in 1998 after a year's closure for redevelopment. It explored the concept of urban experience throughout the twentieth century in work as diverse as that of Otto Dix, Piet Mondrian, Jeff Koons, and Thomas Struth, and provided an appropriate vehicle for the interdisciplinary, critical debate which has characterised Critical Forum conferences. More particularly, it engaged with what has become a pressing theoretical concern: the cultural implications of the construction of urban space.

The range of papers presented at the well-attended conference by Paul Davies, Andrew Hussey, Jane Rendell, Marsha Meskimmon and Sigrid Weigel, reflected the breadth of interest that the subject has stimulated. We were very pleased to have Malcolm Miles chair the conference and subsequently contribute to this volume. Additional contributors to the book are Thomas Bender, Jörn Düwel, Vittorio Magnago Lampugnani, W.G. Sebald, and Robert Venturi and Denise Scott Brown. There is a photo essay by Thomas Struth. We are indebted to Steven Spier for the insightful comments and editing which has shaped this publication.

The substance of this volume resonates the cross-disciplinary, theoretical approach of the conference. It brings together a heterogeneous collection of papers by an international collection of authors, not all of whom are scholars, dealing with issues and debates that occupy thoughts about the urban. Our grasp of these issues and concepts is augmented and refined by the ideas of the contributors.

ELISA OLIVER, Tate Liverpool
ANNE MACPHEE, University of Liverpool
Critical Forum Coordinators

EDITOR'S NOTE
Jane Rendell's conference paper, 'Moving and Looking: Gender and Architectural Space in Nineteenth Century London', unfortunately does not appear in this volume due to copyright restrictions.

EDITOR'S ACKNOWLEDGEMENTS
I would like to thank Elisa Oliver of Tate Liverpool and Anne MacPhee of Liverpool University for inviting me to edit this book and help curate the Urban Visions conference. I am especially grateful for the latitude they have allowed me with the book's contents. I would also like to acknowledge Jemima Pyne of the Tate and Robin Bloxsidge of Liverpool University Press for their easy-going professionalism and good humour. Finally, I would like to thank David Dunster, Roscoe Professor in the School of Architecture and Building Engineering at Liverpool University for his long-standing counsel and friendship.

Steven Spier

'One need only look at the layers of the city that archaeologists show us;
they appear as a primordial and eternal fabric of life, an immutable pattern.
Anyone who remembers European cities after the bombings of the last war
retains an image of disembowelled houses where, amid the rubble, fragments
of familiar places remained standing, with their colours of aged wallpaper,
laundry hanging suspended in the air, barking dogs—the untidy intimacy of
places. And always we could see the house of our childhood, strangely aged,
present in the flux of the city . . . But beyond all else, the images suggest the
interrupted destiny of the individual, of his often sad and difficult
participation in the destiny of the collective.'
Aldo Rossi, *The Architecture of the City*

Introduction

STEVEN SPIER

'a man in himself is a city'
William Carlos Williams, *Paterson*

The modern city initiated by the great, violent forces instigated by the industrialisation of Europe in the late eighteenth century is the city we still inhabit today.[1] By this I mean not so much its physical form, but the condition and sometimes affliction of being urban. It is striking how relevant (and how fertile for scholarship) the antinomies already enunciated in the nineteenth century are, when the city was described as a place of degradation, elevation, deprivation, cultivation, insularity, urbanity, anonymity, sociability, liberation, alienation, commerce and culture. If the modern city's phylogeny is being ominously recapitulated in the developing world's rapid urbanisation, with its attendant demographic, epidemiological and social transformations, the much heralded post-industrial society of the first world is characterised by changes which still remain tendencies and has not yet found its physical form. As much as the city is again topical – in high and low cultures, journalism, policy, and certainly academia, by having the beginning of this age recurring while being concurrently at its end we see sorrowfully how little sense we still

make of the phenomenon of being urban. This book presumes that understanding our urban experience is a prerequisite for envisioning what it could be; radically, they might be the same.

The diminution of the long, post-war economic boom, the tottering of ruling structures, increasing social tensions, not to mention planning and architecture's intellectual and formal weariness, combined in Britain and the United States in the 1970s to terminate a modernism which now must be regarded as the last great, romantic vision of urbanism. Ours is a more tentative age, and while we have some nostalgia for modernism's social certainties we are surely grateful for its cessation. For in the ensuing interregnum we have gained from the vitality of other disciplines and the uncovering and validity of other histories, all of which rightly assert that the city is a place of contested ownership and authorship; or more ominously, that how one chooses to represent the city is a method of social control.[2] The critique of an objectifying or aestheticising idealism of the so-called dominant city takes many forms, indebted in particular to gender studies, critical theory and cultural geography; it is now well-evolved and accepted. In addition to a prominence bestowed on subsumed histories and their figures and a revival of interest in the everyday,[3] one of its most invigorating and resuscitative results has been to insist on the significance of lived over conceived space, or on the primacy of the individual's experience in the city. While startling and eventually welcome advances have been made through these modes of inquiry, it does seem that we have settled into still significant but less heady investigations.

If we have been understandably shy of late regarding idealising scenarios, the contemporary preference for experience over form does now seem to overstate the hegemony of how space is represented.[4] (There is, especially in a consumerist society, no shortage of more specific and/or populist representations; the possibility of a non-commodified experience, though, is more contentious.) The ascendancy of interest in the content of the city has spurred a discussion about its function which admits, if sometimes grudgingly, its complexity. The experience of the city is individually constructed, but the city also exists independently of each of us, with the object and its

representation (or subject) redefining each other, importantly, in a particular time. In different cities through different gazes in different times the city is constructed. This hermeneutic circle is its purpose.

The argument for the elemental necessity of the city, as something to define and likewise be defined by us, is especially clear in modern-day Germany, whose history has been rewritten so often and so baldly this century. (And is one of the reasons this book contains so many authors who address issues through it.) In divided, post-war Berlin, for example, there were strongly competing visions ideologically and physically. Each was imposed from above, however, which in the West competed with a vibrant counterculture that was resistant to such impositions; in the East, the regime's shifting urban and architectural pronouncements left the design professions scrambling to match form to intention. Presently in Berlin there is an aching, understandably, for the presumed certainties and pleasantries of the European bourgeois city. The consensus that neither of its post-war traditions was legitimate, however, supports the contention that the engendering of experience was insufficiently developed to support an urban vision. It raises the hypothesis, which is then hardly of mere academic interest, that the post-war representation of German cities devastated in the air war was insufficient, leaving the culture still traumatised and thus incapable of envisioning its cities, as a reassertion or otherwise, regardless of their having been physically rebuilt.[5]

The question of what is the kind of city which we are trying to have is both obvious and urgent as the world continues its dramatic urbanisation.[6] In Europe there are environmental imperatives to increase densities, and against the homogenising imperatives of late capitalism there is an increasing economic and cultural necessity for cities to be distinctive. This book, by looking assiduously at the urban experience, accepts that visions, which are certainly more articulate currently in disciplines and media other than architecture and planning, need not always be heroic or grand.[7] But our experience of the city does occur in something material which is designed – be it by architects, planners, or more often and anonymously by larger societal or cultural forces. It is an intricate construction in which physical, cultural,

commercial, historical, ideological, and personal presences can coincide. This city of many cities is indeed an urban vision, though it is admittedly a long way from architect Daniel Burnham's exhortation to make no little plans (regarding his 1909 plan for Chicago). The city must embrace and its representations must reflect the wealth of possible experiences of it, which are in truth more often mundane than sublime, crass as well as refined. For if all of those cities can find form in the city, can at least be accommodated if not celebrated, then we will have an urban experience worthy of the complexities of our time, and we will have moved not only beyond universalism but beyond a too-easy divide between the other and (what?) us.

The vogue for all things urban makes this a propitious time to recall such fundamental issues as the nature and complexity of urban experience, to recount the city's necessity, and to assert the complexity of the relationship among the city, the experience of it and what it might be. Illuminating such elemental issues through the contemporary haze may seem too modest an ambition for a book. On the contrary, we are at a moment when we might finally articulate a vision for the city without reverting to megalomania, solipsism, or retreating into supplying what market forces – be they of the societal, economic or intellectual variety and which are also cultural constructs – seem to prescribe. I think it is important to avoid easily seductive and therefore ultimately unsatisfying speculations about what the city will become, and equally simplified explanations about what the city has been. You will find, then, no testosterone-induced fantasies about brave new cyber worlds, no smug continuation of the Anglo–American affair with French-in-translation theory and its hybrid progeny, nor another collection from the usual suspects. There is a marked preference, I hope, for clear writing. I have tried, through assembling a number of authors from a number of disciplines and countries, to put forth a patient examination of what urban experience is and of the city's necessity, with explicit and implicit propositions about what it could be.

NOTES

1. Even suburbanisation, which reached its apogee post-war, and is often regarded as a stage in modern urbanism's historical evolution, is actually contemporaneous with its beginnings. See Robert Fishman, *Bourgeois Utopias: The Rise and Fall of Suburbia* (New York, Basic Books, 1987), especially 'London: Birthplace of Suburbia', and 'The Suburb and the Industrial City: Manchester'.

2. The chilling importance of this assertion can be clearly seen, for example, in the concurrent representations of the inter-war German city as a place of degradation or of liberation (as if those were antonyms). This was not just ideological but political too.

3. For example, see Steven Harris and Deborah Berke (eds), *Architecture of the Everyday* (New York, Princeton Architectural Press, 1997).

4. And also a wearying lack of wit and failure to recognise irony. In contrast, see Roland Barthes' 'The Eiffel Tower', 1964 (in *The Eiffel Tower and Other Mythologies),* in which he admits its overwhelming presence in Paris, but begins the essay by demonstrating the individual's capacity to subvert this: 'Maupassant often lunched at the restaurant in the [Eiffel] Tower, though he didn't care much for the food: "It's the only place in Paris", he used to say, "where I don't have to see it."'

5. See W. G. Sebald, *Luftkrieg und Literatur* (Munich, Carl Hanser Verlag, 1999), in which he argues that the experiences of those who survived the unprecedented destruction of cities in Germany through the air war has not been given form through German literature, and therefore has not been assimilated into the culture. The necessary task of making into memories the horrors of what had been seen and experienced was abdicated by post-war German authors in favour of a collective amnesia. The society made the destruction into simply the first step towards an energetically undertaken reconstruction. Although Sebald was pleased to have an excerpt from this important work appear in this book, it was unfortunately not possible to arrange its translation.

6. This book does not consider developing cities nor social science approaches. For a good survey of the current social science literature on urbanisation, urbanism and globalisation, see David Clark's *Urban World/Global City* (London, Routledge, 1996).

7. For just how far we are from grand utopias see Fredric Jameson's *The Seeds of Time* (New York, Columbia University Press, 1994). After pummelling us in his seminal 'Postmodernism, Or, The Logic of Late Capitalism' (*New Left Review*, no. 146,1984) into submitting that the logic of late capitalism is rampant and triumphant, leaving us so resigned to the present that we could not even conceive of alternatives, he now calls for us to imagine again a future which is not frighteningly post-apocalyptic: 'There is … no more pressing task for progressive people in the first world than tirelessly to analyse and diagnose the fear and anxiety before utopia itself.'

1

Reading the City: Between Memory-image and Distorted Topography
Ingeborg Bachmann's Essays on Rome (1955) and Berlin (1964)

SIGRID WEIGEL

Reading the city refers to the question of how in history space has been transformed into a meaningful topography, i.e. how former experiences, habits, cultural practices, desires, social behaviours, and symbolic orders have become visible signatures inscribed into images of the city. Through reading its topography, the city can be seen as a scenario of memory images and traces of the culture. However, the historical index of this reading depends not only on the past but also on the moment of perception, on the now of readability:

For the historical index of the images doesn't simply say that they belong to a specific time, it says primarily that they only came to legibility at a specific time. And indeed, this 'coming to legibility' marks a specific critical point of the movement within them. Every present is determined by those images which are synchronic with it: every now is the moment of a specific recognition. In it, truth is loaded to the bursting point with time.[1]

In German-language literature of the post-1945 period, images of cities are always at one and the same time images of history, inscriptions of collective memory onto a topography. In this context the writings of Ingeborg

Bachmann[2] offer a paradigm for the way in which the horrors of the recent past erupt into memory only in retrospect, deferred so to speak – a posteriority that becomes the specific trauma of the so-called second generation. It is obvious that the breakthrough of catastrophic aspects into memory took a very long time. It was only after a decades-long period of seeming normality that memory was contaminated by the undescribable events of the Nazi period.

In the work of this Austrian writer, cities are the privileged scenes of memory, topographies in which the images of the unconscious of a culture correspond with the memory traces of the individual. In asserting a correspondence of this kind, Bachmann can be seen as drawing on the work of Walter Benjamin, who states in his *Berlin Chronicle*, for example, that 'memory is not an instrument for exploring the past, but rather its scene'. This formulation shows him transferring Freud's topographical conception of memory onto the memory traces that have become materialised in the relics of the past. In Benjamin's *Berlin Childhood Around 1900*, as in his Baudelaire book and the 'Arcades' project, it is the city in particular that emerges as the prominent scene of memory in the literature of modernity – the city as dream-writing and as recollective space in which cultural and subjective memories coincide. It is in this sense that the cities of Vienna, Rome and Berlin in Bachmann's writings demand investigation.

Bachmann's essay
'Was ich in Rom sah und hörte' ('What I saw and heard in Rome')

Bachmann's essay on Rome, written in the mid-1950s, responds above all to a Benjamin-inspired contemplation of history in the form of memory images (*Erinnerungsbilder*): an attitude through which the historical object presents itself to the contemplating subject as a monad, a fragment of the past blasted out of the continuum of history and charged with the presence of the now (*Jetztzeit*). In her essay 'What I saw and heard in Rome', the narrative gesture 'I saw' charges the over-familiar images of the city of Rome with *Jetztzeit*,

with a form of perception, in other words, which enters into a relationship of immediacy with the materialised and inscribed permanent traces of the past. Via the leitmotif 'in Rome I saw', the text presents a series of images and scenes, as it were imitating movement through Rome with a guidebook in hand. Such modes of observation characteristic of touristic, mythical, aesthetic and historicist representations of the city are simultaneously quoted and invalidated, for in the course of this movement the city emerges as the scene of cultural memory and a topography of the permanent traces of history. Seeing functions here as a rhetorical figure; as anaphora it structures the passage through the text of the city. At the same time, through the constant repetition of 'but' and 'however', a traversal of non-simultaneous and irreconcilable elements is structured. Through the repetition of and variations upon the leitmotif – in Rome I saw, I saw, saw I – a sense of hearing is also brought into play, almost imperceptibly. Proceeding initially from seeing in the sense of recording the sights of Rome, the text leads via the visible traces of the past (architecture, ruins, statues and monuments) and references to the concealed and invisible – 'What is difficult to see is what lies beneath the earth: the watery places and the places of death' (4/33)[3] – to a dialectic of remembering and forgetting. Here, hearing and seeing become skills within a conception of the legibility of the history to be deciphered in the city's images; and these images in turn become thought-images (*Denkbilder*) of the city's cultural history. The 'unmistakable writing' formed by the three cypresses before the glass wall, 'old and new texts' (33), monuments and refuse, signs and objects, all stand juxtaposed in Bachmann's descriptions of Rome as mnemic writing, although without the knowledge preserved in the monuments being made to coincide with other, less durable forms of recollection.

'In Rome I saw that the Tiber is *not beautiful, but* ...' (29, my emphasis). With this invalidation of the postcard view, the essay introduces a series of images of the city out of whose permanent traces moments of actuality arise. The 'but' indicates that the description does not stop at the ideological critique of beautiful appearance, but instead, precisely by cancelling the postcard view, opens up another view onto a different kind of beauty.

The essay's opening section on the Tiber and the Tiberina demonstrates paradigmatically how Bachmann's representation sets up a relation to the Roman legends that have, as it were, congealed into tourist anecdotes in order to allow the particles of *Jetztzeit* to flash up out of these myths of the city. For example, the essay cites the legend as recorded in Baedeker, of how the boat-shaped island in the Tiber came into being when a heavily-laden ship sank there, and cites also the tradition of the cult of Aesculapius associated with the island, carried on to this day as the location of a hospital. But these stories are cited in order to be rewritten into a topography that becomes the place of the 'others', the site of a history excluded from the heroic historiographical tradition:

The Tiberina is inhabited by the Noantri – we others. This is to be understood thus: that it, the island of the sick and the dead since time immemorial, is intended for us others, to live on it, and to travel in it, for it is also a ship and drifts slowly in the water with all the heavy-laden, in a river that does not sense them as a burden. (29)

For the textual moving through the city a perspective is established which might be described as the attempt to 'brush history against the grain',[4] had it not in the meantime become something of a stereotype. Starting from the island of the others, of the sick and the dead, the scenes that follow describe the squares, buildings and distinctive cultural features characteristic of the standard discourse on Rome: St Peter's, the Palazzo Cenci, the ghetto, the Campo dei Fiori, a Roman bar, villas, the Capitol and the Forum, the seven hills, street scenes, the apartment blocks grown up 'organically', without plan, the names of the ancient tribes, the formula of the Roman Republic, the station, the Fontana di Trevi, the catacombs, the sirocco and the testaccio. All of these familiar Roman ciphers are presented as *Denkbilder* in which the process is made visible by the transformation of things, colours, materials, smells, and so on into symbols – 'whoever knows the formula can close the books' (32), or, in which, in reverse, the audible and the visible become once again perceptible in the fixed symbols: 'A match is struck. The flame stretches out towards the symbols. For a moment there appear: fish, peacock, dove …' (33).

When things have long since become standard images in painting, a particular illumination is required so that they can be released for a moment or two from their fixity: 'The houses reside in old canvas; the colours on the canvas are dry. It is only when the light penetrates the porous matter that the colour appears that we see: a brown, capable of any kind of metamorphosis' (32).

By contrast, the traces of the recent past described in the scene devoted to the ghetto elude communication even amongst those participating in it, which portrays a knowledge shared between the generations. On the one hand, the past is preserved and sealed intact in the memories of the old; but on the other, it becomes noticeable as a momentary suspension of movement, when the knowledge of what has gone before breaks through into the present, interrupting for the space of one bar the play of the unsuspecting children:

In Rome I saw in the ghetto that all is not decided for all time, that things may yet take a turn. But on the day of the Feast of Reconciliation, each is forgiven for a year in advance. Close by the synagogue the table is set in a trattoria, and onto the table come the small, reddish fish of the Mediterranean, dressed with raisins and pine kernels. The old remember their friends whose weight was measured in gold; but when they had been bought free, the vans still drove up to the door, and they did not return. But the grandchildren, two small girls in flaming red skirts and a fat blond boy, dance between the tables, their eyes never leaving the musicians. 'Play on!' cries the fat child, and swings his cap. His grandmother begins to smile, and the one playing the fiddle has gone quite white and misses the beat for a bar. (30)

This ghetto scene presents a memory image in which an incommunicable knowledge concerning the events of the recent past is at stake, with the ignorance of the child emphasised by his call of 'Play on!' quoting exactly a formula from the extermination camps, from the hangmen's phrasebook, without being aware of its significance. This is expressed only in the wordless reaction of the fiddle-player who goes white and misses the beat for a bar. At the same time, though, the scene projects an image of hope by presenting how life continues after survival. Even after, or perhaps rather precisely after the events of the recent past there exists a 'secret agreement between past

generations and the present one',[5] a Messianic hope projected onto the descendants.

It was, as Bachmann commented on the Rome essay in an interview shortly after completing it, 'not a narrative text, but in formal terms a rather strange construction' for which she had no name. What she had written were not impressions of Rome; rather she had attempted 'simply to search out the "formulae" for the city, its essence as revealed quite concretely in certain moments'.[6] Here, Bachmann characterises her textual method precisely: in searching out the standard ciphers of Rome, the specific gaze of the specific moment allows something other to shine through the formulae. But at the same time she gives this revelation the problematic title of 'essence', a term which sticks out as unfamiliar within her habitual vocabulary, a linguistic foreign body, so to speak. If we search in the Rome essay for a solution to the puzzle that this word poses we find an answer in the writings of one of the text's historical figures. For whether unconsciously or by design, the reference to essence in Bachmann's commentary on the text is a marker of a third person who must have been a significant contributor within the conception of and mode of representation in the Rome essay. One of the scenes in the essay is devoted to Giordano Bruno, a name synonymous with the art of memory (*ars memoria*) that had such an important place in Renaissance culture. It was Bruno who, in a description of the *ars memoria* in his 1582 work 'On the Shadows of Ideas' ('*De umbris idearum*'), called memory the 'essence of the soul'.[7] But of greater interest for Bachmann's representation of a series of images of the city of Rome in the form of a recollective topography is perhaps the immediately preceding passage in Bruno's work where he writes: 'The art of pursuing things in this manner is in generic terms a "discursive architecture" and so to speak the characteristic gesture of the contemplative soul.'[8]

The statue of Giordano Bruno on the Campo dei Fiori which features in every Roman guidebook becomes the embodiment of the theme of memory in Bachmann's essay as memorial and as cipher for the art of memory. When Bachmann searches out these formulae in her text, it is with the specific intention of disrupting and dissolving their formulaic nature. 'It is only as

an image that flashes up in the moment of its cognisability, *never to be seen again*, that the past can be apprehended,'⁹ as Benjamin writes (my emphasis), save that this apprehension does not allow any kind of fixity or durability. The memory images in Bachmann's essay are born out of the tension between cognisability and the fact that they will never be seen again, out of the non-simultaneity of a history become stone and fleeting or transitory traces, of monuments and of that which has no duration. At one point, for example, Bachmann writes that the smell of rot and decay brings the past to life more vividly than the monuments and memorials do (4/30). And in the scenario of the Campo dei Fiori the continuity of memory which is figured in Bruno's statue is rematerialised and thereby broken by being superimposed onto an everyday image from the present. The sentence 'I saw on the Campo de' Fiori that Giordano Bruno is still being burned to this day', with its evocation of the pathos formula of the martyrdom of the heretic condemned to death by the Inquisition, elides into a concrete scene from the present as the essay describes the burning of the rubbish every Saturday evening when the market stalls are dismantled. If the smoke of the present appears inhabited by the memory of past flames, the image of the past thus conjured up can nevertheless not be held on to: 'Again the smoke rises, and the flames twist in the air.' And yet one cannot see in the flames of the burning rubbish 'how far they reach and what it is they take after', whereas the monument embodies a perpetuated form of knowledge: 'But the man on his pedestal knows it and still does not recant' (31). However, for the people of today what it is that he knows remains concealed in the indefiniteness of the 'it'.

More than just a decade lies between this essay on Rome, in which scenes and images of the city are fashioned into images of cultural memory, and Bachmann's essay on Berlin. The intervening period sees the violent entry of trauma, pain and the structure of a repetition compulsion into Bachmann's work on literary memory. One sees this in the scene of the railway collision in her famous short story *The Thirtieth Year* (1961). This story, which corresponds to Freud's *Beyond the Pleasure Principle*, brings, along with the *télescopage* of the train collision, the motif of distorted memory into play, a motif that will dominate the topographical poetics in her subsequent writing.

Trauma Berlin: symptomatic body and distorted topography

In Bachmann's essay on Berlin 'Ein Ort für Zufälle', literally 'A Place for
Chance Encounters' or 'A Place Where Things Fall To One',[10] it is the
topography of the city itself that is presented as a symptomatic body,
carrying the signs of a history of horrors. This perception of Berlin as a body
bearing the symptoms of German history is only possible on the basis of an
attitude which Bachmann calls being 'prepared to encounter sickness'
(4/279). In her introduction she explicitly denies speaking of impressions of
a city; rather she felt compelled to speak of madness or rather those chances
(Zufälle) that 'communicate themselves to a visual or auditory sense that is
open to what such chance may bring, the nightmare and its consequentiality'
(278). This was not simply the result of the division of the city, but had to
do with a more distant past and with a return. Bachmann makes a connection
between the clinical pictures (Krankheitsbilder) of the city and the return of
a repressed history:

> The damage inflicted on Berlin, the historical circumstances of which are of course
> well-known, does not allow of any mystification or elevation into the symbolic.
> What it compels, however, is that one is prepared to encounter sickness, and the
> consequentiality of the variable images of sickness that sickness calls forth. Being
> prepared in this way can force a person to walk on their head in order that report
> might be given of this place, about which one can tell many things but of which it is
> difficult to grasp hold. The reporter is a stranger to the place – and thus is both at an
> advantage and at a disadvantage. The representation is entirely adequate to the reporter
> and never quite to the matter in hand. But representation requires radicalisation and
> comes from necessity. (279)

If the radicalisation required of representation here recalls the 'painful
compulsion' to remember that made its appearance in The Thirtieth Year, the
sense of necessity is indebted to that which forces itself upon the attention of
the stranger when confronted with the scene that is Berlin. But Berlin allows
Bachmann a dual perspective: on the grounds of historical entanglement it is
as close to her as Vienna, but geographically as distant as Rome since, like
Rome, it is not the place she comes from, but one in which she is a visitor.

Like the reference to walking on one's head – the precondition for being able to give report of the place at all – the *Zufall* of the title of the essay is derived from Georg Büchner's story *Lenz*, which Bachmann states explicitly: '*Zufälle*: a strange word which Büchner applies to Lenz's sickness' (278). Yet Bachmann wishes the sickness of which she speaks to be understood as the legacy of an earlier madness, as a kind of transgenerational inheritance of memory traces.

The madness can also come from outside, can come to, fall upon individual people, has, then, a long time hence gone from the inside of individuals to the outside, and takes the return path, in situations that have become familiar to us, in the inheritances of this time. (278)

Here Bachmann takes the word *Zufall* quite literally, not so much as chance, but as something which falls to one, falls to us, happens upon us. *Zufall* then does not stand in contrast to fate, but rather describes a figure of memory in which the hidden signs of what has been (suddenly) become visible in the now. In the text of Bachmann's Büchner Prize speech, these signs are simply referred to as 'it' or 'something', expressed in the phrase 'there is something in Berlin' ('*Es ist etwas in Berlin*') or the reference to 'then', 'the time before' ('*damals*'). The first of the 21 *Krankheitsbilder* that form the panorama of Berlin as the symptomatic scene of a repressed history is, as it were, generated out of the incantatory repetition of fragmented elements of the contradictory formulae 'it's nothing' and 'there is something in Berlin':

It is ten houses to Sarotti, it is … there are …, is …, is also …, it isn't so far, but not so near either, is – a wrong guess! – a thing as well, is not an object, is by day, is also at nights, … has nothing to do, yes is, has happened once, is given up, is now and has been for a long time, is a permanent address, is to die of, comes, comes forth and to pass, is something – in Berlin. (279f)

Only in the final section does the phrase 'there is something in Berlin' (292) appear in its entirety, and it is then immediately retracted with the conciliatory formula: 'It was an agitation, was nothing more. It won't happen again' (293).

The 21 'variable images of sickness' are constructed as superimpositions of hospital scenarios and places on the Berlin map, so that what appears is a distorted topography in a quite literal sense: 'The streets rise at an angle of 45° … The whole city circles round, the restaurant rises and falls, trembles, judders' (284). Through this movement there occurs a literal *télescopage* of the architecture, as when 'Potsdam with all its houses has slid into the houses of Tegel'. The text creates a panorama in which the images of an overabundant normality – the Havel full of beer, the Spree and the Teltow Canal flowing over with brandy, old ladies at Kranzler's stuffing themselves with cake, old men in front of it cracking obscene jokes – tip over into the scene of a distorted cityscape. Tiny bones, burned and blackened in the grass, and camels in the desert sands of Brandenburg are elements in this scene in which everything has run riot, and out of which the signs of a history repressed from the city's historical consciousness break forth: 'At the knee of the Königsallee there fall, quite muffled now, shots aimed at Rathenau. In Plötzensee the hangman is at his work' (288). Dizziness, screaming, breakdown, ceilings collapsing, concrete barriers, logs for the woodpile, bodies inwardly injured and people wrapped in grease-proof paper, the 'programme continues', the chief doctors' diagnoses are hieroglyphs, and the insurance companies are not accepting responsibility since this is 'a pre-contractual suffering'. All of these are images in which the signs of sickness point towards traumatic events in German history and become readable as the symptoms of collective memory traces.

Berlin thus becomes the scene in which the individual subject may chance upon historical justification for his or her own clinical condition, to the extent that he or she is able to decipher the symptoms. The radicality of this writing, the imitation of the scene of traumatic recollection, a figure of shock, obviously had in turn a profoundly shocking effect on some members of Bachmann's Darmstadt audience, as a number of angrily defensive reactions indicate.

In Bachmann's early sketches for the Büchner Prize speech, the plan for the Berlin *Krankheitsbilder* is clearly interwoven with a plan for a project on the desert which she was to pursue later as a separate book. In the

unpublished notes for a preface to an earlier version of the speech, in which the images of Berlin are still superimposed upon images of the desert, Bachmann explains her textual method of creating a simultaneity of two different scenes with the premise:

… that from one paragraph to the next two movements intersect. That on the one hand I will transport you to Berlin, and in the next moment into the desert. How the one comes to the other, to a Berlin that is not visited by a person so much as by a delirium, by a sickness one might say, by bad dreams, and contrapuntally an I, of whom it is to be believed that it is on a journey, perhaps less on a journey than on a path to healing, incapable of ordered impressions.[11]

Bachmann's earliest text on Berlin is a fragment entitled 'Dying for Berlin' ('*Sterben für Berlin*'). It tells of a journey to Berlin and was probably written shortly after her visit to the city in 1961 (and can thus be seen as belonging to the genealogy of the Berlin essay). Already in this fragment, which amongst other things takes up the question of whether Berlin is a particularly extraordinary place, the motif of the city as a devastated wasteland is associated with the idea of the camels in the Brandenburg sands. And in a further sketch on the visit to Berlin, the formula that was to become so central to the Berlin essay makes its first appearance: 'It was nothing, one might say. And yet there was something.'[12] The preparatory work on the Büchner Prize speech proper is, however, signalled by allusions to Büchner's works – 'Lenz at Oberlin's' and the groan 'ah, art' (172). Here, Bachmann quotes Paul Celan's formulation 'the path of art' from his Büchner Prize speech given four years earlier, although she describes this path slightly differently from Celan, namely as the traversal of a sickness:

… let us stand on our heads, on the path quite far from art, which may one day open onto the place where once more art will come. Will come to join us, soon come to join us, when the burned places are healed, … Art comes only after the second death, after the second innocence. (174)

This can be understood as Bachmann's commentary on the debate about 'art after Auschwitz'. In these early sketches, still written in the first person,

the signs of sickness are reflected as an 'expression of a defeat in the face of reality' (175), and explicitly thematise the blind unawareness that constituted the state of consciousness after the war, a time after the period of the simple 'wish to survive'. There is also talk here of the 'unrememberable' origins, and that it is only through flight into the desert, i.e. to Germany or to Berlin, that one can come to reflect upon one's own origins and one's own path.

The specific mode of representation of *Ein Ort für Zufälle* can, in conclusion, be further illustrated by comparing it with contemporary Berlin texts by other authors. One of Bachmann's sketches for her Berlin essay corresponds – on the basis of a lengthy passage on the 'mass 20-pfennig-revolt against the regime' – with Uwe Johnson's critique of the 'Boycott of the Berlin Suburban Railway' (1964). Johnson not only analysed the Cold War ideology of the protest action[13] by demonstrating that the West Berliners had suffered the greater (financial) damage, he also placed the current situation in the historical context of the legacies of the war. In doing so, he was able to resume the thread of his text on the Berlin suburban railway, *Berliner Stadtbahn*, written three years earlier, in which he had described the particularity of the German–German border with amongst other things reference to the mark made in the city's history by the public transport system since its construction in 1882. (The essay was overtaken by history as soon as it appeared, in that it was published in *Merkur* in August 1961, the month the Wall was built.) In the 1964 text the effects of the railway boycott, with which the Berliners inflicted damage on their own city, are described by Johnson amongst other ways in terms of sickness, but in such a way that the representation of the city as a body remains within the problematical tradition of organic metaphor: 'The comparison of the boycott with an amputation brings in its wake one of severe circulatory disturbance.'[14] Whereas in Johnson's work the historical contextualisation and the metaphorical treatment on the descriptive plane are quite separate, Bachmann's 'images of sickness' of Berlin have an entirely different meaning, are beyond any metaphorical function. Read as the mnemic symbols of collective repressions, they transform the city into a symptomatic scene of German history.

In Bachmann's notes, sketches and essays, Berlin becomes identifiable as the scene of distorted memory in which it also became possible for this Austrian writer to read her own origins and her own path in connection with the traumatised permanent traces of post-war history. The motif of trauma makes its first explicit appearance in Bachmann's writings in the context of her work on the Berlin essay. For her, trauma is a theme of post(-war) history and a phenomenon of posteriority. For Bachmann the trauma is related not so much to catastrophic events whose intensity makes it impossible for the individual subject to find an adequate response, but rather to scenes from the past which are forgotten or which are 'unrememberable', whose traumatic significance becomes clear only in retrospect, on the basis of later experiences. This traumatic significance in turn only comes to the fore through the visit to a symptomatic scene of history, the 'wasteland' Berlin. It is from there that she can begin to recollect her own origins and childhood.

NOTES

1. Walter Benjamin, N [Theoretics of Knowledge; Theory of Progress], *The Philosophical Forum*, vol. XV, nos. 1–2, Fall–Winter 1983–84, p. 8.

2. The Austrian Ingeborg Bachmann (1929–1973) is the most significant female author of post-war German-language literature. As with many authors who shaped the literature of the 1950s and 1960s, her coming-of-age coincided with the historic turning point of the end of the Second World War. A doctor in philosophy, she first achieved notice through her poetry in 1952–53, and was considered the court poet of *Gruppe 47*, but moved away from them at the end of the 1950s. She achieved further fame with her radio dramas (1956–58) and narratives (1961). After almost ten years of not publishing, it was the publication of *Malina* (1971), the first of a planned multi-volume novel *Todesarten*, which led to her rediscovery. It became a classic of women's literature.

3. All numbers of volume and page mentioned within the article refer to Ingeborg Bachmann *Werke*, edited by Ch. Kosel et al (Munich, Piper Verlag, 1978). Author's translations.

4. Walter Benjamin, 'Theses on the Philosophy of History', in *Illuminations*, edited by Hannah Arendt (London, Fontana/Collins, 1973), p. 259.

5. Benjamin, 'Theses' (1973), p. 256.

6. Ingeborg Bachmann, *Gespräche und Interviews*, edited by Ch. Koschel and I. v. Weidenbaum (Munich; Zurich, Piper Verlag, 1978), p. 13.

7. Elisabeth von Samsonow (ed.), *Giordano Bruno* (Munich, Diederichs, 1978), p. 240.

8. Samsonow, *Giordano Bruno*, p. 239 (my emphasis).

9. Benjamin, 'Theses' (1973), p. 257.

10. Given as a speech on the occasion of receiving the Georg Büchner Prize in Darmstadt, October 1964.

11. Ingeborg Bachmann, *Todesarten-Projekt*, edited by R. Pichl et al (Munich; Zurich, Piper Verlag, 1995), vol. 1, p. 181.

12. Bachmann, *Todesarten*, vol. 1, p. 87.

13. The commuter rail system traversed Berlin and its suburbs, but was managed by the East after the war. In comparison to other means of public transportation it was extremely good value for West Berliners. The call to boycott it came from the (West) German Association of Trade Unions after the construction of the Berlin Wall (which commenced on 13 August 1961). With slogans like 'Not a Penny for Ulbricht', and 'Commuters Finance Ulbricht's Barbed Wire', the boycott became a tool of Cold War politics. Those who nevertheless continued travelling by it were morally defamed. (Translated by the editor.)

14. Uwe Johnson, *Berliner Sachen* (Frankfurt am Main, Suhrkamp Verlag, 1975), p. 29.

2

No Place for a Lady
Women Artists and Urban Prostitution in the Weimar Republic

MARSHA MESKIMMON

Suicide

I first came across George Grosz's small but striking painting *Suicide* (1916) in 1987 while working on my doctorate and since then I have seen it as something of a talisman, being a site of conflict between traditional political and socio-critical readings of the brutal 'realist' art produced in Germany during the First World War and the Weimar Republic and, in particular, feminist reinterpretations of modernism. A tape-recording of Frank Whitford's eloquent public lecture about the work epitomises the traditional interpretation.[1] Already ten years old when I listened to it in the Tate Gallery archives, Whitford's lecture summarised the conventional ways in which the so-called *Verist* wing of the *neue Sachlichkeit* had been viewed: Grosz used the motif of the city street, the suicide victim (said by Whitford to be a self-portrait) and the prostitute to show the inhumanity of his times and, indeed, of ours. The artist's politics and personal motivations can be read in and through this work, and its particular tropes act as universal metaphors – ciphers of social decline. In readings such as Whitford's, the

fig. 1
George Grosz
Suicide
1916
© DACS, 2002

figure of the prostitute is defined as but one powerful symbolic evocation of the alienation produced by the debauched urban milieu, one which suggests the reduction of human emotion to mere sexual and economic commerce. Following this line, the visual distortion commonly used in representing the figure of the prostitute is explained as a visible equivalent to the decay of the human spirit; the fleshly excess and repulsive attraction being a function of the prostitute's general symbolic role within works of modernist socio-critical art.

Generations of feminist art historians and cultural critics aware of the significance of gender and sexuality in the visual sphere provided countless critiques of such gender-blind interpretations of modernism and the city.[2] In the context of Weimar, such diverse scholarship as that of Patrice Petro on the popularity of the so-called 'street films', Dorothy Rowe's discussion of the configuration of Berlin as 'woman' in art and literature and Andreas Huyssen's writings on mass culture have all shed light on the gendering of German modernism.[3] To paraphrase Huyssen, the aesthetic structures and definitions of modernism in Germany were a function of the subjects who produced them; the conventional tropes of modernism were thus never simply universal, rather they were the product of a 'masculine imaginary'. Following this line of debate it becomes clear that the urban paintings and graphics of the period described the experience of the masculine subject in the face of socio-political upheaval and that the trope of the female prostitute, as it functions within these works, speaks of men's fears and desires while saying little to women of the period. The structures of modernism as conceived through the masculine imaginary delineate both the urban environment and the representation of prostitution itself as no place for a lady.

I have since looked at Grosz's *Suicide* in these terms, noting particularly the way in which the male figure suffers emasculation and death in a scene presided over by the lurid representation of the woman-as-prostitute. This overtly sexualised city, feared and desired as other by the male artist, required control, and that control was enacted in part by the phantasmic representation of woman as monstrous flesh. To be able to define, through

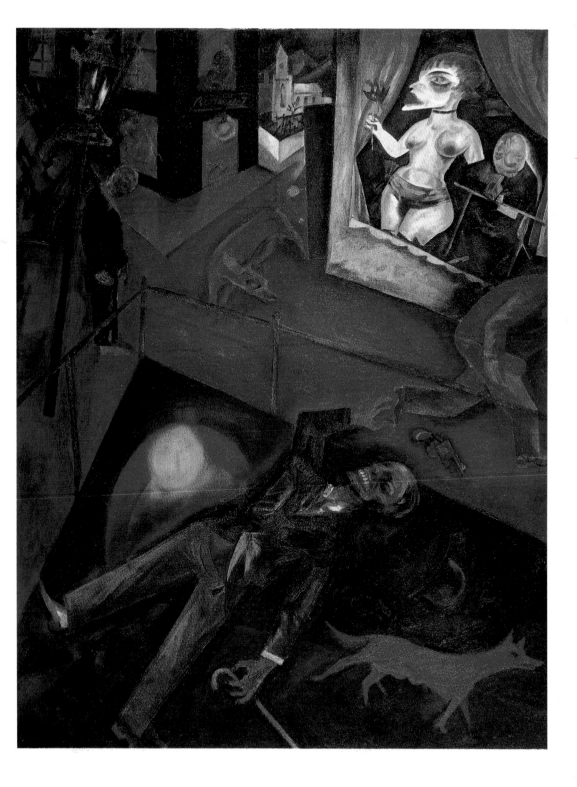

crude and simplistic symbols, the figure of woman as other was to reinforce the unity of the masculine subject in the threatening face of female emancipation and integration into the public sphere. Where boundaries were being broken by women in the city in real terms, symbolic defences tightened around the image of woman. I could not help but realise the exclusivity of the masculine political motives in *Suicide* and wanted to know where or how women could speak within such a univocal system. While it was certainly the case that most women working in figurative modes during the Weimar years avoided the subject of female prostitution, since it offered them so little scope through which to represent their position as women artists, a few notable exceptions existed. Were the women artists who explored images of the prostitute merely acceding to the conventions of the masculine imaginary, or were their works acting to reinterpret the figure of the prostitute in terms applicable to women of the day?

What is at stake here is the tendency for both the traditional interpretive framework and the alternative feminist model to override specificity and difference in the name of homogeneity. In general terms, I would affirm that the figure of the prostitute in German modernist art was an image of the masculine subject in crisis and not representative of any woman *per se*. However, such broad statements make it possible to lose sight of highly significant variations across the theme of the figure of the prostitute which enunciate the multiplicity of gender and sexual politics in that period. For example, there were a number of forms through which prostitutes were most commonly represented by male modernists, and to use widow's weeds was very different than to evoke the mannequin or cyborg.[4] Variations in iconography could make the prostitute a malleable symbol, subject to reinscription in many different registers including, perhaps, as a meaningful image in the art of women.

Similarly, the issue of prostitution in Germany at this time was marked by definitive regional variations – different *Länder* had different laws regarding prostitution, and particular cities were noted as centres for specific forms of sexual vice. In attending to the legal notices, political and sociological treatises (including the work of many sexologists of the period) in addition to popular

evocations of prostitution, it becomes clear that while some gross generalisations were made about the decline of the nation, for the most part only Berlin and Hamburg came under close scrutiny.[5] A similar pattern can be found regarding regional art centres in which the theme of prostitution played a major role – Berlin and Hamburg were the centres in which the prostitute was a key figure in the art of both male and female realists. In centres such as Cologne, Munich and Hanover, the representation of prostitution was far rarer, and even in Dresden and Karlsruhe it tended to figure mainly in the work of male artists who either went to Berlin or Hamburg or who were affiliated with artists from those centres. Moreover, since models of national art practice frequently privilege centre-periphery dominance, there has been a strong tendency in assessments of this art to place the work of Berlin over other centres active during the period, and to cite a few canonical 'masters' as representative of Weimar figuration more generally. Hence, the regional variation in the representation of prostitution in Germany has been occluded in much of the literature in favour of a homogenising approach.

If Berlin and Hamburg were both notorious as sites of large-scale urban prostitution, they were characterised at the time in slightly different ways. Berlin was more significant in the public imagination generally as a symbol of the vices wrought by mass urbanism and commodity culture, not to mention the introduction of foreign influences upon German culture. The loss of social unity and familial values presumed to accompany modernity were represented by the ubiquity of prostitution in Berlin; indeed it was the sheer variety of sexual commodification which enticed and repulsed commentators. There was sex for sale for every predilection – if you could not find something to your taste in Berlin, it did not exist. The prostitute represented the very type of the commodity – in Benjaminian terms, its *ur-form*. Prostitution further implied the transgression of fixed class, race and gender identities through sexual intercourse. For artists such as Rudolf Schlichter and Grosz, this breakdown of boundaries meant the representation of sexual fetishism and predatory urban nightlife as dangerous, frightening and all-encompassing. Grosz particularly emphasised the ubiquity of the whore – any woman on the street was subject to his merciless and sexualised gaze. In the work of

Christian Schad, which frequently considered transvestism and male homosexuality in addition to female prostitution, the instability of these boundaries was more pleasurable if equally shocking to viewers. To paraphrase one famous social critic 'Berlin was becoming a whore'.[6]

Hamburg was the home of the best-known single district of prostitution at the time in St Pauli, the area surrounding the harbour, intersected by the Reeperbahn. The representations of prostitution focusing upon Hamburg thus tended to feature references to the figure of the sailor and the scene of the brothel. In terms of the public criticism of Hamburg, however, it was the state regulation of prostitution which was at issue. The free city of Hamburg and certain other areas of Germany, such as the regions surrounding Bremen and Baden, were the focus of public attention because of their unusual legal regulation of prostitution in brothel-systems. In these systems, the police, judiciary and medical authorities labelled prostitutes, checked them for venereal diseases and ensured that they lived and worked in particular places. By so doing, they were seen to encourage vice as well as to be the corrupt heirs to its profits. With the military brothels of the First World War causing public concern during the period, the system sparked a great deal of controversy and came under nationwide attack after a young girl in Bremen was falsely accused of being a prostitute and died in police custody.[7] Thus, in a very different context than Berlin, the question of defining the prostitute, and therein the boundary between the good and the bad woman, was still a major area of contention.

If the generalised discussions of the image of the prostitute in German modernist art and literature have tended to occlude significant regional issues, so too have they marginalised the role of women in the debates of the day. Women's responses to prostitution were not unified, despite the fact that the Bremen scandal brought many women with differing class and generational affiliations together. For the most part, older, middle-class women, even when involved in feminist politics, defined the prostitute as other in line with mainstream patriarchal views. Thus, even in exhibiting a missionary zeal toward eradicating prostitution, they still emphasised the differences between the prostitute and the lady – that morally superior

woman who was defined in relation to her roles as mother, wife and daughter of a man. In rare instances, other affiliations could outweigh middle-class women's investments in their roles within patriarchal structures, such as when the *Jüdischer Frauenbund* took an extremely liberal view of prostitution in relation to the so-called white slave trade. Here they emphasised, against the views of the male Jewish establishment, the specificity of the threat to all Jewish women of the trade in Eastern European Jewish prostitutes.[8]

However, the most fascinating responses to prostitution were voiced by young, left-leaning urban women. These women, as doctors, lawyers, sociologists, politicians, artists and writers, began to consider the figure of the prostitute in relation to alternative conceptions of female sexuality and self-definition more generally. Such ways of approaching the theme questioned the validity of the very categories through which patriarchal systems defined women as ladies and tramps, and posited modes of exploring the roles of women in wholly new terms.

A significant focus in this work was the threat inherent in the definition of some women as prostitutes in opposition to a normative construction of good women. It was seen to be a tactic used to silence women or divide them from one another. The example of Toni Sender, the woman *Reichstag* representative publicly slandered in the press with false allegations of prostitution in order to thwart her political actions, should remind us that this fear of the use of the term prostitute against women was not just paranoid.[9] It was no accident that the tale of *Elfriede of Schiffbek*, written in 1923 by Larissa Reissner to immortalise the power of revolutionary women, told of Elfriede's torture at the hands of the *Reichswehr* thus:

… each of those gangs started once again on her standing as if naked among wild beasts. 'Communist slut,' they shouted. 'Whore,' they shouted. 'You're not a German woman but an animal,' they shouted … Elfriede stood in that satanic corridor and cried out about Rosa Luxemburg until she was heard. When a girl arms herself with Rosa's name she is as powerful and as dangerous as an armed man.[10]

This threat of definition and castigation was at the crux of the incident in Bremen but it also had repercussions for any woman undertaking professional

and leisure activities in the city. Irmgard Keun's well-known novel *Das kunstseidene Mädchen* (*The Rayon Girl*) is replete with a scene in which the main character is accosted as a prostitute by a man on the street in Berlin; many of the all-woman clubs, cafés and bars established in the period marketed themselves precisely as places in which women could enjoy entertainment without the threat of men's unwanted advances. The sense of insecurity derived from being labelled as a type of woman in a masculine heterosexual economy gave many women the impetus to redefine their own roles and seek new contexts for their understanding of prostitution.

The only sociologist of the period to ask prostitutes themselves about their experiences was a woman: Elga Kern.[11] Significantly, her work was cited most often in other women's writings about prostitution, such as those by Alice Rühle-Gerstel and Anna Pappritz.[12] In all of these texts, the difference of the prostitute from other women is minimised and challenged. Rühle-Gerstel directly countered the tendency to represent prostitutes as objects of fantasy, and Kern consistently asserted the economic necessity of prostitution along with the ordinary, common experiences of the sex workers she interviewed such as their marriages, their families and their children. There was little to be gained for modern women in Weimar to accede to the separation of women through sharp boundaries of sexual morality which only referenced patriarchal familial power structures. The blurring of the boundaries between women in public, masculine and feminine identity and the strict ordering of sexuality offered modern women the chance to voice their own forms of self-definition, which they took eagerly. However, confronting the stereotypes of woman so entrenched in the period and moving into realms which were no place for a lady could be as dangerous as it was invigorating.

Unladylike behaviour: Elfriede Lohse-Wächtler

Elfriede Lohse-Wächtler was an artist who used the theme of urban prostitution in Hamburg as a key element within a wider *œuvre* focused upon the depiction of outsider identities. In her work she questioned the

construction of the prostitute as a symbolic 'other' and located her own identity outside conventional structures of femininity. Beginning her art education in Dresden within the context of the radical left art circles of Otto Griebel and Otto Dix, Lohse-Wächtler moved to Hamburg in 1929, where the next two years, until suffering a breakdown and period of institutionalisation, were her most productive time. Her work centred upon sketches and watercolours of prostitutes, Hamburg's nightlife, self-portraits and scenes of harbour workers. Her affiliation with Dresden's left-wing art scene, the city of Hamburg and the representation of prostitution brings Lohse-Wächtler astonishingly close in terms of influences and incidental biography to Dix, the artist best-known in the Weimar years for his extensive development of the theme of the prostitute. However, while they shared influences and motifs, these were viewed very differently by the art world and the political establishment and the artists would suffer very different fates.

Dix, like Lohse-Wächtler, came from the Dresden milieu, but had a more traditional training in the Academy. After active service in the First World War, including first-hand experience of military brothels, Dix returned to Dresden and continued his art career. It was after a visit to Hamburg, in 1921, that he first represented prostitution in large-scale works centred on images of brothels and sailors in port. These works, most notably the scenes of brothels *Salon I* and *Salon II* (1921), and the scandal which accompanied their showing in Düsseldorf, Berlin and Darmstadt, made Dix one of the most famous painters of the inter-war years. Dix's standing as a controversial modernist artist was enhanced by his use of the theme of the prostitute as a metaphor for urban decline and a symbol of the alienation experienced by the masculine subject in modernity. The critical distance Dix developed through the material techniques of his paintings, in addition to his own and other art critics' verbal defences of the works, are extremely significant in understanding their paradigmatic status within any canon of Weimar realism.

The monumentality effected through rendering these scenes as large-scale oil paintings was not incidental to their critical reception. While their detractors were horrified by such 'obscene' images being figured in the forms associated with lionised western fine art masterpieces, their proponents (not

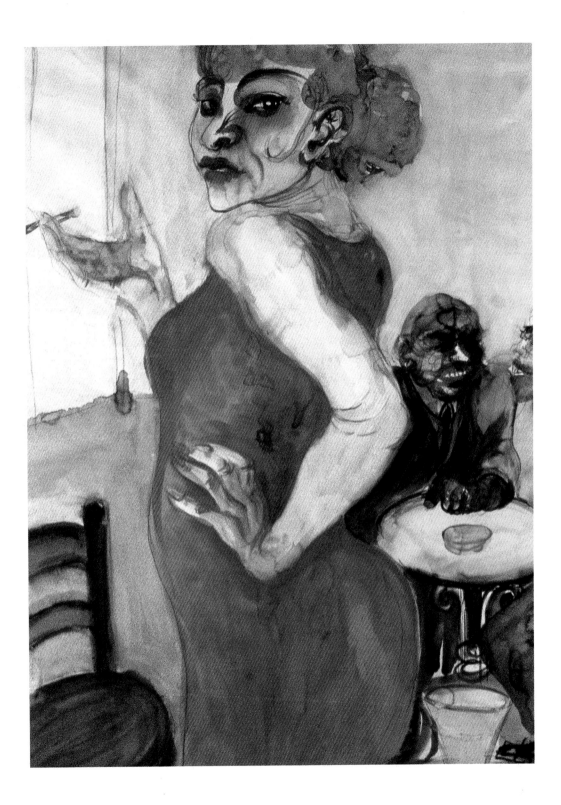

fig. 2
Elfriede Lohse-Wächtler
Lissy
1931

to mention Dix himself) understood the transgressive power which underscored such manipulation of tradition. In valorising these works and countering the court cases brought against him, Dix enunciated this strategy directly. He was cited thus: 'The idea of the painting is to depict the whole ghastly, dehumanising effect of prostitution … The way the women are portrayed is intended to be revolting: to arouse exactly the opposite feeling to lust.'[13] What is implied by both the materiality of the works and the verbal strategies brought to their defence is that they are defined in relation to a masculine tradition and a presumed masculine viewer. The women are portrayed with no reference to their lives or experiences; they are symbols of prostitution and 'dehumanising effects' meant to 'arouse' disgust rather than 'lust'. They are the gross matter of woman transformed into the symbolic register of phallocentric logic by the creative actions of the male artist.

Lohse-Wächtler's representations of prostitutes and urban nightlife could not have been more different. Rather than taking preliminary sketches and transforming them into large-scale oil paintings, the sketch was the finished format of her practice. This format decreased the distance between viewers and sitters, emphasising not the symbolic nature of the scenes but their immediacy and actuality. For example, Dix's painting *Three Women* (1926) used female figures caricatured as types to engage with the commodification of prostitutes as displayed objects for purchase, with references to the fine art subject of the three graces and their judgement by the male figure of Paris. By contrast, Lohse-Wächtler's work of the same title from 1930 is a small-scale sketch in which the female figures are not on display for judgement or purchase. Close attention is paid instead to their facial expressions and the viewer is brought into proximity with the sitters rather than granted an objectifying viewpoint.

Moreover, in Lohse-Wächtler's *œuvre*, the subjects of the works were treated with equanimity – portraits of prostitutes, harbour workers and the artist herself were handled in the same compositional and material modes. This, again, contrasted with Dix who asserted his cultural authority over his subjects in self-portraits which show him as the dismembering murderer of female figures or the cool, alienated visitor to the brothel (see *The Sex*

Murderer: Self-Portrait (1920) or *Homage to Beauty* (1922)). Lohse-Wächtler placed herself within the frame of the women she portrayed. *Lissy* (1931) is a portrait study of a monumental female figure presumed, by references to the location in a bar and her mode of dress, to be a portrait of a prostitute or madam.[14] However, the figure is given pride of place within the scene and viewers must negotiate with her gaze for entry into it. Despite having two male figures in the background, Lissy is not on display and is not controlled by her relationship, visually or thematically, with those male figures. This may be no place for a lady but it is a space controlled by a powerful, named, female figure and the woman artist painting her portrait.

The link between the position of the artist and her female sitters can be demonstrated with reference to the visual details of her works as well as to her own biography. Lohse-Wächtler's self-portraits used similar representational strategies to those deployed in *Lissy*; strong, monumental figural composition with an emphasis upon the painterly details of the facial features, expression and pose. Indeed, her self-portrait of 1931, *The Cigarette Break*, showed the artist in precisely the same pose as the woman represented in *Lissy*. The distance between the young modern woman artist and the prostitute is minimised to the point where it becomes nonsensical to think of the prostitute as other, a symbolic icon of the gross materiality of woman in a masculine heterosexual economy. Rather, we are obliged to begin to think about female sexuality in its own terms and operating within a visual register produced by and for women. Lohse-Wächtler did not shy away from imaging sexual women, nor did she flinch from living amidst prostitutes and gypsies. But while this identification with outsider positions made her art extremely challenging, it later placed her firmly outside the boundaries of womanhood defined by National Socialism. Never attaining the canonical status of Dix, Lohse-Wächtler was incarcerated and killed by the Nazis for daring to question the bounds of ladylike behaviour.

Ladies and/or gentlemen: Jeanne Mammen

Throughout the inter-war period, Jeanne Mammen's diverse artistic practice had at its core a central theme: the manifold public and private experiences of modern young women in the urban centre of Berlin. Through critical graphics, fine art prints, watercolours and illustrations for fashion magazines, advertisements, popular Berlin tourist guides and sociological journals, Mammen's malleable *œuvre* documented and participated in the burgeoning women's culture of its day. As a theme in her work, the prostitute was but one small aspect, yet her representations of prostitution were sophisticated indicators of the development of new, woman-centred definitions of gender and sexual identity as they were debated through high and low cultural practices in Germany. Women were not merely the objects of discussion in debates about gender roles, they were participants in all forms of their redefinition. And while certain areas of the city may have been no place for a lady, they were ideal locations for women to challenge the fixity of gendered social and spectatorial interplay around new definitions of woman. Mammen's work typified this process.

To bring out the subtle strategies of Mammen's *œuvre* in relation to issues of female sexual and gender identity, it is instructive to look again briefly at a work by Dix. Between 1925 and 1927 Dix lived in Berlin, a city he commemorated with one of the most iconic representations of urban prostitution of the period, the *Big City* triptych of 1927–28. In this work, the shifting ground upon which decisive parameters between men and women, masculinity and femininity and indeed, ladies and prostitutes were drawn is evoked by spectacular visual phantasms of woman. This work has been discussed widely and so it will suffice here to remark upon but one particular aspect of its elaborate iconography; namely, the conventions through which the figures of the so-called new woman (*neue Frau*), prostitute and transvestite/transsexual are confused in a fetishistic display of outrageous fashions, garish make-up and wildly distorted body types and poses. The male figures, by contrast, are confined to the fairly ordinary-looking members of the jazz band (a number of whom are portrait-likenesses of Dix's friends) and

fig. 3
Jeanne Mammen
*Garçonne (or Prostitute
on a Green Couch)*
(published Hirschfeld 1931)
© ADAGP, Paris and DACS,
London, 2002

bourgeois club-goers, in addition to the emasculated figures of crippled war veterans and a faint image of Dix himself.

The work epitomised the critique of Berlin's urban decadence as it was figured along gendered lines: a feminised mass culture of pure spectacle and commodification lacking stable definitions of gender, class and racial identity was destroying (male) individualism and the potential for political change. Women within this scenario were figured either as empty-headed consumers, along the lines of Siegfried Kracauer's critiques of cinema and its 'little shop-girl' audience, mere sexualised objects, enhanced by the latest fashion products, or frightening physically perverted types, literally mutated in response to the unhealthy moral environment of the city. Links between the prostitute, the lesbian or transsexual and the *neue Frau* were common in this period and relied upon crude physiology to associate active female sexuality with biological deviance. Prostitutes and lesbians were represented as monsters, and the androgynous form of the *neue Frau* was thought to prove biologically that women in the public sphere were losing their capacity to conceive and bear children. Hence, the grotesque display of the flesh of prostitutes and the sheer variety of bodily types Dix used in *Big City* were not simply coincidental, they pointed out the difference between the familiar man on the street and the outrageous otherness of the woman of the street, perverted from the course of true womanhood.

Mammen's work was steeped in the same set of contexts – commodification, fashion, display, mass culture, the dissolution of sharp sexual and gender boundaries, and the significant role of visual culture within all of these spheres. However, her determined emphasis upon women as cultural agents within these constructs caused her works, which explored fashion, nightlife, sexual identity and prostitution, to be very different than those of Dix and indeed, to counter prevailing discussions of women as objectified, mindless consumers. Mammen's artistic practice cut across the boundaries between fine art and graphic illustration and the visual languages she deployed in representing modern women seamlessly merged the two. This multiplicity in the visual, referencing cinema and the celebrities of the revues, high-circulation pictorial magazines and fine art, made

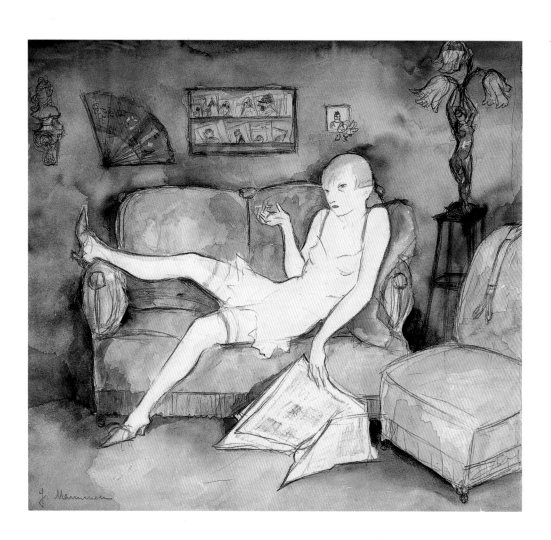

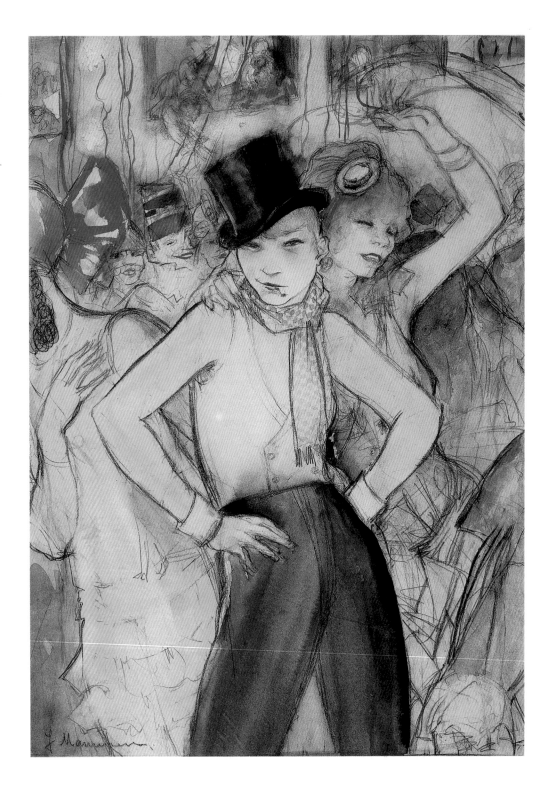

fig. 4
Jeanne Mammen
Masked Ball
(also known as
She Represents)

(published in Kurt Moreck's
Guide to Immoral Berlin, 1931)
© ADAGP, Paris and DACS,
London, 2002

Mammen's practice a mirror of women's experiences of visual culture during the period. Women were both the ubiquitous objects of, and targeted audience for, the mass media onslaught seen during Weimar. As an artist engaged with women's experiences of visual culture, it was not surprising to find Mammen working simultaneously for fashion magazines, treatises on sexology and fine art print commissions, since these were but a few of the sources through which woman was being given visual form at the time. Only with reference to the traditional evaluation of a male fine artist would such a diverse practice be unintelligible; only within that context has Mammen not been recognised as a major and successful artist of the Berlin scene of the inter-war years.

Mammen's own status as a woman consuming and producing visual work on the theme of women made it impossible for her to reproduce the structures which premised women as unthinking consumers of externally-defined icons of womanhood. Rather, her work documented particularly the areas of the city in which women engaged actively with performing identity in their own terms: the clubs, shopping streets, cafés and bars in which they displayed themselves variously in the company of other women. In 1931 a number of Mammen's works were published as part of the infamous *Guide to Immoral Berlin*, written by Kurt Moreck to entice visitors to the city with the sheer diversity of entertainments available. In the reproduction of *Kurfürstendamm, Uhlandeck* for this volume, Mammen represented a scene of prostitutes on the street. The women are shown fashionably dressed, standing on a corner mentioned in the text as well-known for solicitation. However, there is little in the image besides the suggestion of loitering to encode the figures as prostitutes. In visual terms, they are all but indistinguishable from any urban *neue Frau*. In this sense, it is significant that this street was also the centre of the west end of Berlin, the main shopping district and the street on which Mammen lived. The whole area was one well-traversed by women both day and night as they worked, shopped and went to cafés and clubs. Choosing to name the location of her representation of prostitution in this way, and making the imagery anything but fantastic, placed the activity of prostitution within the remit of women's

wider experiences of the city and refuted the myth of the prostitute as a fantastic other. As Sabine Hake described, even the pre-war conventions associated with prostitution in terms of dress and make-up had become standard garb for young urban women in Weimar, worn both during the day and at night.[15] Fashion and spectacle could not define the prostitute in opposition to the lady any longer.

More pointedly, it was in her representations of the all-women balls held on the lesbian underground scene (known colloquially as 'Eldorado' because of the famous club of that name) reproduced in Moreck that Mammen showed women in spectacular displays. In *Masked Ball* (c.1927; also known as *She Represents*) and *Masked Play in the Silhouette* (1931) female figures dressed in the most outrageous of modish clothes, sporting chic hairstyles and trendsetting make-up, demonstrably pose and display within the context of other women – not as fantastic types soliciting or threatening men. This was a lesbian underground, but also one in which many straight women were participants, especially women artists, writers and performers. These all-women clubs were places in which women could safely enjoy all aspects of urban spectacle outside the oppressive boundaries of heterosexual advances and definitions of woman which limited their behaviour. Within this context the conventional concepts of femininity, posited as other to masculinity and condemned as mindless consumerism, had no meaning. Prostitutes, ladies and lesbians, as terms with reference to a masculine heterosexual order, were not fixed categories and women took an active role as producers and spectators of the masquerades of femininity and masculinity through which woman was being redefined. Identity was tried on and placed aside; female sexuality and gender roles could be variously performed by and toward other women to new ends.

One particular work which brought together the modern *neue Frau*, the prostitute and the lesbian within Mammen's *œuvre* deserves mention here: *The Garçonne* (1931; also known as *Prostitute on a Green Couch*). In this work, a young, thin female figure reclines in modern undergarments on a sofa in a well-appointed Berlin flat. She is depicted wearing the latest, androgynous hairstyle (*Herrenschnitt*, or man's cut), smoking and reading

a newspaper – the archetype of the *neue Frau*. Given the working title of prostitute in the making of the sketch, this *neue Frau* figure was, in 1931, published as *The Garçonne* to illustrate one of Magnus Hirschfeld's pioneering texts on homosexuality. Hirschfeld was well known for his political interventions on behalf of gay and lesbian rights during the period, and was also involved in the production of books and films which took a liberal stance on the theme of prostitution. Not only a social scientist and sexologist, he was also an active proponent of the mass media as a tool through which to challenge conventions and inform the public. Mammen's emphasis upon the performative nature of gender and sexual roles and their shifting boundaries during the period, encoded in the fashionable icons of the period, made her representation of *The Garçonne* ideal as an illustration to Hirschfeld's work.

The malleable titling of the piece and its ability to move between various illustrative contexts through the multiple modes of its visual languages are a striking challenge to fixed definitions of woman within patriarchal terms. A final definition of this figure as a prostitute, lesbian or lady is nonsensical; she could be all, she could be none, and at best these tropes hold meaning only provisionally. Significantly, the shifting contexts and definitions of woman within this work are not ciphers for urban degeneration or the terrifying dissolution of the unified subject, as suggested in works such as *Big City*. Mammen's demonstration of the performativity of gender roles provided powerful images of modern women's potential to define themselves in new and exciting ways. These new tropes were as intelligible in the context of liberal writing on the freedom of sexual choice as they were in fashion magazines or fine art prints. The prostitute need not be made into an allegory of decline for the masculine subject, rather, it could be brought into dialogue with multiple choices for women in the city.

The mother and the prostitute: Elsa Haensgen-Dingkuhn

Arguably, the representation of prostitutes in the work of Lohse-Wächtler and Mammen countered prevailing tendencies in the art and critical theory of the

period, which cast the figure of the prostitute as a frightening and fantastic other in order to symbolise the alienation of the masculine subject in modernity. In this sense, their work was challenging and subversive of traditional gender roles and can be seen to have been part of an increasing participation in public life by women who sought new ways of defining their own sexual and gender identities. However, within the individual *œuvres* of these two women artists, the subject of prostitution is not wholly unexpected; exploring the margins of society and/or the commodification and display associated with sexuality in the city would tend to presuppose some reference in the work to prostitution.

Like Lohse-Wächtler and Mammen, the works of the Hamburg painter Elsa Haensgen-Dingkuhn focused upon the experiences of women in Weimar Germany. However, she emphasised this mainly through an investigation of domesticity, producing family portraits, representations of mothers and children and even self-portraits in which she was imaged holding her young son. Her works were included in a number of exhibitions on the theme of women during the period, most notably in the 1929 and 1934 shows *Die Frau von Heute* (The Woman of Today) organised by the *Verein der Berliner Künstlerinnen* (Union of Berlin Women Artists) and the 1933 Berlin exhibition *Frauen von Frauen Gemalt* (Women Paint Women). Throughout her career she was known for her maternal sensibility, and was heralded as an example of a particularly womanly realist painter. For example, Ludwig Benninghof, writing of the artist in 1930 said: 'So it happens that this woman paints not in spite of, but because she is a mother, because she is a housewife.'[16] Similarly, Rosa Schapire, who wrote about Haensgen-Dingkuhn a year later, used the metaphor of the tree bearing fruit to suggest the natural way in which the artist conceived and produced her artwork.[17] The tendency to associate Haensgen-Dingkuhn with domestic subject-matter and a 'feminine' approach continues to this day, the most recent German exhibition of her work being focused on her paintings of children.[18]

Significantly, between 1929 and 1934, when she was enjoying the peak of her critical notice and exhibition success, Haensgen-Dingkuhn made a series of paintings of Hamburg's notorious red-light district. The inclusion of these

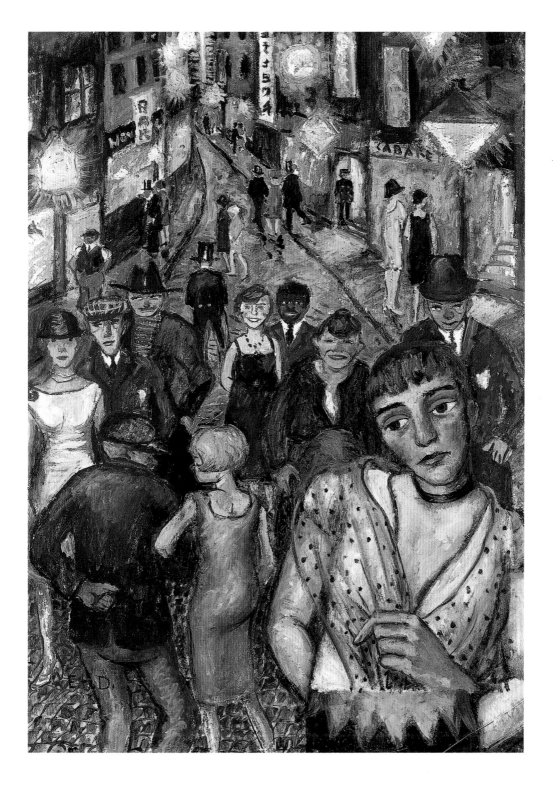

pictures within a wider body of work associated mainly with maternity is fascinating and unusual, and asks for a radical reconsideration of the traditional evaluation of women's art. This important element of her *œuvre*, usually omitted from discussions of her work, both challenged the conventions of traditional symbolism in which the mother and the whore are diametrically opposed terms for woman, and implied the importance of contemporary women in redefining the tropes of femininity and female identity.

The mother and the whore (Madonna and Magdalen) traditionally represent the binary terms of womanhood conceived in relation to the patriarchal family. The ultimate bad woman (or no lady) is the whore whose untamed sexuality deceives men and threatens the structures through which lineage can be assured. The mother, by contrast, is the vessel through which patriarchy is attained, her purity and status as a good woman (or lady) by needs must remain beyond doubt. This dichotomy has been reinforced through centuries of myth- and symbol-making in the west and need not be reiterated here. Suffice to say that in Weimar these traditions still conditioned the visual representations of women, as shown, for example, by *Wretchedness on the Street* (1920) by Franz Maria Jansen, a Cologne-based artist known for his socio-critical graphics which critiqued the inequities of capitalism in no uncertain terms. *Wretchedness on the Street*, produced after a trip to Hamburg, mobilised the figure of the prostitute as part of its symbolism, playing her full-bodied, lurid sexuality and decadence against the figure of an emaciated, poor mother, holding an infant and begging for money on the street. The mother and the whore were invested with immediate legibility and critical power even in modernity.

Haensgen-Dingkuhn's works cannot be classified within this mother–whore paradigm; indeed the even-handed visual approach she took to all female figures in her work defied the very logic which underpinned this symbolic divide. The fact that critics regularly ignored the St Pauli works indicates that they were operating within a theoretical framework which assumed that domestic subjects were apolitical, and that womanly painters were excluded from the symbolic structures which made the prostitute a

powerful icon. Only the artist's son, Jochen Dingkuhn, argued that his mother's practice was socio-critical in all its manifestations, thereby challenging such unsophisticated reading of her work.[19] Haensgen-Dingkuhn's *Self-Portrait with Little Son in the Studio* (1928) might be used uncritically to argue for a natural link between a woman artist and maternity, but that neglects the fact that the portrait was not merely an unmediated expression of feminine creativity, but was a culturally coded artefact, speaking of the interrelationship between the public and the private spheres for women in Weimar.[20]

The determined exploration of gender and space in the work of Haensgen-Dingkuhn makes her representations of the streets of St Pauli far more pointed. In *Große Freiheit in St Pauli* (1929), Haensgen-Dingkuhn examined a scene which by conventional standards was certainly no place for a lady, but which was accessible to any number of different women during the period. This disjunction between ideological and actual spaces in the experiences of women in Weimar was precisely the threat which women's self-definition posed. Increasing access to the full range of urban opportunities, from work and political representation to shopping and entertainment, made women challenge the traditional delineation of their place in the widest sense of the term. The space of St Pauli that Haensgen-Dingkuhn represented contained all of the blurred boundaries used in the canonical urban work of this period to indicate debauchery and the alienation of the masculine subject, yet there were no traces of such symbolism in her work. The work was a large-scale figurative painting of a local scene rather than an allegorical rendering of the terrors of modernity and urbanism.

Große Freiheit represented the city street at night, a red-light district, the intermingling of the social classes as well as mixed race couples, old and young people together and the connections between high and low cultural forms in modernity. Sailors are seen wandering the streets along with men in dress clothes and young women out together, unaccompanied and unthreatened. The most prominent figure in the picture could be a prostitute, but no definitive visual signals are given to differentiate her from the other female figures. The women depicted enjoying the urban nightlife of

fig. 6
Elsa Haensgen-Dingkuhn
Evening in St Pauli
1934

Hamburg's notorious harbour streets have slipped the reins of fixed identification in a patriarchal order – they cannot be contained by simplistic visual definition. Women's entry into the public spaces of the city suggested the potential for positive forms of boundary-dissolution, which afforded them the chance to articulate multiple identities outside a unified norm. This did not threaten their status as autonomous subjects since they had never attained such a status in the first place. Haensgen-Dingkuhn's explorations of the multiplicity of the urban environment moved toward creating an intersubjective space in which women's agency could be articulated. Additionally, it provided a powerful political counterpoint to the male establishment's role in Hamburg as manifest in the labelling and locating of prostitutes as other through the legislative control of the brothel system.

This chapter began with a problem of whether works by women artists in Weimar which represent prostitution merely replicate a dominant masculine imaginary or could act otherwise. Clearly, they can and did. A final brief comparison brings this argument full circle. In 1934, Haensgen-Dingkuhn painted *Evening in St Pauli*, a scene of a sailor with two women on the streets of Hamburg's harbour district. As a painting of an urban scene with a sailor on leave in the streets of a well-known red-light area, the assumption that the two women are prostitutes might be expected. Haensgen-Dingkuhn, however, did not play to this expectation by making the women fantastic creatures of the night, or by displaying them hideously distorted or nude, or by emphasising sexual acts or monetary exchange. In fact the female figures dominate the scene, and we gain access to it through the engaging look of the figure on the right. Moreover, they are represented as any young modern woman out in the evening might look – clad in fashionable clothes and sporting trendy haircuts. We cannot fix their status, subordinate them to our gaze as objects or place them in relation to male figures as other. Here the gender politics of *Frauenkultur* were demonstrated by ordinary events; women were no longer easily defined by their biology or granted their place only in relation to a heterosexual male norm.

Dix also painted a picture of a sailor on leave walking through a red-light district and encountering female figures in *Tropical Night*. The difference

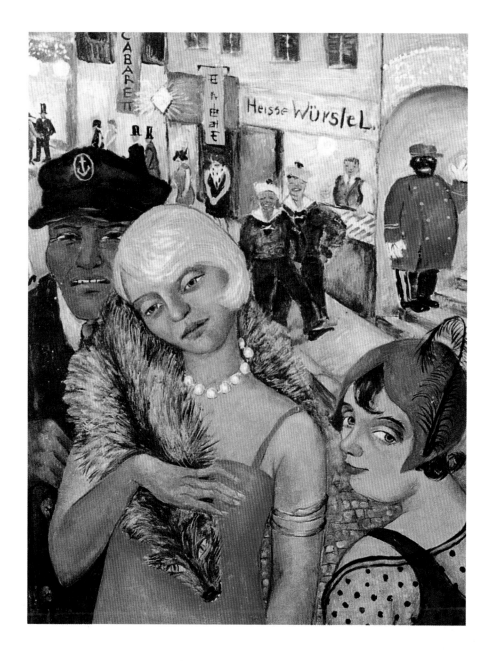

between this work and *Evening in St Pauli* could not be clearer. Dix's sailor is demonstrably sexual and the women are merely pieces of naked flesh, displayed for his appetites. Racial differences in the female figures indicate no community of multiplicity, merely another variation of the delectations of the body of woman offered to the male subject. Such striking and brutal imagery, commonly taken to represent the experience of urbanism and modernity, also commented implicitly on the gender politics of the day. However, while it shouted loudly about the decay of modern society to the establishment of its time, it said nothing to women except know your place.

NOTES

1. Frank Whitford, *'Suicide'*, 16 March 1977 (TAV293A 2/2).

2. For general overview, see Marsha Meskimmon, *Engendering the City: Women Artists and Urban Space* (London, Scarlet Press, 1997).

3. Patrice Petro, *Joyless Streets: Women and Melodramatic Representation in Weimar Germany* (Princeton, NJ, Princeton University Press, 1989); Dorothy Rowe, 'Desiring Berlin: Gender and Modernity in Weimar Germany', in Marsha Meskimmon and Shearer West (eds), *Visions of the Neue Frau: Women and the Visual Arts in Weimar Germany* (Aldershot, Scolar Press, 1995), pp. 143–64; Andreas Huyssen, 'Mass Culture as Woman: Modernism's Other', in *After the Great Divide: Modernism, Mass Culture, Postmodernism* (London and New York, Macmillan Press, 1986), pp. 44–62 and 'The Vamp and the Machine: Fritz Lang's *Metropolis*', in *After the Great Divide*, pp. 65–81.

4. Marsha Meskimmon, 'The Prostitute', chapter 1 in *'We Weren't Modern Enough': Women Artists and the Limits of German Modernism* (London, I. B. Tauris; Berkeley, University of California Press, 1999).

5. For example, see Dr Ludwig Leun-Lenz (ed.), *Sexual-Katastrophen: Bilder aus dem modernen Geschlechts- und Eheleben* (Leipzig, A. H. Banne, 1926).

6. Thomas Wehrling, 'Berlin Is Becoming a Whore', cited in Anton Kaes, Martin Jay and Edward Dimendberg (eds), *The Weimar Republic Sourcebook* (Berkeley, University of California Press, 1994), pp. 721–22.

7. For detail, see Elizabeth Meyer-Renschausen, 'The Bremen Morality Scandal', in Renate Bridenthal, Atina Grossmann and Marion Kaplan (eds), *When Biology Became Destiny: Women in Weimar and Nazi Germany* (New York, Monthly Review Press, 1984), pp. 87–108.

8. Marion Kaplan, 'Sisterhood under Siege: Feminism and Anti-Feminism in Germany 1904–1938', in *When Biology Became Destiny*, pp. 174–96, p. 179.

9. T. W. Mason details the slander of Toni Sender by the right in 'Women in Germany 1925–40: Family Welfare and Work', *History Workshop Journal*, no. 1, 1976, pp. 74–113 and no. 2, 1976, pp. 5–32, p. 89.

10. Larissa Reissner, 'Schiffbek', in Kaes, Jay and Dimendberg (eds), *The Weimar Republic Sourcebook*, pp. 224–27, p.227.

11. Elga Kern, *Wie Sie dazu Kamen: 35 Lebensfragmente bordellierte Mädchen nach Untersuchungen in badischen Bordellen* (Munich, Verlag von Ernst Reinhardt, 1928).

12. Alice Rühle-Gerstel, *Das Frauenproblem der Gegenwart: Eine Psychologische Bilanz* (Leipzig, Verlag von S. Hirzel, 1932); Anna Pappritz, *Einführung in das Studium der Prostitutionsfrage* (Leipzig, 1921).

13. *Otto Dix, 1891–1969*, exhibition catalogue (London, Tate Gallery, 1992), p.110.

14. See the framing of *Lissy* with an illustration of a Dix portrait of a Madam and a text about 'bar girls and prostitutes' in Sergius Michalskis, *New Objectivity: Painting, Graphic Art and Photography in Weimar Germany, 1919–1933* (Munich, Benedikt Taschen, 1994), p. 20.

15. Sabine Hake, 'In the Mirror of Fashion', in Katharina von Ankum (ed.), *Women in the Metropolis: Gender and Modernity in Weimar Culture* (Berkeley, University of California Press, 1997), pp. 185–201.

16. Ludwig Benninghof, 'Elsa Haensgen-Dingkuhn', *Der Kreis: Zeitschrift für Kunstlerische Kultur*, vol. 7, no. 6, June 1930, pp. 336–40 reprinted in *Elsa Haensgen-Dingkuhn*, pp. 67–68. Translation mine.

17. Rosa Schapire, 'Elsa Haensgen-Dingkuhn', *Frau und Gegenwart*, vol. 11, 1930–31, pp. 290–91, reprinted in *Elsa Haensgen-Dingkuhn*, pp. 69–70.

18. See, for example, the most recent exhibition catalogue *Elsa Haensgen-Dingkuhn (1898–1991): Kinder und Heranwachsende im Zentrum eines Malerischen Lebenswerks* (Hamburg, Galerie im Elysee, 1998).

19. Jochen Dingkuhn, 'E.H.D.', in *Elsa Haensgen-Dingkuhn*, pp. 9–11, p. 9.

20. Marsha Meskimmon, *The Art of Reflection: Women Artists' Self-Portraiture in the Twentieth Century* (London, Scarlet Press; New York, Columbia University Press, 1996), p. 34.

Photo Portfolio: Thomas Struth[1]

ANNE MACPHEE

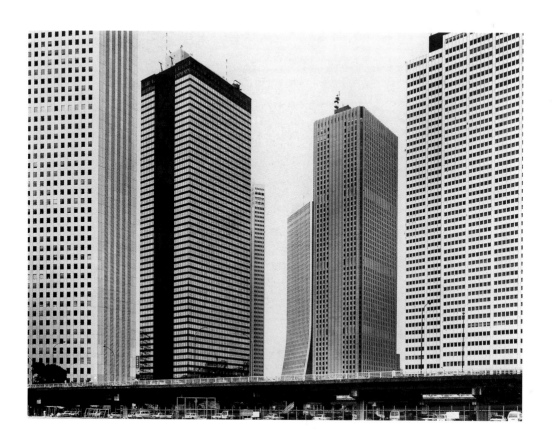

Thomas Struth
Shinju-ku (TDK), Tokyo 1986
1986, photograph on paper.

[previous page]
Thomas Struth
*Shinju-ku (Skyscrapers),
Tokyo 1986*
1986, photograph on paper.

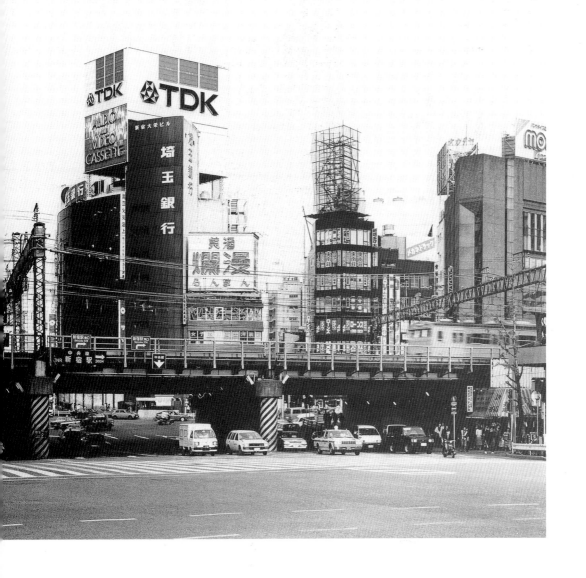

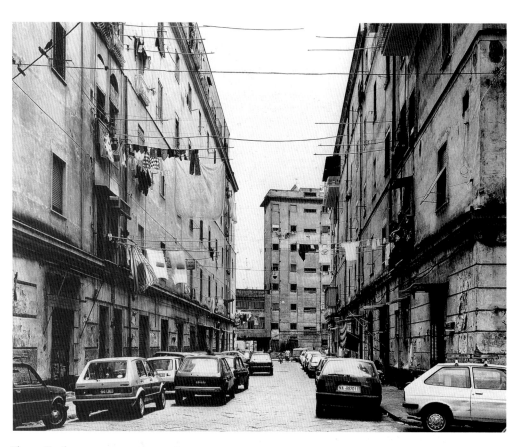

Thomas Struth
*Via Giovanni Tappia, Naples
1989*

1989, photograph on paper.

[opposite]
Thomas Struth
Vico dei Monti, Naples 1988

1988, photograph on paper.

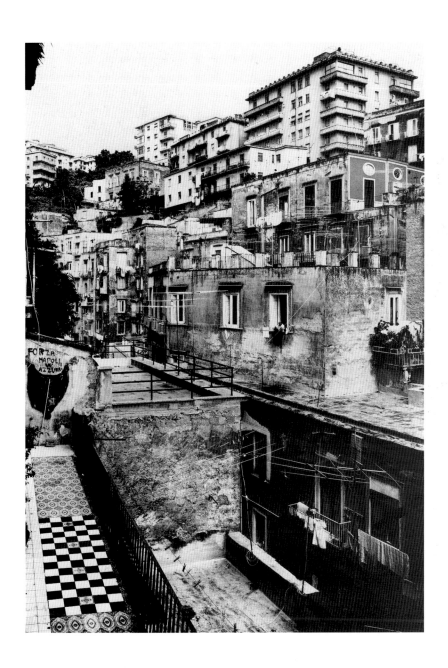

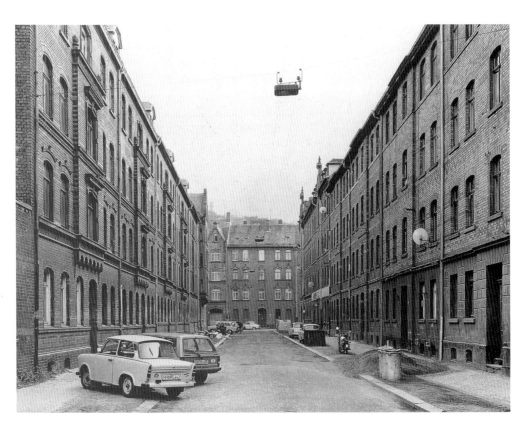

Thomas Struth
*Hermannsgarten,
Weissenfels 1991*

1991, photograph on paper.

[opposite]
Thomas Struth
*Schlosstrasse,
Wittenberg 1991*

1991, photograph on paper.

Responses in art and literature to the growth, progress and authority of the city have been extensive and heterogeneous, with photography holding an important place within this legacy. Richard Sennett even connects the reconstruction of Paris in the 1850s and 1860s and its unstable economic climate with the emergence of photography as an art form.[2] This medium has been much influenced by its historical antecedent, the panoramas of the late eighteenth and nineteenth centuries, which were 'an attempt to bring painting closer to the actual nature of seeing than it had ever been before'.[3] Thomas Struth's work though, first impressions notwithstanding, is radically different from this tradition. For what appears so complete is incomplete, and leaves the viewer searching for something hidden behind the façade of the architecture or outside the field of view. His response to the urban environment appears to be tempered not only by his realisation of its visual complexity but of its existence as experience too. The dialectic he creates is between general and local, between truth and doubt. Struth's urban images are contradictory, simultaneously consoling and uncomfortable, familiar yet mysterious, and thus arouse in the viewer the desire to know more.

In the last 30 or so years a seemingly objective photography has become significant within contemporary art, partly attributable to the influential work of Bernd and Hilla Becher, who taught at the Kunstakademie Düsseldorf in the 1960s and 1970s. Struth was among their students. The Bechers' work consists of serial photography of mostly industrial structures that form a common type, photographed with a large format camera at a consistent viewpoint, often assembled in a grid by which they emphasise apparent similarities but also powerful distinctions. The structures the Bechers chose to photograph could be linked conceptually to the Duchampian notion of anonymous sculpture and also to minimalist artists' utilisation of serials.[4]

'The city in these pictures looks cleared out, like a lodging that has not found a new tenant … It gives free play to the politically educated eye, under whose gaze all intimacies are sacrificed to the illumination of detail', says Walter Benjamin of the work of turn-of-the-century French photographer Eugene Atget.[5] Later in the same essay he states that, 'not for nothing have Atget's photographs been likened to the scene of a crime … But is not every

square inch of our cities the scene of a crime?'[6] This suggestion that the most ordinary, familiar, unremarkable city space could nevertheless be home to acts of transgression is an apt description too of Struth's urban photographs. The cool, empty, detached, almost archaeological images that he presents create a displacement of meaning. There appears to be little authorial presence. Like Atget's, few if any people inhabit Struth's streets, creating a sense of presence through their absence: it is as though much has been concealed, which is all that is revealed.

First impressions of Struth's Tokyo photographs are of order, pattern, clarity and detail. In both works the composition consists of strong verticals opposing the horizontal, although the subject of each photograph is completely different: one focusing on stark high-rise buildings of the financial or business district, the other on the activity of the shopping and eating district. In both, the architecture is distanced from the spectator by a horizontal bridge parallel to the frame that separates the foreground from the rest of the composition, thus creating a conceptual, visual, almost physical barrier between the work and the viewer. A sense of place is evoked in *Shinju-ku (TDK), Tokyo 1986* by Struth's ability to convey the character of the location through its specific architecture. Such icons as skyscrapers, bridges and church spires are central to our negotiation of the city; abstracted, they are the basis of our construction of geographies of urban social space. *Shinju-ku (Skyscrapers), Tokyo 1986* refers to the universal rather than the local. In this street-level depiction Struth draws on the tradition of the skyscraper as a symbol of the modern and of progress. Negotiating the same spaces at eye-level, however, would be something different: the viewer then would engage with the confusion of the city and could celebrate its plurality, particularity and latent danger.

There is a dialectic, again, in Struth's images of Naples, this time between public and private, unity and disunity. Though the viewpoint and eye-level are different in each image, the subject is similar. The photographs evoke an atmosphere that is crowded and enclosed, yet with few people visible. Both images compositionally convey the viewer to an abrupt visual dead-end. In *Vico dei monti, Naples 1988* there is an asymmetrical viewpoint that allows

one to see the backs of apartment buildings and consequently more intimate information than if we were to see the building from the street. It is as though the viewer were looking from a bridge or from the window or balcony of another building, and thus suggests such Impressionist paintings as Camille Pissarro's views of Paris. The presence of washing hanging out is evidence of the proximity of people, though only one small figure, at an open window, is to be seen. In *Via Giovanni Tappia, Naples 1989* a much lower eye-level is used and a symmetrical single viewpoint conveys us to the end of the street. The image consists of dingy, commonplace apartment buildings surrounded by untidily parked vehicles that offer confirmation of a human, even culturally specific presence without contravening decorum by revealing true intimacy.

The dialectic in the photographs of German streets, composed similarly with a low eye-level and the strongly sensed grid of the façades, is between local and general. One photograph is specific – unique, even, due to the tower – while the other was once general; although named, it could exist anywhere in former Communist Eastern Europe. Both images then are concerned with revealing a sense of place, and the sense of order here might be considered helpful in orienting us. In *Schlosstrasse, Wittenberg 1991* Struth reveals a historic Germany that had recently re-emerged after forty-five years of Communist rule. An ornate Gothic-style tower – which the viewer approaches along a pleasant, car-free, tree-lined street with leaning bicycles the only vehicles present – dominates the image. When we look at *Hermannsgarten, Weissenfels 1991* the contrast with the first image is clear. Here Struth has photographed workers' housing in a drab, tired, treeless street devoid of people, but an implied human presence is revealed by dustbins, cars, motorcycles, and satellite dishes. This image of the former East Germany invites us to question how people withstood such an existence, for even while the material goods assure that the scene is post-reunification, there is little other sign of improvement.

Artists in the twentieth century have taken different approaches in asking what the city means and how it can be represented. Some have concentrated on the inhabitants of the city, using photography almost as a tool of anthropological study to reveal aspects of the city and its people that would

normally be out of bounds for the middle-class viewer. Some have viewed the city as private space, disclosing the loneliness and sadness of life for the isolated, bourgeois citizen. Others have viewed it as a beholder, from the outside looking in, sometimes with a concealed camera; still others have read the city as a historical text. Equally, the city has functioned as spectacle, signifying power and progress through its monumentalism. For Richard Sennett, Struth's images offer 'a quintessentially urban art precisely because the buildings, places and people he photographs do not make statements or reveal their secrets'.[7] He stresses the objectivity and restraint in Struth's photographic vision that represents the necessity and desire of city dwellers for privacy. Struth uncovers evidence of duration and rhythm, signs of habitation, as though he were looking for the true identity of a specific place. In *Camera Lucida*, Roland Barthes discusses the difference between the *studium* of a photograph and its *punctum* – the former being the field of knowledge and reference that can be brought to the image or interpreted by the viewer, the latter being the specific emotional element found in the image by each viewer individually. Struth's urban photographs appear at first glance to consist only of the former, but on closer viewing the *punctum* emerges as a strong constituent, prompting the viewer to retrospection, empathy and recognition.

NOTES

1. These six photographs by Thomas Struth from the National Collection of Modern Art were included in the *Urban* exhibition at Tate Liverpool in November 1998. They were shown in pairs, but interspersed with works by other artists executed in other media, usually paintings or prints. Because of a curatorial necessity for low light levels, the viewer was compelled to stand very close to each work to examine it.

2. Richard Sennett, 'Recovery, The Photography of Thomas Struth', in *Thomas Struth, Strangers and Friends* (London, ICA, 1995)

3. Ralph Hyde, *Panaromania! The Art and Entertainment of the 'All-Embracing' View* (London, Trefoil, 1988).

4. Susan Butler, 'The Mise-en-Scène of the Everyday', in *Art and Design 10,* nos. 9/10, September–October (London, AD, 1995), pp. 16–23. Struth was also influenced by Ingo Hartmann, with whom he collaborated on making collages, by Gerhard Richter's photographic experimentation and Ed Ruscha's writings.

5. Walter Benjamin, 'A Small History of Photography', in *One Way Street and Other Writings,* translated by Edmund Jephcott and Kingsley Shorter (London, Verso, 1985), p. 249.

6. Benjamin, 'A Small History of Photography', p. 256.

7. Sennett, 'Recovery, The Photography of Thomas Struth'.

4

New York City, 1910–35
The Politics and Aesthetics
of Two Modernities

THOMAS BENDER

Urban modernity privileges the visual. Classic essays on the topic –
whether one refers to Baudelaire's unsettling writings about Paris, Simmel's
sociological analysis of Berlin in 'The Metropolis and Mental Life', Carl
Schorske's historical evocation of *fin de siècle* Vienna, or Richard Sennett's
essayistic explorations of contemporary New York – utilise a scopic approach
to frame their representations of the specifically modern urban experience.[1]
Not surprisingly, artistic modernism, at least in painting and photography,
has been closely associated with the city, and vice versa.

With these commonplaces reiterated, I want to examine a phase of artistic
modernism in New York City in roughly the first third of the twentieth century.
Not too long ago, there was thought to be a single logic to artistic modernism
in New York: the development of abstract painting and sculpture, from the
introduction of post-impressionist art into New York by Alfred Stieglitz at his
291 Gallery and a couple of years later in the famous Armory Show of 1913,
to the international 'triumph' of Abstract Expressionism in the 1940s.[2] But
that story has now been complicated, partly by curatorial judgements that
elevated Edward Hopper, for example, to the status of major modernist, and

partly by other recent scholarship.³ It is now becoming common to delineate a realist or representational as well as an abstract modernism in the history of painting and photography in New York City.⁴

I will examine two bodies of modern New York art in the early years of modernism in the city, one representational, the other abstract, treating each, to adopt a phrase of Raymond Williams, as a 'structure of perception' that aims to frame the meaning of modernity in New York City. There is a politics embedded in each of these two strategies, which I propose to identify not only in the realm of aesthetics, but also in the conventional political ideologies and movements of the city in the twentieth century. In associating art and politics here, I mean to suggest that aesthetics, by giving powerful form to our structures of perception, helps to shape and reinforce structures of power. One of the services of history and of the humanities in general is to highlight and continually re-examine these historical constructions of perception and power.

The structures of perception that we shall be defining here bear a partial resemblance to a brief commentary on New York in Michel de Certeau's book, *The Practice of Everyday Life*. In a chapter titled 'Walking in the City', de Certeau explores his subjective relationship to the physical and visual force of the modern city, which he describes elsewhere as 'a sort of *epic* of the eye'. Recounting a visit to the observation deck of the World Trade Center, he speaks of the pleasure, even erotic ecstasy, of seeing the city 'whole' from above.

In fact, here and elsewhere his references to a totalising vision and a panoptic perspective bring little insight to the notion of the whole. But he does say quite a bit, perhaps unconsciously, about perspective, and in particular about being able to look down upon parts of the city. One becomes Icarus, flying high, transfigured by the elevation 'into a voyeur'. The voyeur observes at a distance. Position 'transforms the bewitching world by which one was "possessed" into a text that lies before one's eyes. It allows one to read it, to be a Solar eye.' Here is realised 'the lust to be a viewpoint and nothing more'. Posed against this Olympian site of clarity available to the 'voyeur-god' is the darker, grimier city of the masses lacking the

self-awareness and understanding which comes with such hei͜ ͜.͜.͜. enlightenment. 'The ordinary practitioners of the city live "down below", below the threshold' of such empowering visibility. Down there are the 'walkers' who write the urban text, but, claims de Certeau, 'without being able to read it'. To enter this world is to become enmeshed in the story, in 'the networks of these moving, intersecting writings [that] compose a manifold story that has neither author nor spectator'.[5]

De Certeau explicitly identifies the first structure of urban perception with the modern planner, and I will do the same here. But his second characterisation invites challenge. Even as he wishes to rescue the ordinary lives of the city, de Certeau, like the planner, grants them too little. There are authors to the stories, and spectators too. The narratives, however, inevitably remain obscure; one will know there is a story, but not be sure of its origins or its trajectory. De Certeau, like the planners, omits the historicity of the city. The two structures of perception to be examined here also constitute two attitudes toward history: one largely denying or freezing history into a perpetual urban present, the other insisting that the city itself is historical, that its ordinary people are continually making their own and the city's history.

Although de Certeau does not say it directly, he implies, quite correctly, that twentieth-century planning converts the city into an abstraction, often articulated in geometric or quantitative terms. What he does not say, but could, is that history resists abstraction, and insofar as one understands urban places as the precipitate (social, narrative, physical) of lived experience over time, one is constructing a city that contrasts with that of the planners.

Modern painting and literature in turn-of-the-century New York moved out of doors and explored a novel kind of urban life and form. The modernity of New York was a sudden, even startling discovery. The illustrator John Pennell remarked at the time that 'the new New York has come, come in my lifetime. I have seen it come …'. Like other artists of his generation, he sought to possess this moment in his art. 'I have', he reflected, 'loved it, and drawn it, and I shall go on drawing it till the end, it is mine, it was made for me.'[6]

fig. 1
Alfred Stieglitz,
The City of Ambition
1910
Alfred Stieglitz Collection,
National Gallery of Art,
Washington, DC

Magazine illustrators had long been interested in the city, and popular literature often narrated the urban scene, as in Horatio Alger's *Ragged Dick* (1867). Higher forms of literature, most notably the novels of Edith Wharton and Henry James, kept the action indoors. But Theodore Dreiser, who had worked as a newspaper reporter, brought the themes and the style of the press into the novel, blurring the boundary between the enclosed city of Brownstone culture and the more public city life that characterised popular writing. The same shift occurred in painting as one moves, for example, from John Singer Sargent to William Glackens and Maurice Prendergast.

If both versions of New York modernism under discussion here were deeply indebted to the process of discovering and representing the city, I want to emphasise that writers and artists discovered and represented two very different cities. One is a City of Ambition, characterised by Dreiser in *Sister Carrie* as a 'walled city' and a 'sea of whales'.[7] The other city, not often described in the canonical works of American literature, is a City of Making Do, focused on daily life, on neighbourhoods, local streets, and families. One finds accounts of this New York, like Anzia Yezierska's stories, written by immigrants, especially women. But some native-born Protestant writers, like Hutchins Hapgood, in *The Spirit of the Ghetto* (1912) and the canonical Henry James, in his remarkable report on New York in *The American Scene* (1907), were drawn to the more 'authentic' life of the Lower East Side.[8] The imagery of this city is that of ethnic enclaves and neighbourhoods, of local entertainments and small businesses. Certainly this world, too, is a milieu of ambition, but this ambition is complicated by external constraints and, often, internal doubts. Here the aim is to prevail rather than to triumph.

The two traditions (or faces) of artistic modernism to be considered here can be most conveniently identified as the work of distinct circles of self-consciously modern artists in early twentieth-century New York. It is even more convenient to identify each with a particular figure: Alfred Stieglitz for one group, and John Sloan for the other.[9] Both were deeply interested in the city, and equally fascinated by the aesthetic implications of its representation.

The different kinds of literary representations outlined here parallel the distinction I want to make in respect to pictorial representations in art and

photography. To some extent, it is a contrast between 'realism' and 'abstraction'; one might also call it a difference between content and form, or politics and aesthetics, but neither of these two formulations is really accurate. I cannot think of a better way of stating the difference than this: Steiglitz and his circle were particularly interested in the formal qualities of the city, in its geometry. The city for them is largely physical, something to see; it represents novel and interesting forms, the most interesting of which, moreover, seem to be associated with the architecture of modern, corporate power. Sloan, too, is drawn to the physical qualities of the city, but most important for him and his circle are the human activities and connections for which they provide a stage. Formal opportunities are often exploited with great effect, but the emphasis is elsewhere, on human stories. Both groups are drawn to the romance of the modern city, but the nature of that romance is radically different for each: warm, soft, and slightly nostalgic for Sloan; cool, hard-edged, and futuristic for Stieglitz.

Alfred Stieglitz identified the 'City of Ambition' with a skyscraper, the Singer Building to be precise, in a photograph of that title, made in 1910 [fig 1]. It is a powerful image; the skyline represents the desire that gives content to ambition. Stieglitz inscribed the print he gave to Paul Haviland with a phrase that implied the endlessness of this desire: 'Does it tower into the skies? Beyond them?'[10]

If one moves from aesthetics to social history, two questions emerge: 1) What historical narrative connects this city with the lived experience of the viewer? 2) How does one enter this city? Even with the shadowy ferry slip visible in the foreground, it is difficult to find a practical route into this walled city. The City of Ambition is nearly always viewed from the outside; it is hard to enter, whether from the Jersey towns from which Stieglitz photographed the Singer Building, or from Sloan's New York neighbourhoods. Perhaps no one said it better in one sentence than Norman Podhoretz, a generation later. He opened his autobiography, *Making It*, with the observation that 'one of the longest journeys in the world is the journey from Brooklyn to Manhattan – or at least from certain neighbourhoods in Brooklyn to certain parts of Manhattan.'[11]

In some ways, Stieglitz's picture could represent the search for the gate into the walled city of Dreiser's *Sister Carrie*, or, perhaps, even more precisely, the city Dreiser described in his autobiographical work, *The Color of a Great City*, when he wrote:

If you were to … see the picture it presents to the incoming eye, you would assume it was all that it seemed. Glory for those who enter its walls seeking glory … The sad part of it is, however, that the island and its beauty are, to a certain extent, a snare. Its seeming loveliness, which promises so much to the innocent eye, is not always easy of realisation.[12]

Whatever the similarities of their fascinations with the city, Stieglitz's understanding of the challenge of New York was very different from Dreiser's. The early chapters of *Sister Carrie* establish Carrie Meeber's trajectory, and indicate the resources available to her as she enters into the life of the American metropolis. Dreiser warns that New York is no easy triumph, promising success to no one, neither the ambitious nor the virtuous, and the story becomes a dialogue between the talents and aspirations of Carrie and the city, the terrain of her ambition. Stieglitz offers a very different representation of the meaning and possibility of ambition, a representation that, although aesthetically powerful, has no sense of trajectory or history. He has created an icon that silences such stories as Carrie's.

The denial of history, of narrative, is typical of the urban representations of Stieglitz and his circle. Compare it, for example, with Aaron Douglas's later mural of the 1930s, *Aspects of Negro Life*, at the Countee Cullen Branch of the New York Public Library. He, too, understands the power of the skyscraper, as is especially evident in a preliminary sketch, but it does not stand alone for him. Murals as a genre are narrative, and Davis offers the history of an epic folk movement, the story of the African-American quest for freedom and equal opportunity, with the city as a destination of promise in the last panel, *Song of the Towers*. Vertis Hayes, in *The Pursuit of Happiness*, a mural for the nurses' residence of the Harlem Hospital, offers a similar narrative and iconography of African-American aspiration.

fig. 2
John Sloan
The City From Greenwich Village
1922
Board of Trustees, National
Gallery of Art, Washington DC
Gift of Helen Farr Sloan

The romance of the modern city for modernists of the Stieglitz stripe is represented by an aesthetic of distance. Sloan and his circle got closer and put their feet on the ground, and the romance changed. Instead of a distant, glistening modernity, one becomes aware of the oldness, the layers, and the mixing that characterises the metropolis.

Few visions of the City of Ambition include people; if they do, they are often dwarfed by huge structures representing the power of modern technology. By contrast, the closer view of the ordinary city portrayed by Sloan and his ilk stresses common city people doing the things they ordinarily do. More often than not, the people represented are working class – or not far from it. New York has today become such a racially and class-divided city that it takes some effort to recall its essentially working- and lower-middle-class character in the first half of the twentieth century. Stieglitz did not explore that city, save for a few photographs in the first decade of the century, but Sloan and his circle identified with and represented it.

In Sloan's painting, *The City From Greenwich Village* (1922) [fig. 2], there is some suggestion of the larger City of Ambition, but the point of view, the unmistakable location of the creator of the image, is that of a local, neighbourhood observer. We are drawn to Sixth Avenue at West Third Street in Greenwich Village, not to Wall Street in the distance. One is reminded of Jean-Paul Sartre's comments on New York in the 1940s. He was struck by the grid, especially the avenues; the streets running without end and stressing free movement were, he wrote, symbols of energy and ambition. In Paris, by contrast, small streets and neighbourhoods surrounded residents, providing enclosure and security. In this respect, Greenwich Village was like Paris. Yet Frenchmen, from Le Corbusier (who celebrated New York's grid and despised Greenwich Village) to Sartre, were looking for a specific kind of modernity, and simply failed to recognise that such archaism was part of the modernity of New York, just as it was of Paris. It was this New York that Sloan painted. Even when he portrayed people in an entertainment district, as in *White Way* (1926) or *Little Movie Theatres* (1913), he did not emphasise midtown glamour: there is a feel at once of an outing and of local comfort. Nor did

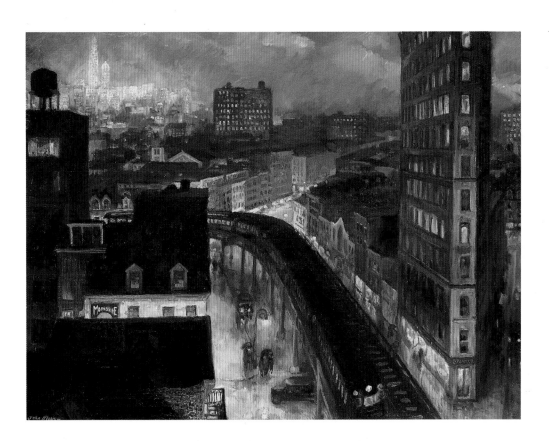

he establish much distance between institutionalised forms of entertainment or culture and the common humanity of life in the city.

The men and women he painted might work in various parts of the city, yet his focus on them was not at work but at home, in their neighbourhoods. In *Six O'Clock Winter* he portrays the Elevated and the crowds of working New Yorkers streaming home from work and animating the local streets. The city's modern economic institutions and places of work have little presence in this image of the city; the emphasis is on the humanity of those who work, who live in ordinary neighbourhoods. When Sloan painted New Yorkers at work it was more likely to be a routine domestic task, as in *Women's Work*

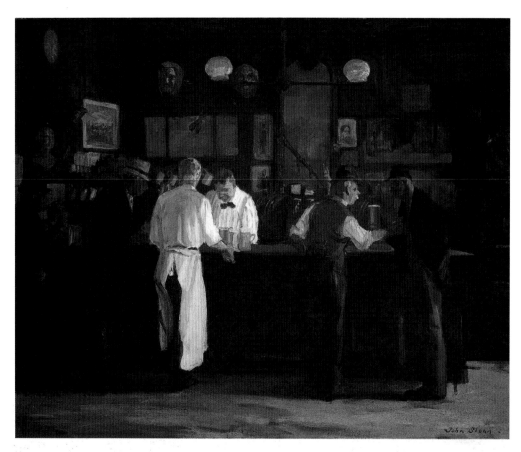

fig. 3
John Sloan
McSorley's Bar
1912
Detroit Institute of Arts
Founders Society Purchase

(1912), which shows a woman hanging out the laundry, or the low-paid workers in his *Scrubwomen, Astor Library* (1910–11). While there is in this latter picture a hint of class exploitation, there is equally a sense of personal connection between the women in the picture that suggests a certain blending of work and sociability. Men find security and friendship at work in *McSorley's Bar* (1912) [fig. 3], still a popular bar today, on the borderland between Greenwich Village and the Lower East Side, that only in the 1970s allowed women to enter. Perhaps it is fittingly paired with his *Three AM* (1909) [fig. 4]. Here two women return home from an evening out; again, it is not glamour that he emphasises, but security, friendship and pleasure. There are presumed narratives in Sloan's vignettes, not the whole story, of course; the whole story is never known in the city, yet one knows there is a story.

Sloan was a socialist, and one might argue that the representation of both work and culture in his paintings was a critique of modern, hierarchical, bureaucratic structures of power and categories of culture, but that is not clear. Nor is it clear that Stieglitz's fascination with the skyscraper, the symbol

fig. 4
John Sloan
Three AM

1909
Philadelphia Museum of Art
Given by Mrs Cyrus McCormick

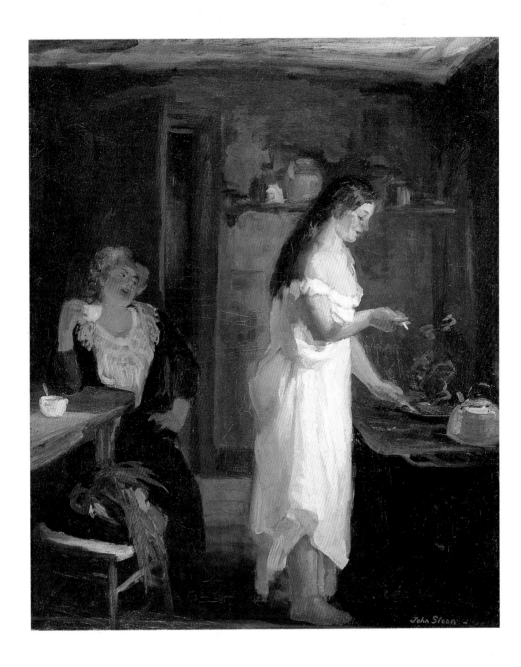

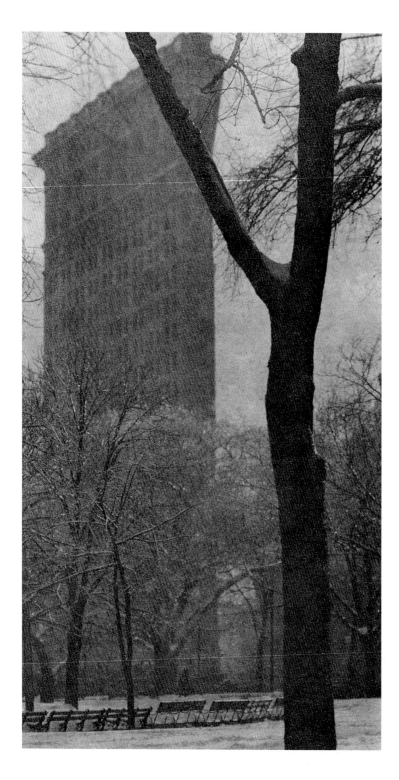

fig. 5
Alfred Stieglitz,
The Flatiron Building

1903
Metropolitan Museum of Art
Alfred Stieglitz Collection, 1933

fig. 6 [opposite]
John Sloan,
Nursemaids, Madison Square

1907
F. M. Hall Collection
Sheldon Memorial Art Gallery
Association, University of
Nebraska

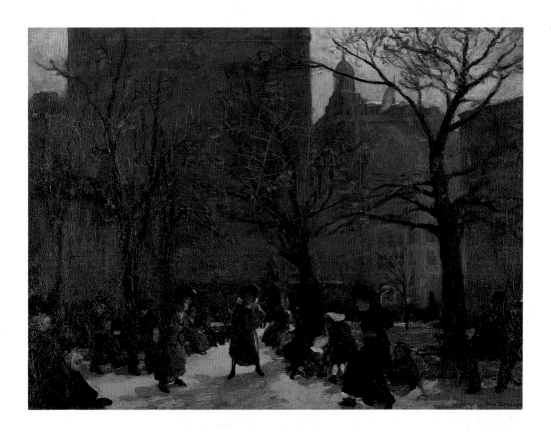

of modern economic power, stood for a political commitment, yet there were political implications to each of these structures of urban perception.

At Madison Square Stieglitz was drawn, almost irresistibly, he later recalled, to the Flatiron Building [fig. 5]. He turned that prow-like skyscraper form into an icon that represented, at least to him, the progress of American culture.[13] While Stieglitz looked up at the Flatiron, Sloan surveyed the park itself, noting the people who regularly populated it. His *Nursemaids, Madison Square* (1907) [fig. 6] focused on working-class women, giving them pride of place over the structural forms so fascinating to Stieglitz and many other modernist photographers.[14]

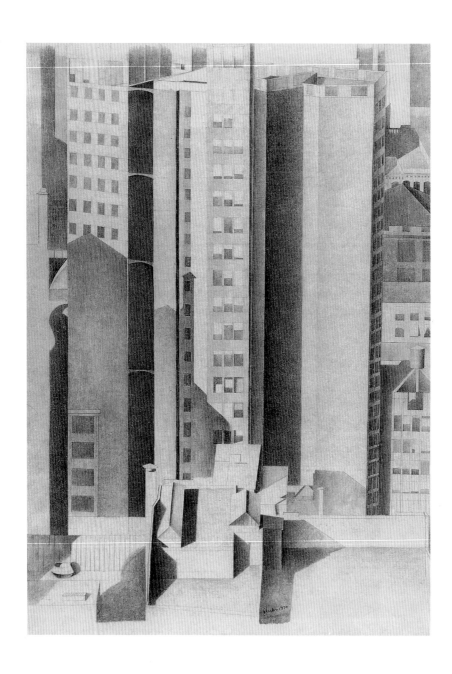

fig. 7
Charles Sheeler
New York (Buildings)
1920
The Art Institute of Chicago
Gift of Friends of American Art

The highly rationalised city, the capital of capitals, as New York was becoming, depended upon a highly skilled and highly organised labour force. The people who were that city, according to Waldo Frank, a modernist writer and friend of Stieglitz, were mostly ground down, living a routinised and spiritually impoverished life. His critique of capitalism is so thorough that it effectively erased the people for whom he would speak: 'Our centers of civilization … are cities not so much of men and women as of buildings.'[15] That city is recognisable in the work of the circle that formed around Stieglitz. Charles Sheeler's *New York (Buildings)* (1920) [fig. 7] offers a city of its title, without people. Paul Strand's celebrated and ambiguous *Wall Street* (1915) is difficult to read as social commentary, either directly from the print or on the basis of Strand's later comments. Making matters yet more complex, the tone (and thus the emotional feel) differs in its two most famous prints. Still whatever its precise political intent (if any) and meaning, the picture surely tends to diminish the working people rushing past the J. P. Morgan banking house.[16]

But Sloan and the others in the group called 'The Eight' documented an utterly different relation of people, buildings, and streets. George Luks's evocation of *Hester Street* (1905) [fig. 8], for example, portrayed working people's lives with colour and vitality, even if they did live within recognised limits enforced by social conditions.[17] Likewise, in George Bellows's famous painting *Cliff Dwellers* (1913) the immigrant working classes are clearly not ground down to drabness.

When Bellows focused on an architectural object, as in *The Bridge, Blackwell's Island* (1909), he also presented the texture, people, and ordinariness of the general cityscape. The bridge is not monumental or awesome, nor is it utterly separated from the artist or the spectator. The people on the right-hand border of the painting catch the eye of the viewer, thus humanising the scene. Much the same can be said of his painting *New York* (1911), with people and street activity in the foreground of the city's large commercial buildings.[18]

If Sloan and his circle had focused on spunky, pugnacious people who carried on in spite of the odds of New York life, modernists emphasised physical forms and a vital but cool energy. For both groups, the city

fig. 8
George Luks
Hester Street
1905
The Brooklyn Museum
Dick S. Ramsay Fund

represented escape from the constraints of traditional notions of order, whether social or visual. But the Stieglitz group was drawn more to the visual novelty than to the social lives of the new city, and in this they agreed with and learned from the European avant-garde temporarily living in New York. Marcel Duchamp, who came to New York with his *Nude Descending a Staircase, No. 2* (1912), the most widely discussed of the paintings in the Armory Show, declared that 'New York is itself a work of art, a complete work of art.' Europe, he thought, was finished; the future was the dynamic city of skyscrapers. Francis Picabia, also just arrived for the Armory Show, shared this view, famously declaring in 1913: 'New York is the cubist city, the futurist city. It expresses in its architecture, its life, its spirit, the modern thought.'[19] Their interest, however, was not in documentation of form, but rather in evoking the heights, the kinetic energy and emotional power of the city, a theme that would especially interest John Marin of the Stieglitz group. Others in the group were fascinated by the perspective of height, but were also drawn to study the precise forms, angles, massing, and shadows of the recently formulated and emergent skyscraper aesthetic.

The painters associated with the 291 Gallery, those in the Stieglitz circle, understood themselves as having formed the first American avant-garde. Still, their perceptions and representations of the city bore greater similarity to those of the Europeans than to those of 'The Eight'. They sought to represent the energy, the barely contained chaos of the city, or, at the opposite extreme, the formal qualities of the city's buildings, often stressing the precisionist geometry of the modern skyscraper and other urban technologies.

There are differences among the pictures made by this group, of course, but they have much in common. They portray a city of power, whether that power is represented by turbulent energy, as in John Marin's watercolours, or cool energy, as in the paintings and photographs of Charles Sheeler. It is almost always an image of the city from a distance, one that diminishes people. These paintings are all versions of Stieglitz's photograph *The City of Ambition* (1910) [fig. 1].

In a remarkable series of drawings and watercolours, John Marin, who had studied architecture in his youth, captured New York's dynamism in his

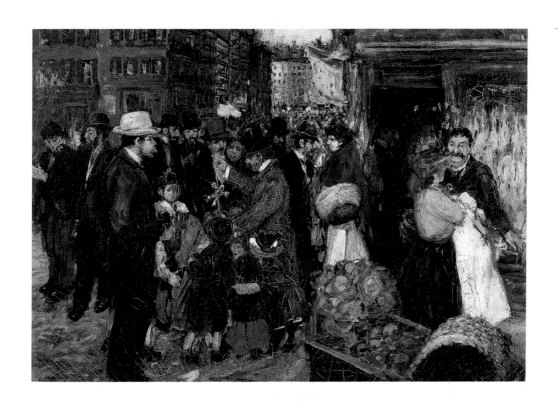

fig. 9
John Marin
Movement, Fifth Avenue

1912
Alfred Stieglitz Collection
The Art Institute of Chicago
(photograph: Kathleen Culbert-
Aguilar) © ARS, NY and DACS,
London, 2002

explorations of the city's physical forms. He was obviously influenced by Cubism and by Cézanne, but he was especially affected by the direct experience of the city's newness and energy upon his return from Paris. Its jagged skyline came to life in his images. The tall buildings that made up a panoramic wall jostled against each other; one could say that they even danced with each other. His was an unmistakably physical and kinetic city. Commenting on his paintings of the Woolworth Building in 1913, he explained: 'I see great forces at work; great movements; the large buildings and the small buildings, the warring of the great and small.'[20]

These mobile buildings are portrayed in his many versions of the Woolworth Building and in the remarkably kinetic *Movement, Fifth Avenue* (1912) [fig. 9]. His paintings before World War I tend to bring together streets and buildings in a kind of symbiosis of energy. Only occasionally, as in his later *Related to St. Paul's, New York* (1928) did he explore the relation between historical fixity and modern energy and transformation. Or, put differently, he addressed in this work the meaning of monuments in modern cities.[21] Henry James had recognised the same phenomenon when he revisited the United States in 1904, but he observed it from the opposite point of view, when he wrote with deep regret in *The American Scene* of the new buildings that, in his words, 'so cruelly overtopped' Trinity Church's spire.

Contrary to the usual association of the Stieglitz group with Greenwich Village bohemianism, I would argue that the artists associated with the 291 Gallery, located above Madison Square, faced north, toward midtown. Few of that group lived in the Village. In the 1920s, for example, Stieglitz and Georgia O'Keeffe lived in midtown; Marin, who lived in the New Jersey suburbs, was always a visitor in the city. The Sloan group, by contrast, lived mostly in the 'extended' Village.[22] Each group depicted its own neighbourhood.

Sloan painted a Village made up of working-class immigrants, mostly Italian, and the newcomers to the adventure of bohemianism, a complex world brilliantly described in Caroline F. Ware's sociological classic, *Greenwich Village, 1920-1930*.[23] Stieglitz and O'Keeffe, who moved to the Shelton Hotel in 1925, photographed and painted the prosperous world of midtown that was particularly fascinating to them for its geometry. Georgia O'Keeffe's

fig. 10
Georgia O'Keeffe
City Night
1926
The Minneapolis Institute of Arts
© ARS, NY and DACS, London,
2002

Shelton with Sun Spots (1926), with the sharply etched skyscraper forms energised by a giant sunspot on the building at the picture's centre, stands somewhere between Marin's kinetic and playful evocation of the city, and the much less mobile urban aesthetic of Charles Sheeler, toward which she moved. Her more famous *Radiator Building, Night* (1927) wonderfully enlivens the skyscraper forms with the fantasies prompted by the city lights and colours. But in *City Night* (1926) [fig. 10] and *New York Street* (1926) the colours are muted, and the feel of the city is sombre. Her exploration of the massive forms of New York urbanity owes much to Sheeler. The buildings are overlarge, somewhat intimidating, but they are not as cool as his. Rather there is an aura of mystery close to the evocation of the skyscraper city found in Hugh Ferriss's *Metropolis of Tomorrow*, published in 1925. O'Keeffe's street anticipates the modernism that would become associated with Le Corbusier, though without the open space.

I have emphasised the external perspective of the 'City of Ambition' artists, yet these uptown Bohemians had entered Dreiser's Walled City. Stieglitz and O'Keeffe resided near Rockefeller Center, at the Shelton Hotel, and from that roost in the middle of New York's commercial wealth they recorded the city. In the late 1920s and early 1930s Stieglitz made a remarkable run of photographs taken from their windows in the Shelton, particularly of Rockefeller Center, both its building and its finished form, as in *From the Shelton, Looking West* (1933), wherein he explores the line and shadow of that spectacular skyscraper complex. Many of O'Keeffe's paintings were also from their hotel window. They were confidently inside Dreiser's Walled City, including several that looked away from the commercial centre, across the East River to the dull industry-scape of Queens, whence came some of the men and women who were captured in Sloan's *White Way*.

Whether looking in, looking out, or exploring the city within the walls from within those walls, the view offered by Stieglitz and O'Keeffe in the 1920s was always distanced by the position from which they viewed the city. Where Sloan and his circle were at street level, mixing with the urban populace that was their subject, O'Keeffe and Stieglitz almost always assumed a perch well above the ground, detached from the human life below.

fig. 11
Hugh Ferriss
The Lure of the City
1929
Avery Architectural and Fine Arts
Library, Columbia University,
New York

'New York', Stieglitz commented in a letter to Sherwood Anderson in 1925, 'is madder than ever. The pace is ever increasing. – But Georgia and I somehow don't seem to be of New York – nor of anywhere. We live high up in the Shelton … All is so quiet except the wind – & the trembling shaking hulk of steel in which we live. It's a wonderful place.'[24] Others in the circle seem to have shared this sense of distance, whether Edward Steichen in his *Sunday Night on 40th Street* (1925) or Sheeler, in his *New York (Buildings)*. The city thus presented is a frozen city; there is no history. Dreiser may have described this city too: 'It was silent, the city of my dreams, marble and serene, due perhaps to the fact that in reality I knew nothing of crowds, poverty … It was an amazing city, so far-flung, so beautiful, so dead.'[25]

The Stieglitz group was interested in form and order, making no attempt to penetrate the human qualities of the city, and with little interest in evoking human sympathy or dignity. There is a detached playfulness about urban form and power. This visual attitude reiterates a contemporary literary stance that articulated a new urban 'sophistication', first in the magazine *Vanity Fair* and then, from 1926, in *The New Yorker*. It is a new kind of urbanity: detached yet affectionate; anonymous but not alienated; exploring or curious but not penetrating or engaging. This sensibility establishes an attitude toward urban phenomena, but does not engage it.

In Hugh Ferriss's beautiful drawings from his book *The Metropolis of Tomorrow* (1925), the City of Ambition is represented as pure form and atmosphere.[26] Ferriss was fascinated by form, and it was he who developed the handbook of skyscraper forms allowable under the 1916 New York City zoning law. No image more powerfully represents the seemingly unreachable City of Ambition than his *The Lure of the City* (1929) [fig. 11].

There is another major difference between the city of the Sloan circle and that of the Stieglitz circle. There are no domestic environments portrayed by the latter group: the focus is on offices, symbols of power, money, and ambition. There is little interest in the intimate locales of security and identity. Indeed, Stieglitz and O'Keeffe did not have a home; they lived in a hotel. Nor do they show men at work. Lewis Hine (not a member of either group but a contemporary) celebrated the skyscraper by photographing the workers who

fig. 12
James VanDerZee
Parade on Seventh Avenue
1924
© Donna Mussenden VanDerZee

constructed the Empire State Building.[27] Not the Stieglitz circle. For them the city is a place of visual delight, not a place of working, living and laughing, or of homes, families and neighbourhoods. Neither is the city a place of active public life, of people enjoying the streets, or using them for formal rituals of self-representation. One looks in vain among the Stieglitz group's *oeuvre* for a photograph resembling James VanDerZee's picture from the mid-1920s, *Parade on Seventh Avenue* [fig. 12].

I have emphasised the separation of these two traditions of urban representation, and one could track that difference further in the contrasting work of photographers Paul Strand and Walker Evans. But now I want to make a different point. Later, in the 1930s, the two modes of urban representation meet in fascinating ways in the photography of Berenice Abbott who between 1935 and 1937 photographed the city. In 1939 a selection of these photographs were published under the title *Changing New York*.[28] Few have done better than Abbott in capturing the aesthetic possibilities of the city's tall buildings. Her brilliantly conceived and rigorously cropped vertical image, *Exchange Place* (1935), is a powerful delineation of the form of verticality and the feeling of closure in the forest of Lower Manhattan skyscrapers. She could, in other words, do Stieglitz's thing, but in *Changing New York*, as the title indicates, her purposes were fundamentally different. Her city is dynamic, historical, defined in narrative terms.[29] By the order she gives the pictures in the book, she achieves both a narrative of change and a conversation between the New York of Stieglitz and that of Sloan: between a newer and urbane New York and an older and more common New York.

She paired an aerial photograph of Broadway meeting the Battery with one of the firehouse on the Battery; on the East Side, near South Street, she paired the Manhattan Bridge tower with a nearby rope store; a downtown tower, portrayed in what she called a 'city arabesque', is contrasted with a local shop in the nearby Lower East Side. Most compelling of all to me, perhaps because it shows where I live and work, is her photograph of Washington Square [fig. 13]. Here, Abbott captures the narrative of urban

fig. 13
Berenice Abbott
*Washington Square,
Looking North*

1936
Museum of the City
of New York
(photograph: The Federal Arts
Project)

fig. 14 [opposite]
John Marin
Mid-Manhattan No. 1

1932
Nathan Emery Coffin Collection
of the Des Moines Art Center
© ARS, NY and DACS, London,
2002

transformation that is her theme – in a single picture of considerable formal interest. The caption to this picture makes the point: 'Behind the arch the old houses of Washington Square North so far have resisted demolition; but the skyscraper apartment at No. 1 Fifth Avenue symbolises the fate the old square may look forward to.'[30]

During the 1930s others represented the city in ways similar to Abbott. The Great Depression produced in all writers and artists a deeper interest in the 'people' and in social issues.[31] This is obvious in the murals of the era, as we have already noted with those of Douglas and Hayes. But more striking, partly because it is surprising, is the shift in the work of John Marin, who changed his focus to human figures, seeing in them something of the drama of urban life. The life-like structures that had earlier represented the drama of the city were moved back in the 1920s, and he examined the street. In his *Mid-Manhattan No. I* (1932) [fig. 14], he goes farther yet. It is a cultural comment on the City of Ambition. The city of towering ambition is not working: in the foreground of the city of skyscrapers are the residents of a Hooverville, a self-built squatter settlement named for the President who presided over the Stock Market crash.[32]

At the outset, I promised to establish the political importance of these different representations of urban modernity. I would argue that these alternative structures of urban perception do, in fact, define the twentieth-century politics of urban development. There is a significant and surprisingly direct translation of artistic visions of the city into public policy, and this is in part for aesthetic reasons. The midtown vision of the city offered by Stieglitz, O'Keeffe, Sheeler and Ferriss resonated with the midtown financial élite, who supported the Regional Plan of New York, published in six fat volumes between 1929 and 1931.[33] This privately financed plan aimed to enhance those qualities of the city that had fascinated the Stieglitz group – a Manhattan of grand ambition, devoted to high rent uses of business administration, luxury housing, and luxury retail. It was a plan, as the young Lewis Mumford pointed out in a stinging critique, designed to develop the centre, to serve the élite who lived there and made their money there.[34]

All other uses – working-class housing, cheap retail, and industrial jobs – were relegated to the fringes.

Those who fashioned the Regional Plan pioneered new analytical techniques. It is a vast compendium of impressive statistics – about the economy, housing, jobs, traffic, communication, and more. Their city was in part a statistical city – a city of aggregate figures on needs and services – but it was, for that very reason, a city devoid of the particularities and textures of places, and the peoples who lived in those places. To read the Regional Plan is to discover a city whose social meaning is numerical, whose visual representation is geometrical.

The Regional Plan Association drew directly upon the City of Ambition aesthetic I have described in presenting its own urban vision. They hired Hugh Ferriss to give visual representation to their ideas; his beautiful drawings reduced the city to a geography of skyscraper forms. The aesthetic power of the visual parts of the plan, especially those in volume two, *Building the City*, surely enhanced its appeal and advanced its prospects of implementation. And it was largely implemented. It has been argued, and plausibly so, that it was this city that Robert Moses created between 1933 and 1964 – a city of highways and towers, of offices rather than factories, of professionals rather than workers, of Lincoln Center at the expense of the sort of local, neighbourhood cultural vitality chronicled by Sloan and his circle.[35]

Did the vision of the city represented in the work of Sloan's circle find political expression? One need look no farther than *The Death and Life of Great American Cities*, by Jane Jacobs.[36] Marshall Berman has praised her book for 'perfectly expressing' an urban modernism 'close to home, close to the surface and immediacy' of the lives of 'modern men and women'.[37] Jacobs, who forged her ideas in opposition to Moses, begins her book with a discussion of the street, emphasising the particularity and texture of local street life in cities, rarely addressing a social unit much bigger than the neighbourhood. She articulated and gave powerful literary form to what was apparently a widely felt concern; the city planners and architects at whom she had aimed her arrows absorbed her ideas with alacrity, substantially altering urban policy.

Most of us, I think, are probably drawn to *both* of these New Yorks, and we may hope that art will, as it did in the 1930s, again provide us with complex and aesthetically compelling representations of a city that offers its citizens the romance of both skyscraper ambition and of local neighbourhoods, the power of utilitarianism and the humanity of sympathy.[38]

The divided image and experience of the city is not unique to New York; one finds the same conditions in Paris, Rio de Janeiro, Mexico City, and elsewhere. Such is the condition of metropolitan modernity, as it has been for nearly a century now. The neighbourhood and the centre (the CBD in planning jargon) are *both* products of modernity, both distinctively characteristic of the specifically modern city. Art has often, as I have argued here, represented and re-enforced these divisions, which have in turn been a focal point for our politics. Yet we might look to art, as well as politics, for new structures of urban perception, ones that may bring these aspects of urban life into a mutually enriching relationship.

NOTES

1. Walter Benjamin, *The Arcades Project* translated by Howard Eiland and Kevin McLaughlin, based on German volume edited by Rolf Tiedman (Cambridge: Harvard, Verso, 1999), esp. pp. 1-26, 461; Georg Simmel, 'The Metropolis and Mental Life', in Kurt H. Wolff (ed.), *The Sociology of Georg Simmel* (New York, Free Press, 1950), pp. 409–24; Carl Schorske, *Fin de Siècle Vienna: Politics and Culture* (New York, Knopf, 1980); Richard Sennett, *The Conscience of the Eye* (New York, Knopf, 1990).

2. Meyer Schapiro, 'The Introduction of Modern Art in America: The Armory Show', in his *Modern Art* (New York, Braziller, 1978), pp. 135–78; Irving Sandler, *The Triumph of American Painting: A History of Abstract Expressionism* (New York, Harper & Row, 1971).

3. See, for example, Gail Levin, *Catalogue Raisonné of Edward Hopper* (New York, Whitney Museum, 1995); Serge Guilbaut, *How New York Stole the Idea of Modern Art* (Chicago, University of Chicago Press, 1983); Robert Storr, 'No Joy in Mudville: Greenberg's Modernism Then and Now', in Kirk Varnedoe and Adam Gopnik (eds), *Modern Art and Popular Culture* (New York, Harry N. Abrams, 1990), pp. 160–90.

4. There are at least two other major modernist lineages in New York during the period covered by this essay. One I would call Duchampian, and it points toward the New York Minimalism from the 1960s onward. The other is the Harlem renaissance, to which I briefly advert below.

5. Michel de Certeau, *The Practice of Everyday Life*, translated by Steven Rendell (Berkeley, University of California Press, 1984), xxi, pp. 92–93.

6. Edward Bryant, *Pennell's New York Etchings* (New York, Dover Publications, 1980), notes for illustration no. 35.

7. Theodore Dreiser, *Sister Carrie* [1900] (Boston, Houghton Mifflin, 1959), pp. 275, 245.

8. For a pioneering exploration of these alternative representations of the city, see Sidney H. Bremer, *Urban Intersections: Meetings of Life and Literature in American Cities* (Urbana and Chicago, University of Illinois Press, 1992).

9. Useful discussions of each of these circles may be found in William Innes Homer, *Alfred Stieglitz and the American Avant-Garde* (Boston, New York Graphic Society, 1977); Merrill Schleier, *The Skyscraper in American Art, 1890–1931* (New York, Da Capo, 1986), esp. ch. 3; Elizabeth Milroy, *Painters of a New Century: The Eight & American Art* (Milwaukee, Milwaukee Art Museum, 1991); and Rebecca Zurier, Robert W. Snyder, and Virginia M. Mecklenburg, *Metropolitan Lives: The Ashcan Artists and Their New York* (New York, Norton, 1995).

10. This print was last exhibited in 1977; it is now presumed to be in the possession of an anonymous private collector.

11. Norman Podhoretz, *Making It* (New York, Harper & Row, 1967), p. 3.

12. Theodore Dreiser, *The Color of a Great City* (New York, Boni & Liveright, 1923), pp. 284–85.

13. Dorothy Norman, *Alfred Stieglitz: An American Seer* (New York, Random House, 1973), p. 45.

14. See, for a photographic history of the Flatiron Building, Peter Kreitler, *Flatiron* (Washington, American Institute of Architects Press, 1990).

15. Quoted in Casey Blake, *Beloved Community: The Cultural Criticism of Randolph Bourne, Van Wyck Brooks, Waldo Frank & Lewis Mumford* (Chapel Hill, NC, University of North Carolina Press, 1990), p. 144.

16. Some critics have argued that this picture was intended to be political, even suggesting the *later* anarchist bombing of the building realised its political content. Strand's comments are, in fact, ambiguous. See Maria Morris Hambourg, *Paul Strand: Circa 1916* (New York, Harry N. Abrams, 1998), p. 29.

17. Two other Luks paintings of the same neighbourhood could be used here to make the same point: *Allen Street*, Hunter Museum, Chattanooga, Tennessee; *Houston Street* (1931), St. Louis Art Museum.

18. And the same can be said of his *Men of the Docks* (1912), Maier Museum of Art, Randolph Macon Women's College.

19. Both quoted in Schleier, *The Skyscraper in American Art*, p. 64.

20. Ruth E. Fine, *John Marin* (New York, Abbeville Press, 1990), p. 126.

21. On the meaning of monumentality and history suggested here, see Hans-Georg Gadamer, *Truth and Method* (Crossroad, 1982), p. 138.

22. By extended Village, I expand the boundaries of the Village to include an indeterminate area between East 14th Street and East 20th or 21st Streets, where Bellows lived, and where some others of the Eight lived at one point or another in their careers. Sloan lived in the Village 'proper' during the whole of the period under consideration.

23. Caroline F. Ware, *Greenwich Village: 1920–1930: A Comment on American Civilization in the Postwar Years* [1935] (Berkeley, University of California Press, 1994).

24. Quoted in Sara Greenough and Jane Hamilton, *Alfred Stieglitz* (Washington, DC, National Gallery of Art, 1983), p. 214.

25. Dreiser, *The Color of a Great City*, p. 1.

26. Hugh Ferriss, *The Metropolis of Tomorrow* [1929] (Princeton, NJ, Princeton Architectural Press, 1986).

27. Lewis W. Hine, *Men at Work* (New York, Dover Publications, 1977).

28. Berenice Abbott's 1939 text was republished as *New York in the Thirties* (New York, Dover Publications, 1973). The whole project has recently been documented in Bonnie Yochelson, *Berenice Abbott: Changing New York: The Complete WPA Project* (New York, The New Press, 1997).

29. Similarly, Stieglitz could do Abbott's thing. His *Old and New New York*, done in the same year as his *City of Ambition*, was conceptually (and even formally) very close to Abbott's picture of Washington Square discussed below: it portrayed nineteenth-century buildings in the foreground with a very large modern skyscraper rising in the background.

30. Abbott, *New York in the Thirties*, text (by Elizabeth McCausland) accompanying figure 40.

31. See Michael Denning, *The Cultural Front* (London, Verso, 1997).

32. There is some background to this picture. During the 1920s, Marin became as interested in the streets as in the buildings, but in 1931, human figures begin to emerge. See his *Bryant Square* (1931), a preliminary drawing, and *Bryant Park* (1932), the finished picture, both at the Phillips Gallery, Washington, DC. See also *Pertaining to Fifth Avenue and Forty-Second Street* (1933), Phillips Gallery, Washington, DC.

33. Particularly informative in connection with the argument made here is the volume entitled *Building the City* (New York, Regional Plan Association of New York, 1931).

34. Lewis Mumford, 'The Plan of New York', *The New Republic*, June 15, 22, 1932, pp. 121–26, pp. 146–54.

35. See Robert Fitch, 'Planning New York', in Roger E. Alcaly and David E. Mermelstein (eds), *Fiscal Crisis of American Cities* (New York, Random House, 1977), pp. 246–84. He complicates (and softens?) this interpretation in Robert Fitch, *The Assassination of New York* (London, Verso, 1993). On Moses and the urban politics he represented, see Robert Caro, *The Power Broker: Robert Moses and the Fall of New York* (New York, Knopf, 1974).

36. Jane Jacobs, *The Death and Life of Great American Cities* (New York, Random House, 1961).

37. Marshall Berman, *All That Is Solid Melts Into Air* (New York, Simon & Schuster, 1982), p. 315.

38. It was such a vision of the city that Lewis Mumford tried, without success, to define by much of his writing in the inter-war years. This theme would require a whole study, but see Thomas Bender, 'The Making of Lewis Mumford', *Skyline*, December 1982, pp. 12–14.

Las Vegas at Middle Age

PAUL DAVIES

Two legendary casinos face off across Fremont Street: Binion's Horseshoe
and The Golden Nugget. Both have undergone changes, Binion's gobbling
up the adjacent Mint in 1988, The Nugget transforming in the hands of new
owner Steve Wynn in the early eighties. The renovated Nugget redefined the
casino environment upscale, without the neon glitz and cowboy memorabilia,
into something akin to a very large cream Cadillac. Like the car, you sink into
a world of cream walls, cream ceilings, and cream leather with black 'ebony'
trim. For Wynn, the future of Las Vegas lay in class.

Binion's Horseshoe, on the other hand, has all the class of a bus station
in collision with a boudoir, but is still one of the world's greatest rooms;
large with life, packed full of it, crushed even, elbow to elbow, head to head.
Entranced by the hubbub and serenaded not by Muzak, but by a waterfall
of quarters cascading from slots packed cheek by jowl, there is no room
to move. Even Benny Binion's famed million dollars in its bullet-proof giant
horseshoe lies tucked away in the back lobby by the parking, next to a shabby
news-stand selling cheap jewellery, fifths of bourbon, *The National Enquirer*,
and *Hustler Magazine*.

fig. 1
Las Vegas: Rio rooftop
(photograph: Julie Cook)

The Binion family is a casino-owning legend. Benny himself wrote a significant chapter of The American Dream, the chapter that says halfway through that even if things haven't gone just right so far, you can still make it. Staring down between cowboy hat and buffalo skin on the wall, he surveys the scene much as he left it; a casino where 'class' is all the calculated flourish of an impatient madam. There are crimson drapes with golden tassels; there is rough-and-ready dark wood panelling. The space of each table across the ranch of the casino floor is staked out not by South Sea Island rafts, nor Neapolitan awnings, nor oceans of cream paint, but by traditional timber coffers and imitation gas lamps. The bars are cramped and stacked with boxes and the bar stools commodious in worn buttoned leather, and supporting sometimes four jostling drinkers each. At Binion's, even the white-veiled brides are wearing jeans and surrounded by Johnny Winter lookalikes, without the albino eyes exactly, but with a decent wash of pink around their sockets all the same.

At the other end of town, something else is happening. When you fly in to be bedazzled by the legendary Strip that carves its way through Clark County beyond Downtown's city limits, prepare yourselves for a shock: Las Vegas has gone green. A large swathe of northern Italian woodland, including a lake, fronts Wynn's latest casino adventure, Bellagio, transforming The Strip into tree-shaded Las Vegas Boulevard.

In a city where construction has the glamour of a high stakes poker game, Bellagio is a very expensive $1.6 billion gamble, and the crowning achievement of Mr Wynn, CEO of Mirage Resorts, whose Midas touch first rescued The Nugget in 1972. He says Bellagio is 'about things which are good for the soul – fine art, gardens, flowers, fashion', an elegant, sophisticated, and graceful place where 'everything is just right'.[1] It has lots of room, lots of space. It has its own art gallery. About the Bellagio Collection of Fine Art, James Mann, curator of the Las Vegas Art Museum, says: 'It's a small, gemlike collection of works and a wonderful thing for the city. It dispels once and for all the old canard that Las Vegas has no culture.'[2]

Collections are a demonstration of taste and cultural capital. Now 30 'intellectual' essays by distinguished academics have been marshalled

to describe in detail the 40 works of a casino's art collection. Mr Wynn even travelled to Paris to meet Françoise Gilot, long-time companion of Picasso, to hear her account of one of his paintings in the collection, providing the catalogue with that essential veracity that would seem such anathema to Las Vegas. But this art gallery is inspired, it fulfils a popular, mainstream desire for status and 'high culture' shared by the vast majority of middle-class Americans. No matter that, for students of popular culture, Las Vegas is famous as the epicentre of kitsch. Here lies the irony faced by many critics of popular taste. The film *Showgirls* may have bombed critically and at the box office, but its gloriously crass representation of Las Vegas has made it a cult classic. It seems, paradoxically, that true aficionados of popular culture now often stand outside mainstream (and therefore truly popular) values. As a cultish minority, they are the ones admiring the snow domes, not the Picassos.

This confusion extends to fashion; in Las Vegas, for each Elvis in that white jumpsuit, for each Liberace dripping with rhinestones, for each Siegfried and Roy escorted by Siberian white tigers, there has always been an opposite, a very cool dude indeed. Bugsy Siegel, founder of The Flamingo in 1947, did not dress in 100% rayon 'vegaswear', he was famously immaculate. Frank Sinatra was also notoriously fastidious, and The Rat Pack, who commandeered Vegas as their playground through the fifties and sixties, were apostles of style and sophistication. These days, Mr Stephen A. Wynn himself comes, of course, immaculately dressed.

In Bellagio, the sheer of a Donna Karan dress or an Armani suit, whose qualities are those of the world's most exquisite fabrics and of perfect tailoring, are just as Vegas as the downtown vegaswear you'll find in Binion's. Today's *haute couture* may still be significantly black, and it positively minimalises the pockets and patterns, collars and colours that intoxicate enthusiasts of popular culture. The infamous Mario-Puzo inspired 'Vegas jacket', with its expanded range of hidden zippered pockets for keeping your stash discreet, has gone (if it ever really existed!), except in the minds of enthusiasts (like me) who scour the side-streets off Fremont Street with other tourists in search of the real thing.

Some legendary characters, 'Mr Las Vegas' Bob Stupak in particular, still propagate the impression that Las Vegas garb should mirror twinkling neon, in combinations of colours Tom Wolfe recorded as, 'Tangerine, broiling magenta, livid pink, incarnadine, fuchsia demure, Congo ruby, methyl green, vividrine, aquamarine, phenosafranine, incandescent orange, scarlet fever purple, cyanic blue, tessellated bronze and hospital fruit basket orange',[3] while retro clothing shops such as Attica (Main Street, Downtown) and Valentino's Zootsuit Connection (906 6th Street) thrive on a steady stream of groovy youth keen to experience the Las Vegas Bellagio appears to excise.[4]

Architecturally the new Las Vegas has grown larger, more seamless, and more spacious, while the collections inside, be they of clothes or of paintings, have become smaller, more refined, and more carefully arranged. Wolfe's babbling lilt would be challenged by 'The Intimate Collection' of seven (not 70) 'world class' *haute couture* retail stores and seven premier restaurants that 'fill' the 'incomparable beauty and romance' of Bellagio's expansive, spectacular and (genuinely) daylit shopping promenade. There is even 'The Bellagio Collection' of selected designer wear for those seduced by the choices of Mr Wynn himself. Across each marble floor, clothes are presented singly in cabinets, where 'each step reveals a new visual experience'.[5] This shopping experience becomes a languid sequence of long, empty, views.

fig. 2 [opposite]
*Relaxing by the pool: Luxor,
Las Vegas*
(photograph: author)

fig. 3
*The Fremont Street
Experience, Las Vegas*
(photograph: author)

Congestion and hubbub, have disappeared; no more 'hernia hernia hernia'(fifty-nine times!)[6] no more 'Las Vegas … I Can't Hear You!' just the eerie silence and statuesque beauty of collections neatly arranged for contemplation by discreet designers, curators, or even chefs, from all over the world. Bellagio sources its architectural 'elegance, sophistication, and grace' in the classical vernacular, a classical vernacular collection of high points selected from tessellated tower to teapot, and including accessories such as the classic Viva speedboat moored on the lake. With the consistency of gelati, this vernacular classicism has more than a hint of baroque about it; you can marvel at the detail, but you won't find any junctions.

Some architectural wisdom holds that buildings are more interesting under construction than they are when they are finished, the construction process demonstrating the mysteries of how materials go together. Las Vegas has always held this to be a lot of tosh, the effect of the ensemble being of primary interest. Buildings under construction on today's Boulevard look simply unfinished, with a miniature Eiffel Tower over here, half a hideously extended Doge's Palace over there. You have to wait for the full disorientating effect really to enjoy them. In Bellagio's case, trees and flowers provide softening accents to mellow this bombastic informality. There are flowers on every fabric, and 20,000 real chrysanthemums (replaced daily) packed into the atrium display for The Bellagio Gallery of Fine Art. The floral displays will

fig. 4
Bellagio, Las Vegas
(photograph: Julie Cook)

always be fresh, changing to represent a further import to the Nevada scenery: seasons. Four times a year, award-winning artists will simulate the effects of the earth's orbit of the sun and the traditional festivals that accompany it, on a global scale; a New England Thanksgiving, a Chinese New Year, and so on. The floral motif is continued into the main hotel lobby, where a $10 million glass chandelier, resembling large poppy petals, tumbles across the ceiling.

Accompanying the flowers, out goes the dark, clockless, interior of old. Bellagio looks, feels, and smells less like a casino and more like New Bond Street meets La Residenzia. Inside the 120,000 square feet gaming floor is a festival of awnings demarcating the areas over the tables. Awnings to make John Lewis weep, awnings even where the sun don't shine. A further new concept in Bellagio, 'romance in the literary sense', may perplex fans of popular culture. Advertisements for Bellagio depict a knowing relationship between a slightly older man and an attractive younger woman exchanging suggestive glances as they promenade along the lakeside balconies that front the casino. From the lake, just as the girl touches the man's hand, 1,000 water jets spurt 240 feet up in the air to the accompaniment of Pavarotti – 'And so it begins'. According to the *Las Vegas Journal*, folks in Chicago just don't get it. Is it all too subtle? Finally, and dramatically, unlike almost any casino in the city without clocks, Bellagio is quiet at 4.30 a.m. It seems professional, middle-aged Bellagio guests do not want to party all night, like Frank, Dean, Sammy, Peter and Joey. They watch their ulcers.

Bellagio has taken an astonishing five years to build, not the usual 18 months. Las Vegans have waited a long time for its impact. On opening night 18,000 people came for a look; 10,000 of their friends and relations being employed in the new casino, and thousands more involved in its construction. Around 11 p.m. (after the celebrity charity fund-raiser in aid of the blind) the locals trooped through with their families to appreciate this new and ground-breaking rejuvenation of the city's prospects, and flooded towards that new talisman of cultural value, the art collection.

Unlike municipal collections, The Bellagio Gallery of Fine Art, $280 million worth, is permanently for sale. If you get lucky, and sentimental, you can swan

off with a Renoir. A guest once famously walked out of The Thunderbird
in 1948 carrying his hotel room art, $200 worth of copies, while the
management looked on, smiling, since he'd lost $14,000 at the tables. With
Bellagio the negotiation with art is a little subtler, with some questions as to
its tax-deductible status and the entrance fee of $10, but a deal has been
struck. There is something reassuring about this; firstly that fine art in Las
Vegas, whatever its authenticating baggage, is still a commodity just like any
other. Secondly that you can scratch the surface of an art patron in Las Vegas
and still find the golden heart of a used-car salesman.

This is not to say that Las Vegas does not propagate values. Casino design
has much in common with baroque art, the politically motivated special
effects contrived to reduce even the most indifferent congregation to
swooning religious fervour. Today the emphasis is on the virtues of the good
life, the casino environment undergoing a transformation under a newly
clean, corporate ethos, with Steve Wynn reputedly standing up in front of his
staff to declare: 'It's your casino … we have just built it for you!' Those staff
enjoy the same fine conditions front and back stage, a continuous education
programme that allows them to go to college and encouragement to

fig. 5
Bellagio: shopping
(photograph: author)

fig. 6 [opposite]
Bellagio: people
(photograph: author)

contribute to the United Way charity, to whom Mirage Resorts employees are the industry's biggest contributors.

Tom Wolfe in 1964 likened Las Vegas to Versailles, Robert Venturi et al. in 1972 used the analogy of Rome.[7] But in both cases there was a sense that this Las Vegas Versailles, or this Las Vegas Rome, encapsulated particularly democratic notions. No matter that through this period the corporate structure Las Vegas laboured under was largely corrupt and invisible. Through Las Vegas steamed the great 'proletarian cultural locomotive', leaving in its wake some flickering, ephemeral trace rather than any deadening monumental structure. One driving force behind the erasure of such an apparently promising phenomenon from the surface of Las Vegas has been its burgeoning population. Las Vegas residents (numbering over 1.5 million; Nevada is the fastest growing state in the USA) are keen to make their community a safer and better place for their children to live. The maturity of a new raft of anxious, God-fearing parents has brought the values of mom's apple pie directly into conflict with those of the casino and the whorehouse. A. Alvarez spotted early manifestations of this concern in 1982 when, on the way through McCarran Airport to 'The Biggest Game in Town', he noticed a poster proclaiming 'Kids live in Las Vegas too!'[8] 1998 saw the removal of advertisements for the numerous exotic cabarets overtly placed on the roofs of cabs, and the telephone directory no longer has 64 pages of full-colour photographs of escorts and dancers; rather it has 40 pages of curiously understated adverts depicting high-heeled shoes, doors and bathrooms, top hats

and wardrobes, and the occasional rose. Residents are fighting to close the adult video warehouses that their children might stray into. Owners wanting the right to trade as 'Hot Stuff' plead their constitutional rights to the 9th Circuit Court of Appeals, not to City of Las Vegas officials (who shut them down).

The environment also figures high in general concern. An appreciation of the beauties of the desert, coupled with boom town encroachment, has fostered a new-found awareness of what Las Vegas has famously ignored by its lack of public amenities, parks, and nature reserves. Locally, the desert has undergone a shift in interpretation to something more akin to a garden. Water usage is a big issue, but even with all the lakes, lagoons, fountains and swimming pools the biggest use of water is still for domestic front lawns. To make the point, tribes of local children are marshalled on television commercials to encourage their moms and dads into a sprinkler programme which recommends the time and duration of sprinkler operation, and even includes the appointment of a water cop. As a result residents overreached their targeted 15% water saving for 1998. Clean water, waste disposal and the dumping of nuclear waste in the Yucca mountains are all hot political issues. Politics is still haunted by the ghost of corruption, and there is a fresh emphasis on the integrity of delivering the promise. Clark County, almost bankrupt, finds its politicians openly lambasting opponents in an atmosphere where honesty has become hard currency. All this in a town based on the opportunities afforded by bluff over the green baize of the poker table.

Meanwhile a body is found asphyxiated in The Gateway Motel in naked city.[9] Heidi Zwieg died on the second day of the new year, with her boyfriend promptly whisked into the Clark County Detention Centre. Another long-sufferer threw himself off the sixth floor of Binion's parking garage on Thursday at 2.43 in the afternoon. He died instantly, but police say they have no idea what prompted Kent Wade to jump. Poker genius Stu Ungar is found

fig. 7
Bellagio: floral display,
Thanksgiving
(photograph: author)

dead in an anonymous motel room, a far cry from his halcyon days at Binion's when he won that 'biggest game in town'. Vegas remains the suicide capital of America.

Teen suicide, teen pregnancy, drugs, juvenile incarceration, home cooking and the departure of loveable old timers rank high in the concerns of *Las Vegas Review Journal* columnist John L. Smith, voice of respectable Las Vegans. With so many families arriving in the booming state, education is a number one priority. Nevada Governor Kenny Guinn, throughout his 1999 budget address, concentrated on 'reading, writing and arithmetic', funding initiatives by 'turning liabilities into assets' (privatisation, and the hiring out of Nevada correctional facilities to other states), and diverting funds from the prosecution of tobacco companies into education. The state is in a hole, with tax revenues coming in lower than expected, but any squeeze on the casinos will hurt them further. Nevada spends 50% of its state budget on education, but comes bottom of the tables in progression from the most basic schooling. (The national average is 65% continuation; Nevada struggles to put 40% through college.) The solution: a millennium scholarship of $2,500 per student with grades averaging over B. Still, the universities and community colleges 'won't get nearly what they asked for' in Guinn's budget, because Nevadans, especially new Nevadans, view any personal taxation with horror.

Mayor Jan Jones proposes that America's top 500 companies invest in gambling-free Las Vegas properties. That same day, the Candlewood Hotel Company buys the plaza on Paradise Boulevard (known simply as Paradise) that used to house The Crazy Horse Saloon strip joint, its most conspicuous lease holder. Candlewood proposes to build a 280 suite non-gaming hotel on the 4.4 acre site, the rooms equipped with full kitchenettes, oversized recliners and a business desk with two phone lines to accommodate personal computers and fax machines. Paradise and Industrial, parallel twins of The Strip but with seedier reputations, find themselves gradually moving upscale. Paradise is now known as Restaurant Row, or The Airport Corridor.

Global recession may have given casinos the jitters, Hilton announcing a 15% drop in gaming revenues, Las Vegas Airport activity down 1.5% on 1997, at the opening of Bellagio, its public relations people downplaying the

importance of Asian high rollers on Las Vegas fortunes, but the unusual response has been to build more and better facilities as fast as possible. The reason is cold-hearted demographics; Glen Schaeffer (CEO of Circus Circus Enterprises) gleefully notes: 'Somebody will turn 49 every 13 seconds for the next 15 years, and they have the highest personal income and the lowest spending rate.'[10] The result: for the millennium, four new 3,000 room hotel casinos are springing up: Mandalay Bay, Paris, The Venetian, and a new Aladdin. They really do believe: 'If you build it, they will come!'

So what has happened to popular culture's epicentre, that unique urban vision of the twentieth century to accommodate what people really want (for three days at least) in electric anarchy? The fashions certainly appear to have transformed from *ad hoc* (100% rayon) to seamless (100% Donna Karan), but there are underlying consistencies and that thriving market for retro. By instinct, Las Vegas remains true to itself: build it and they will come (whoever they might be). In short, Las Vegas, the city, embodies the spirit that surrounds any craps table, that altarpiece of gambling culture, with its stickman, its banker, its spiritual adviser, its supervisor, your new best friend at your side, and all those others either betting for or against you as you shoot a little pair of dice across a ludicrously confusing field of baize. You weigh up the odds, you pray for luck, and you throw the dice; you build it and (you pray!) they will come!

The shift begs the question as to our common understanding of what popular culture looks like, and at the same time undermines fashionable readings that seek to distance form from content. In particular Venturi,

Scott Brown and Izenour's *Learning from Las Vegas* implied that the 'great proletarian cultural locomotive' left behind a glitz that proved versatile as a model for an energetic, vital city, that there was something about the architecture which could be distilled from this intoxicating context of risk. The Las Vegas Strip became an exemplar for an idea that 'Main Street is almost alright'. But was the Las Vegas Strip ever anything like a main street? How many main streets are supported by fields of slot machines and craps tables?

Dreaming of ideal cities, Renaissance architects geometricised with respect to God and the symmetries of the human body. Recently, pathologies of the city (an altogether contrasting view of the city as a body) seem to dominate architectural discourse. Las Vegas, the city advertised now as much by The Bellagio Gallery of Fine Art (a publicity coup!) as by neon Vegas Vic and Vicky in travel agency windows, might encourage an alternative urban vision. It is perhaps better viewed not so much as an abstracted body but as a living personality. There may be some death wish, some looming catastrophic demise, but this cannot belie its singularly purposeful momentum. Las Vegas has reached middle age (The Strip turned 50 in 1997) and has saddled itself with many of the quandaries middle age seems to bring: oscillations between responsibility and personal freedom, youthful vision and sanguine reconciliation, reckless energy versus (conspicuously) acquired sophistication.

In terms of architectural form, the complexities of retropop have become a curiosity, so much so that students of popular culture, rooting through the YESCO (Young Electric Sign Company) scrap heap of discarded neon for the real thing, no doubt clutching copies of Robert Venturi, Tom Wolfe or Hunter S. Thompson, finally forced YESCO to close their Boneyard. Grasping an opportunity, the City of Las Vegas decided to extend the Fremont Street experience with a Neon Museum. Such a Neon Museum provides an architectural equivocation of Las Vegas's dilemma, and is not without pathos.

The Fremont Street experience itself, in pedestrianising the street under a celestial vault computerised light show, providing an electronic lobby to the delights of the existing Fremont Street casinos, is almost schizophrenic.

fig. 8
*Aladdin's Lamp, Neon
Museum, Fremont Street,
Las Vegas*
(photograph: author)

The first time I saw the Fremont Street experience I thought it looked like a shopping centre, its space frame dull in the sun, its punters bored, minds elsewhere. The second time I thought it was something heavenly, a plasmatic, neuron-frying, all enveloping nuclear-submarine-and-seahorses thing above my head with a soundtrack by Dwight Yoakham while, somewhere in the crowd, a man in a gorilla suit and gold Elvis shades was doing an Indian dance to his video camera. The third time, it looked like a shopping centre again. This new architecture could be seamless and dull one minute, intoxicating and dramatic the next. To some it represented a dismal example of political sanitisation (compulsory orders seeing many poor occupants downtown moved on to make the area more attractive to bigger, better, cleaner, and more prestigious concerns); to others, I suppose that includes me, just matronly instinct.

In January 1999 Mayor Jan Jones spoke at the Korbel Champagne promotion for the year 2000 at The Fashion Show Mall. But would the Mayor intervene to support organised millennium celebrations? The previous year's celebrations had gone well Downtown, where the Fremont Street experience ('an urban theatre where people feel safe') managed entertainment with an entry charge, with Danny Gans, an impressionist, keeping everybody quiet. Back on The Strip, there was more anarchic, less savoury, fun; crowds tearing up the signs and the landscaping that had 'beautified' The Strip, into The Boulevard, and overturning cars.

Today the open-air Neon Museum sits between two large construction sites, a consequence, no doubt, of this improved environment. But despite the mountain bike riding Fremont Street security teams, the same drunks still congregate at the street's south end, sipping their bottles from brown paper bags, but this time huddled under a collection of historic neon signs advertising the long lost accommodations and grills of yesteryear, *sans facilités*, set within tasteful landscaping. Sponsored, restored, podiumed, plaqued popular culture, the high point of the collection is the lamp (c. 1966), dedicated to Mayor Jan Jones, and her children Maura, Kaitlyn and Patrick.

NOTES

1. Steve Wynn is quoted from the Bellagio press pack.

2. James Mann is quoted from T. Erwin, 'A Master Stroke', *Las Vegas Life Magazine*, November 1998.

3. Tom Wolfe, 'Las Vegas (What?) … Las Vegas! … (Can't Hear You! Too Noisy) … Las Vegas!!!', *Esquire Magazine*, February 1964.

4. For example 'The City Guide to Las Vegas', *Max Magazine*, April 1999.

5. Bellagio press pack.

6. The opening paragraph of Tom Wolfe's essay repeats the word 'hernia' fifty-nine times.

7. R. Venturi, D. Scott Brown and S. Izenour, *Learning from Las Vegas* (Cambridge, MA, MIT Press, 1972).

8. A. Alvarez, *'The Biggest Game in Town'* (London, André Deutsch, 1983).

9. A particularly downtrodden section of Las Vegas Boulevard north of The Stratosphere Tower.

10. Robert Hughes, 'Wynn Win?', *Time Magazine*, 8 February 1999.

6

Wish You Were Here

MALCOLM MILES

At the opening of the twenty-first century, the city is the primary form of human settlement. A stereotypical image of it includes gleaming towers, waterside vistas and the unity of a skyline, the city as image of the modernist utopia. But the idealism associated with modern architecture – the notion that a better society can be engineered through design – is threadbare in the face of actuality. Instances of urban injustice, deprivation and unrest state the failure of idealism and the fallacy of representing what is the diversity of contemporary cities and urban lives as 'the city'.

For people drawn by dreams of affluence or driven by depopulation of the land, living in a city is a necessity. But for others, particularly in affluent countries and including professional critics of urban dysfunctionality, it is a choice. Cities, where dwellers feel no obligation to know their neighbours or be observed by them, offer anonymity and excitement as much as danger. Cities enable the displaced patterns of sociation that Georg Simmel saw as defining modernity, through which new cultural forms are engendered.[1] The city remains, as John Rennie Short argues, 'a metaphor for social

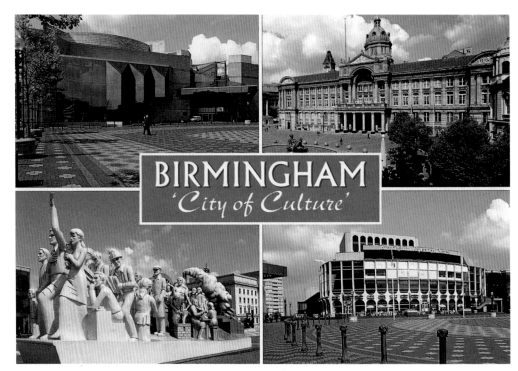

BIRMINGHAM
'City of Culture'

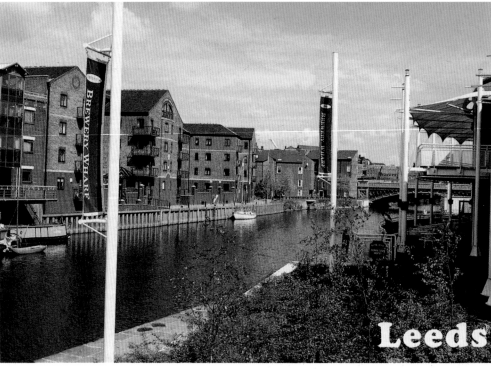

Leeds

fig. 1 [opposite above]
Birmingham 'City of Culture'
postcard
(by permission, © J. Salmon Ltd.,
Sevenoaks, Kent)

fig. 2 [opposite below]
River Aire, Leeds
postcard
(photo Alan Curtis,
© Dennis Print, Scarborough)

change'.[2] But the question, now, is by whom and for whose well being is that change engineered?

Conventional accounts of the city emphasise the design of urban form and the planning of urban spaces. Such exercises of power privilege national narratives, civic virtues and grand strategies. But these accounts are increasingly questioned in the multi-disciplinary literature of urbanism in terms of the lives of dwellers, for whom urban experience consists of events rather than architectural forms. Corresponding to this is an emerging literature of the architectural everyday[3] informed by perspectives from Marxism, feminism and ecology. Amongst these, feminism contributes an affirmation of the personal in investigations of alternatives to the expectation that better cities are produced through professional methodologies derived from given (patriarchal) structures of power.[4] Cities, then, are sites of contended ownership in which the production of space is a 'human sensuous activity'.[5]

But imagery of the dominant city still permeates urban representations. Postcards of city views replicate an idealised city that bears little relation to the everyday experiences of its dwellers. These images are ubiquitous and commonplace, and the concept of the city they affirm is lent credibility by the normalisation they construct. To investigate such material is not to argue for an alternative genre of postcards depicting launderettes, bus stops and kitchen sinks (though this would be interesting); the point, here, is to use postcard images as a way into a theoretical territory from which to ask to whom does the image of the city belong, and why should that matter?

City views

Postcards depict dominant narratives and state dominant values. A postcard of New York might show the twin towers of the World Trade Centre flanked by older, lower skyscrapers reflected in a suitably calm Hudson River; or the Statue of Liberty seen from the walkways of Battery Park City, with New Jersey

greyly lodged in the background, diminished through linear and atmospheric perspective in keeping with its status. New York is thus represented as a world-class city in a world the values of which are money and opportunity. Postcards tend not to add to their cheery messages that the distribution of such benefits is restricted.

Other cities, seeking new investment and recognition, whose authorities are aware of the relation of symbolic and money economies[6] – cities such as Birmingham, Leeds and Liverpool – use images in promotional material and postcards which follow the stereotypes set by their more glamorous competitors. Birmingham is portrayed as a city of culture, with its Convention Centre, Hyatt Hotel and new public art alongside monuments referencing its nineteenth-century prowess. Leeds, not known as a waterfront city, still finds a development of waterfront lofts in Brewery Wharf through which to be likened to London Docklands, Cardiff Bay and Battery Park City. And Liverpool has the culturally led regeneration of Albert Dock, site of Tate Liverpool, a museum of slavery, and some expensive apartments.

The realities of, say, Birmingham are, of course, more complex and difficult to define than the city's postcard representation. Even a multiple-view card seems to say the same thing with each compartment. These are the kinds of image available from kiosks in railway stations and airport concourses, newsagents and tourist shops, convenient to send a message home but also emblems that inform memories of a city. In time, the postcard image might stand for a memory otherwise difficult to recall, as the family snapshot serves as a prompt for conversations in the absence of experiences lost in time. These images contribute to the normalisation of the city's dominant image, yet in a way which seems so trivial as to be harmless. But, if statues and the architectural forms of public buildings and monuments condition constructions of national and civic identity, postcards are contributors to the same story. When they take the city, or city form, as a metaphor for change, then the change projected is that of the global city of enclaved development and information superhighways, the city of late capitalism.

In this context, the publicity material for London Docklands in the early 1990s used images of a waterside vista, trading on the mythicisation of a

Thames which once ran sparkling clear and is now a place for sailing and messing about in old Thames barges with rust-red sails, even windsurfing.[7] What is striking is not the gap between the hype and the reality, but the appropriateness of the hype to an architectural reality of surfaces in a site from which all histories have been erased.[8] Collectively, such images constitute the vocabulary of a conceptualisation of the world's cities as *the* city: a site of affluence, ease and visual elegance. In such places, how could you not have a great time?

A contrasting, literary representation of cities is given by Stephen Barber. The short texts of *Fragments of the European City* [9] are not linked to precise locations. Their portrayal of Berlin and Belgrade is thematic, but each text plucks and elaborates an idea from the mesh of impressions produced by the writer's urban travels and is thus rooted in experience. Whilst postcards unify the city according to a set of prototypical scenarios, Barber's texts seek a more difficult identity. He begins: 'The European city is a hallucination made flesh and concrete, criss-crossed by marks of negation: graffiti, bullet-holes, neon.'[10] Later, writing of demolition sites: 'Demolition of the city's elements strengthens what remains, and also strengthens the sense of a vital damaging through which the city takes its respiration.' He continues: 'The visual arena of the city must move through concurrent acts of construction and obliteration, extrusion and intrusion, incorporation and expulsion.'[11] Barber's city and the postcard image are products of culture, mediated, distanced from the everyday. Yet for Barber distance offers criticality, for the postcard affirmation of the dominant city. The postcard photographer, often anonymous, is not paid to participate in aesthetic discourse.[12]

Visual concepts

The postcard privileges the visual sense as a means of interpreting a city, and reduces cities to their representation in keeping with a given conceptualisation. The postcard, then, has a function similar to that of the monument in the production of disciplined publics.

fig. 3
Victoria Square, Birmingham
postcard
(by permission, © J. Salmon Ltd.,
Sevenoaks, Kent)

Both aspects could be normalised. It is common sense that postcards, being mediations by two-dimensional, photographic images, stand for a memory or projection of a city in visual form. Promoters have not tried the postcard that can be eaten or smelled, though these might be intriguing. Since the visual memory survives with the aid of reproduction after tactile and aural memories fade, it will tend to a privileged status. Similarly, since postcards are usually photographic, they depend on the technology of the lens, sweeping across the skyline in a panorama, or homing in on something interesting. But this is culture, and there is nothing natural about it. Not only does the photographic viewpoint itself represent a technology and ideology of modernity, but the selectivity of the image and its framing are acts of determination. The skyline, for instance, eliminates the spatial diversity of its components as a metaphor for other kinds of reduction. The point is not that images are any more or less effective, or appropriate, aids to memories of experience than textures, sounds, smells, or tastes; it is that modernist culture gives the visual a special status. And the more a city is projected through the visual means of photographic images, architectural drawings and conventional city plans, the more its reality is subordinated to the conceptual representation which graphic means convey. The city thus becomes in these images a fantasy.[13]

Doreen Massey links the privileging of the visual sense in modernism with a way of seeing 'from the point of view of an authoritative, privileged and male, position'.[14] She argues that the visual is privileged precisely because it offers detachment, 'the sense which allows most mastery'.[15] The distant viewpoint of many postcard images supports this point . The conventional city view and the city plan are elements in the possession of the city and its objectification by what might be termed the 'planning gaze'.[16] This gaze unifies disparate elements of urban form, whilst reducing human participants in its spectacle to a role equivalent to the figures in an architectural model.

Distance – a city seen either from its ramparts, through a viewfinder, or television, or through the windscreen of a car – makes possible the separation of the visual from other senses; visuality then constructs its objects as dematerialised signs. Amongst these, monuments have (as constructed

BIRMINGHAM

in the imaginations of urban and tourist publics) a particular place. Marina Warner writes of the Statue of Liberty and the Eiffel Tower that: 'They are in the first place expressions of identity: Paris' sign has become the Eiffel Tower …'[17] The use of such signs is to conceal rather than reveal meaning. Often, their political histories are subsumed in their adoption as landmarks. Nelson's Column, for instance, is a monument to victory by reformist England over revolutionary France, and the hub of a reconfiguration of the surrounding neighbourhood as a series of utopian vistas. To make way for this nineteenth-century form of enclaved urban development, the rookeries which housed poor people, who were hated (that is, feared) as much as the French and demonised as criminals, were destroyed. With unintended irony, the Statue of Liberty, to take another example, was unveiled a year after the first laws were

fig. 4
Skyline, Washington, DC
postcard
(The Postcard Factory, Toronto)

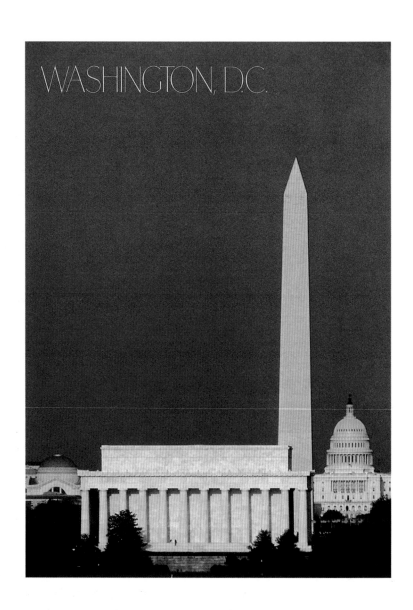

passed restricting immigration by Chinese labourers to the USA. Warner notes the softening in illustrated books of the Statue's face, in contrast to its 'upright and unmerciful' aspect.[18]

The Statue of Liberty conveys a mythicised freedom contradicted by the histories of the society in which it stands. It legitimises that society by allegorical allusion to a founding principle. The Washington Monument works in a slightly different way. Taking the form of an Egyptian obelisk, it lends one of the newest societies in the world, constructed in a most brutal way at the cost of native people's lives and wilderness destruction, an aura of time, a suggestion of universal cultural value and inevitability.[19] Being abstract in form, its metaphor is its purity, the lack of decoration through which it expresses a kind of ur-statement which is, however, specific to modernity in a city and state which has no pre-modernity. In the postcard image, the night sky becomes the absolute aesthetic space in which to contemplate this pure form, as value-free as the white walls of a gallery. Washington DC, and the monument to its eponymous founder, is thus a pure statement of civic values. Yet infant mortality, for example, is currently higher there than in Cuba.

The contradictions of the monument and the selectivity of the postcard view indicate a privileging of a single concept of the city over a multiple actuality. This parallels the privileging of the visual over other senses and is enabled by it. It is through the visual media employed in architectural design and urban planning that city form is brought into conformity with its dominant conceptualisation. A critique of representations of cities entails interrogation of these professional ideologies.

To speak of the city as concept and form is, anyway, to make an artificial separation. A more useful comparison is between city form and its occupation. The limitation of some progressive writing on cities, notably by Kevin Lynch,[20] is that it seeks to define a good city as one that has been well designed. Good design may include elements of so-called informality, just as pictorial composition in the Academies included balanced asymmetry, but informality cannot be designed, and design does not admit the acts of appropriation which construct a sense of emotional ownership. Lynch writes of the informal industries of recycling that have emerged amidst the

demolitions of Manhattan: 'It is a landscape of ruins, like medieval Rome [but unlike Rome] it is also a healthy and comfortable place, and not oppressed by history.'[21] This sits uneasily with the social history of, say, the construction of the South Bronx Expressway.[22] And when he writes of paths and junction nodes, these are given identity 'not only by their own form … but by the regions they pass through, the edges they move along, and the landmarks distributed along their length.'[23] The emphasis is on form as an autonomous entity, and the outcome is an aestheticisation of the city that inhibits engagement with its social production.[24] Lynch remains, however, a key figure in urban design.

For Henri Lefebvre, in contrast, city spaces are produced in society and their meanings derived from social interactions. In *The Production of Space* he sets out three categories for the discussion of urban space which have been widely taken up as spatial practice, conceived space and experienced space.[25] Applied as a framework for a critique of postcard representations of cities, the postcard illustrates conceived space – in Lefebvre's terms 'representations of space [that is] the space of scientists, planners, urbanists … the dominant space in any society …'[26], whilst the realm of experiential space – 'representational spaces [that is] the space of "inhabitants" and "users" … the dominated – and hence passively experienced – space which the imagination seeks to change and appropriate',[27] is seldom granted visibility.

Lefebvre links the homogenised space of modernist architecture to the Cartesian tradition, adding that it is also 'unfortunately … the space of blank sheets of paper, drawing boards, plans, sections, elevations, scale models, geometrical projections, and the like.'[28] Ken-ichi Sasaki, in a critique of western aesthetics, also links Cartesian space to visuality, citing Descartes' well-known passage from the *Discours* of 1637, in which he contrasts the merits of buildings designed by a single architect with the mess of old cities adapted by many hands.[29] Sasaki writes: 'The essence of the Cartesian city consists in the geometrical principle which unifies and dominates the totality of the city, and which excludes all forms of contingency from its urban space.'[30] Reality is reduced to its representations in systems of signs. In a

society in which the visual is privileged, and in which structures of power enable the construction of utopias, conceived space becomes dominant over lived space to an oppressive degree. Hence the fascination of demolition sites.

Other cities

The city of lived space never disappears. It re-emerges in urban graffiti, the addition of Georgian-style doors, porches and stone-cladding to houses as a mark of ownership, and in street parties and political demonstrations. A simple act, such as posing for a family photograph beneath a war memorial – a child's hands raised in delight under the darkly swooping eagle of the United States – begins to undo the dominant city. The mass placing of flowers along the Mall in London after the death of Princess Diana can be seen as an act of reclaiming public space from its monumental, controlling function. The sentiments and the means through which they were expressed may have been drawn from a restricted vocabulary, sometimes trashy, but for a week or so spaces within the city's monumental zone were occupied by ordinary citizens making shrines. When empty buildings are squatted or open spaces occupied, lives can become transgressive.[31] That the lives of dwellers become a feminine other to the city follows from the conceptualisation of the city in representations of space. Ordinary lives are messy; only the city as vista and plaza conveys the perfection of Descartes' 'regular places',[32] perhaps as a defence against a split-off aspect of the (masculine) subject which constitutes itself through an objectification of all it perceives.

Aestheticisation is integral to the Enlightenment city as a site of order and display from which unruly elements, such as the vagrant, insane and dissenting, are removed, and seductive elements confined to certain quarters. This parallels the process of Descartes' thought in which the sense-impressions of the body are discounted in favour of mathematical certainty. It is a process, intellectually driven, of purification, of exclusion of dirt from the visible city and its confinement in institutions and other secreted spaces. Michel Foucault[33] and Ivan Illich[34] have each written on changing practices

fig. 5
A family group at the
East Coast Memorial,
Battery Park, New York
(photograph: author)

of burying the dead, which resulted, by the nineteenth century, in the establishment of cemeteries at the margins of cities. The commission appointed in Paris in 1737 to study the problem of the aura of the dead was not concerned with the appropriateness of the churchyard as a site for the resurrection of the flesh; it feared contamination. Foucault writes: 'The dead, it is supposed, bring illnesses to the living, and it is the presence and proximity of the dead ... that propagates death itself';[35] and Illich: 'The presence of the dead was suddenly perceived as a physical danger to the living.'[36] The production of cities as centres, then, with margins of otherness, of which the treatment of the dead is one element (and the poor another), is part of a conceptualisation of the city as pure form. The city is pure because it has been purged; its form is an object of formal rather than social relations. These, however, normalise relations of power between classes and genders.

The relation of art to the city, given art's post-Romantic status as avant-garde, might be seen as one of problematising such power relations and their spatial manifestations. Art is seen as a location for the new; autonomous of social conventions it is free to say anything. Can art challenge urban injustices whilst the postcard and the tourism poster are complicit in the dominant city?

At certain times, such as the years immediately following the October Revolution in Russia, some artists developed ways of working with mass publics to arouse revolutionary consciousness. In the late 1960s, again, some artists adopted media which refused commodification to make art against the US war in Vietnam and the art market. Yet, as Martha Rosler writes: 'The anti-institutional revolt was unsuccessful.' She adds that the 'mass culture machine' has redefined structures of cultural meaning 'so that patterns of behaviour and estimations of worth in the art world are more and more similar to those in the entertainment industry ...'[37] But if mainstream art at the end of the 1990s is either discreetly self-referential or cynical, does the growth of art in public rather than gallery sites offer a means to reconstruct cities according to the values of an alternative society?

Birmingham has made more investment in art than most UK cities. During the late 1980s and into the 1990s, it redesigned its centre as a series of linked

fig. 6
Child's toy on a tree,
The Mall, London after the
death of Princess Diana
(photograph: author)

pedestrian areas flanked by Victorian civic buildings and decorated with
public art. It is of two kinds: the 3-acre brick paving scheme and integrated
designs for street furniture, by Tess Jaray and Tom Lomax, in Centenary
Square; and monumental sculptures, by Raymond Mason in Centenary
Square, and Antony Gormley and Dhruva Mistry in Victoria Square. These
squares and their sculptures are now depicted in postcards available at New
Street station.

What has happened in Birmingham is the construction of a new central
business district disguised as a cultural centre. According to recent studies,[38]
the intention behind the new squares was part of a plan to attract inward
investment. This has produced an economy which has few benefits for local
people. Although the convention centre and associated business services are
commercially successful, questions remain as to whose city has been
reconfigured.[39]

Ownership and the urban imaginary

Why should all this matter? Because the contradictions implicit in dominant
conceptualisations of the city (exemplifying the contradictions of late
capitalism) are so evident as to bring the viability of cities as the primary
form of human settlement into question.

Whilst postcards promote cities as attractive places, the images of news
broadcasts convey violence. Widening differentials of wealth and access to
housing, healthcare, education, transport and culture – put into sharp focus
by developments such as Canary Wharf and Broadgate in London – suggest
an abandonment of liberal society. The notion that cities can endlessly
expand, stamping ever-larger footprints of consumption on the surrounding
land (now a global exercise) is no more sustainable than, and part of, the
notion of an ever-expanding economy.

But what, as someone once said, is to be done? Can widely reproduced
images, of which the postcard is one type, contribute to the creation of
a possibility for radical social change? Luce Irigaray writes of the gendering

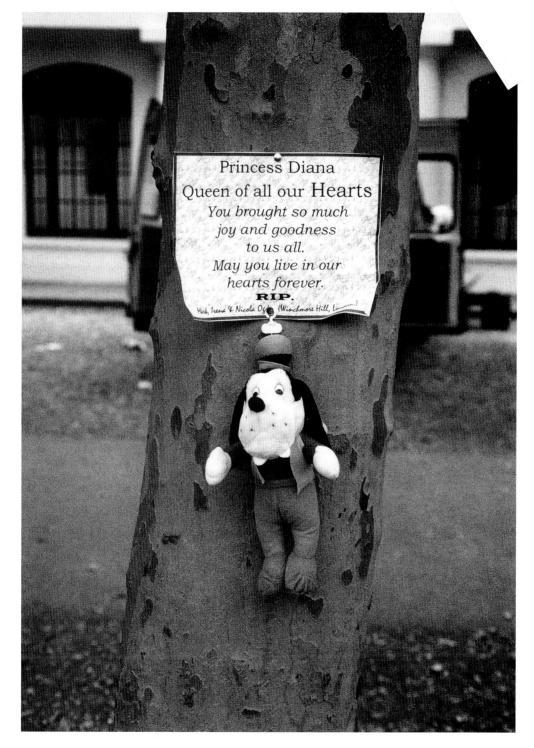

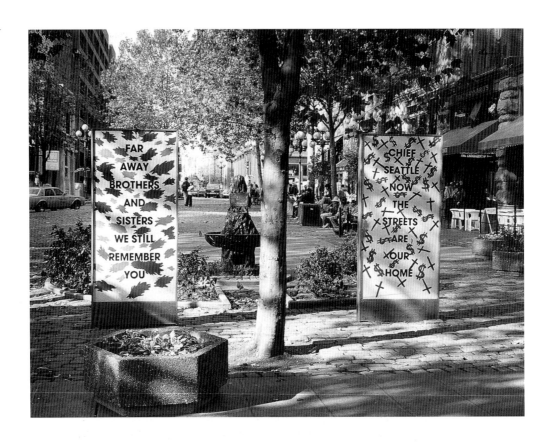

fig. 7
Hachivi Edgar Heap of Birds
Day/Night
1991, Seattle
(photograph: author)

of language as an aspect of patriarchy. To undo this, she recognises, is a long process. More immediate, she claims, would be a visual display which reasserted the feminine: 'To anyone who cares about social justice today, I suggest putting up posters in all public places with beautiful pictures representing the mother-daughter couple ...'[40] Irigaray is writing polemically, drawing attention to the lack of such images in western culture.[41] But, 'Such representations are missing from all civil and religious sites. This is a cultural injustice that is easy to remedy. There will be no wars, no dead, no wounded. This can be done before any reform of language, which will be a much longer process.' This suggests the construction of a new narrative through which people, especially but not only women, might project a new role and place in society. According to Arran Gare, writing on environmentalism, 'we only know what to do when we know what story or stories we are part of'.[42] The narrative written by monuments, public art, most postcards and tourist posters, like the conventional city plan, is one the subject-citizen is required to accept. Irigaray, in a simple verbal gesture, offers a vision of a narrative written by its participants for themselves.

Richard Sennett felt his way towards such a possibility in 1970, in *The Uses of Disorder*: 'To make modern cities serve human needs ... planners are going to have to work for the concrete parts of the city, the different classes, ethnic groups, and races it contains. And the work they do for these people cannot be laying out their future ...'[43] He envisages cities made by their inhabitants. To state this more in Lefebvre's terms, dwellers will reclaim their right to the city through the production of space. An example is the development of Coin Street on the south bank of the Thames, between the Festival Hall and the new Tate at Bankside. Here, an association of tenants controlled the development and even chose the developer after the Greater London Council, in one of its last acts, imposed planning controls to preserve the site for social housing. The message of Coin Street, architecturally and socially, is that inner city areas can be revitalised through mixed uses in which ordinary dwellers are not marginalised.[44] This is not the aspiration communicated by grand civic and heritage schemes such as Victoria Square, Birmingham.

Far away, in Pioneer Square, Seattle, another heritage site was recoded in 1991 by two graphic steel enamel panels. Native American artist Hachivi Edgar Heap of Birds took the words of Chief Sealth, from whom the land of the city that muddles his name was taken by treaty in the nineteenth century, to restate a presence of indigenous peoples. Pioneer Square is the oldest part of Seattle, and its redundant warehouses have been redeveloped as tourist markets. But perhaps these texts (in Lushootseed on one side, English on the other) are more poignant than a postcard, though they could be easily reproduced in that medium.

The city of the conventional postcard view is the city of affluence and power. The current political and economic realities of this city are not sustainable, and perhaps as new models of urban regeneration – a term distinct from development – reclaim the right to the city of its inhabitants, in process translating 'the city' into 'cities', so a new kind of representation will follow. This is not to say that images of non-affluent, non-utopian vistas such as Shadwell will replace those of more privileged sites in the postcard racks at London City Airport. It might be, however, that the production of representations of cities becomes part of a visual culture reclaimed by publics who today are seen only as its consumers.

fig. 8
Shadwell, East London
(photograph: author)

NOTES

1. Georg Simmel, 'The Metropolis and Mental Life' [1903], in N. Leach (ed.), *Rethinking Architecture* (London, Routledge, 1997), pp. 69–79.

2. John Rennie Short, *Imagined Country* (London, Routledge, 1991), p. 41.

3. Recent publications include Steven Harris and Deborah Berke (eds), *Architecture of the Everyday* (New York, Princeton Architectural Press, 1997); Sarah Wigglesworth and Jeremy Till, 'The Everyday and Architecture', Profile 134, *Architectural Design*, July–August 1998; Iain Borden, 'Body Architecture: Skateboarding and the Creation of Super-Architectural Space', in Jonathan Hill (ed.), *Occupying Architecture* (London, Routledge, 1998), pp. 195–216. The scope of these texts ranges from the construction of informal settlements in non-industrialised countries to informal activities, such as skateboarding, through which dwellers reclaim space in the cities of the industrialised countries.

4. In feminist critiques of the city, narratives tend to be in the first person. For instance, Elizabeth Wilson begins *The Sphinx in the City* (Berkeley, University of California Press, 1991) by recalling journeys to the metropolis with her mother. Doreen Massey remembers seeing acres of boys' football pitches on childhood journeys into Manchester by bus, *Space, Place & Gender* (Cambridge, Polity, 1994), p. 185. In 'My Mother Lives Now in a Nursing Home', Massey writes of 'an unseen city which can be felt, smelled, heard' and of 'local landscapes of sound and touch', in Iain Borden, Joe Kerr, Alicia Pivaro and Jane Rendell (eds), *Strangely Familiar* (London, Routledge, 1996), pp. 72–76. In 'Doing It, (Un)Doing It, (Over)Doing It Yourself: Rhetorics of Architectural Abuse', Jane Rendell writes of the transformations of a house in which she once lived, of its piecemeal patching-up with waste materials, and of recycling as evidence of 'a desire to subvert the system of consumption', in Jonathan Hill (ed.), *Occupying Architecture* (London, Routledge, 1998), pp. 229–46. The use of the first person rejects the viewpoint of distance through

which the city is aestheticised, and locates its voice within that from which it speaks.

5. See Karl Marx, 'Theses on Feuerbach' (1845) in Frederick Engels, *Ludwig Feuerbach* (London, Martin Lawrence, n.d.), pp. 73–75. For instance, 'The chief defect of all hitherto existing materialism … is that the object, reality, sensuousness, is conceived only in the form of the *object* or *contemplation* but not as *human sensuous activity, practice*, not subjectively.'

6. See Sharon Zukin, 'Space and Symbols in an Age of Decline', in A. King (ed.), *Re-Presenting the City* (London, Macmillan, 1996), pp. 43–59.

7. See Jon Bird, 'Dystopia on the Thames', figs 7.2 and 7.5 for illustrations of the promotion of a riverside lifestyle for London Docklands, in Jon Bird, Barry Curtis, Tim Putnam, George Robertson and Lisa Tickner (eds), *Mapping the Futures* (London, Routledge, 1993), pp. 120–35.

8. See also Fredric Jameson, 'The Cultural Logic of Late Capitalism', in Leach (ed.), *Rethinking Architecture,* pp. 238–47.

9. Stephen Barber, *Fragments of the European City* (London, Reaktion, 1995).

10. Barber, *Fragments of the European City*, p. 7.

11. Barber, *Fragments of the European City*, p. 29.

12. There are exceptions of signature postcards. For example the series of scenes in Cairo and other parts of Egypt by Maurice Subervie, whose signature appears (though discreetly) on the front of the card in the way a city's name is more often used. These cards depict what might be called ordinary life. In one case, a woman in black and two men stand in front of a barrow selling greens; behind the barrow between two small shops stands the vendor in his long Arab shirt. Old, faded posters decorate the space above one of the doorways. A broom is placed against the

side of the other. The cards are distributed by Readers' Corner Bookshop, Sarwatt Street, Cairo, and reproduction is 'forbiden' [sic].

13. See Henri Lefebvre, *The Production of Space* (Oxford, Blackwell, 1991), p. 361. Lefebvre describes the architect's representation of space as 'a medium for objects, an object itself, and a locus of the objectification of plans'. He sees its origin in 'the linear perspective developed as early as the Renaissance: a fixed observer, an immobile perceptual field, a stable visual world'.

14. Massey, *Space, Place & Gender*, p. 232. Massey cites Luce Irigaray interviewed in M. F. Hans and G. Lapouge (eds), *Les Femmes, La Pornographie, L'Erotisme* (1978); Craig Owens, 'The discourse of others: feminists and postmodernism', in H. Foster (ed.), *The Anti-Aesthetic* (Seattle, Bay Press, 1985); and Griselda Pollock takes John Harvey to task for failing to cite the work of John Berger in *Vision and Difference* (London, Routledge, 1988), p. 245, note 8.

15. Massey, *Space, Place & Gender*, p. 224.

16. Leonie Sandercock builds on Massey's argument: 'the mechanism through which the threat of violence [to women] is perceived – *the gaze* – is neither masculine nor feminine … the power of the gaze is that it is employed as a method of social control (for example in surveillance tactics)'. Sandercock continues that surveillance used in urban planning as a safeguard against violence can increase fears of violence, when women, aware of being watched, acknowledge the threat contained in the other's gaze: '… she not only legitimises the power implied by the gaze but also legitimises the reproduction of her violent fantasy, her city-fear.' See Leonie Sandercock, *Making the Invisible Visible: a multicultural planning history* (Berkeley, University of California Press, 1998), p. 223.

17. Marina Warner, *Monuments and Maidens* (London, Pan, 1987), p. 6.

18. Warner, *Monuments and Maidens*, p. 9.

19. An analogy is found in North American landscape painting in the nineteenth century, for instance in Asher B. Durand's *Progress* (1850) and George Inness' *Lackawanna Valley* (1855). For a critique of this genre see Angela Miller, *Empire of the Eye: Landscape Representation and American Cultural Politics 1825–75* (Ithaca, NY, Cornell University Press, 1993).

20. Kevin Lynch, *The Image of the City* (Cambridge, MA, MIT Press, 1960); and *Good City Form* (Cambridge, MA, MIT Press, 1981).

21. Lynch, *Good City Form*, p. 309.

22. See Marshall Berman, *All That Is Solid Melts Into Air* (London, Verso, 1983).

23. Lynch, *The Image of the City*, p. 84.

24. See also Rosalyn Deutsche, 'Alternative Space', in Brian Wallis (ed.), *If You Lived Here* (Seattle, Bay Press, 1991), pp. 45–66. Deutsche sees art history as structuring a single, aesthetic relation of art and the city, and an extension of this approach in urban studies, pp. 46–47.

25. For example by Doreen Massey in *Space, Place & Gender*, pp. 250–55 (in which Ernesto Laclau is also considered); by David Harvey in *Justice, Nature and the Geography of Difference* (Oxford, Blackwell, 1996); by Edward W. Soja in *Postmodern Geographies: The Reassertion of Space in Critical Social Theory* (London, Verso, 1989), and in *Thirdspace: Journeys to Los Angeles and Other Real-and-Imagined Places* (Oxford, Blackwell, 1996).

26. Lefebvre, *The Production of Space,* pp. 38–39.

27. Lefebvre, *The Production of Space*, p. 39.

28. Lefebvre, *The Production of Space*, p. 200.

29. Ken-ichi Sasaki, *Aesthetics on non-Western Principles. Version 0.5* (Maastricht, Jan Van Eyck Akademie, 1998), pp. 44–47.

30. Sasaki, *Aesthetics on non-Western Principles*, p. 44.

31. See Neil Smith, *The New Urban Frontier* (London, Routledge, 1996) for an account of the occupation of Tompkins Square Park, Manhattan during the early 1990s.

32. René Descartes, *Discours de la methode* [1637], translated by E. S. Haldane and G. R. T. Ross, in *The Philosophical Works of Descartes* (Cambridge, Cambridge University Press, 1911), pp. 87–88. This is the translation used by Sasaki – see note 30.

33. Michel Foucault, 'Of Other Spaces', *Diacritics*, spring 1986, pp. 22–27. Reprinted in Nicholas Mirzoeff (ed.), *The Visual Culture Reader* (London, Routledge, 1998), pp. 237–44. The text is based on a lecture delivered by Foucault in 1967.

34. Ivan Illich, *H$_2$0 and the Waters of Forgetfulness* (London, Marion Boyars, 1986), pp. 50–51.

35. Michel Foucault, 'Of Other Spaces', in Mirzoeff (ed.), *The Visual Culture Reader* p. 241.

36. Illich, *H$_2$0 and the Waters of Forgetfulness*, p. 50.

37. Martha Rosler, 'Place, Position, Power, Politics', in C. Becker (ed.), *The Subversive Imagination* (London, Routledge, 1994), pp. 55–76. Rosler's critique, based on her own experiences, can be compared with Jameson's remarks that 'aesthetic production today has become integrated into commodity production generally: the frantic economic urgency of producing fresh waves of ever more novel-seeming goods …' See Fredric Jameson, 'The Cultural Logic of Late Capitalism', in Leach (ed.), *Rethinking Architecture*, p. 240.

38. Patrick Loftman and Brendan Nevin, 'Pro-growth Local Economic Development Strategies: Civic Promotion and Local Needs in Britain's Second City', in Tim Hall and Phil Hubbard (eds), *The Entrepreneurial City* (Chichester, Wiley, 1998), pp. 129–48.

39. For an extended form of this argument, see Malcolm Miles, 'A Game of Appearance: Public Art and Urban Development – Complicity or Sustainability?', in Hall and Hubbard (eds), *The Entrepreneurial City*, pp. 203–25.

40. Luce Irigaray, *Thinking the Difference* (London, Athlone, 1994), p. 9.

41. This point seems to have been misunderstood by Christine Battersby, who cites a version of the same text and comments: 'this treatment of art as mere propaganda cannot be excused'. Christine Battersby, 'Just jamming: Irigaray, painting and psychoanalysis', in Katy Deepwell (ed.), *New Feminist Art Criticism* (Manchester, Manchester University Press, 1995), pp. 128–37.

42. Arran Gare, *Postmodernism and the Environmental Crisis* (London, Routledge, 1995), pp. 139–40.

43. Richard Sennett, *The Uses of Disorder* [1970] (London, Faber & Faber, 1996), p. 102.

44. A reference that might be expected here is the work of Dolores Hayden and a multi-disciplinary team called Power of Place in Los Angeles. However, these projects seem often restricted to secondary interventions, making monuments to invisible histories as a means to constructing minority cultural identities, but seldom leading to the use of such identities to change the political and economic conditions of the city. See Dolores Hayden, *Power of Place* (Cambridge, MA, MIT Press, 1995).

Mess is More

ROBERT VENTURI AND DENISE SCOTT BROWN

Chaotic integration and its valid aesthetic

Chaotic integration constitutes perhaps an ultimate oxymoron characteristic for our time.

What I write on the subject of East and West involves distinct limitations: 1) I write as an architect, not an anthropologist; 2) I write about the East via perceptions and intuitions evolved from travelling and working specifically in Japan during the last few years; and 3) I focus on architecture and urbanism as cultural exemplars.

It can be said the Western cultural landscape, urban and rural, evolves more or less consistently within its own ethos – containing its own integral parts and at least until recently little subject to outside influence. It is thereby essentially unified – albeit sometimes fragilely as when historically Latin and Nordic subcultures were juxtaposed or currently when American commercial vernacular challenges Euro-American highfalutin.

Of course, until the mid-nineteenth century, the Japanese cultural ethos was more purely contained and totally unified than even any regional or

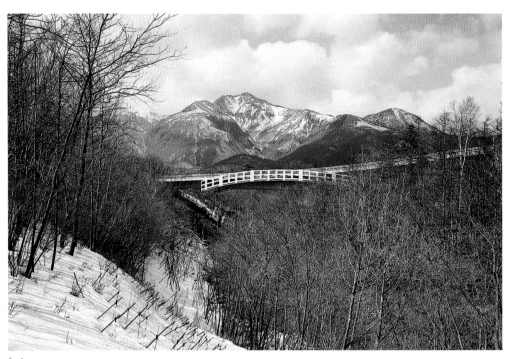

fig. 1
View of entrance bridge,
Hotel Mielparque Resort
Complex, Nikko, Kirifuri

Kawasumi Architectural
Photograph Office, Tokyo

fig. 2 [opposite]
Aerial view,
Hotel Mielparque Resort
Complex, Nikko, Kirifuri

Kawasumi Architectural
Photograph Office, Tokyo

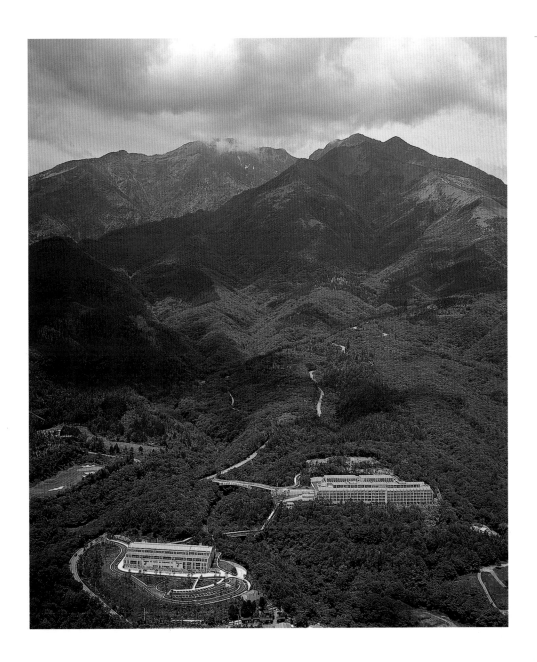

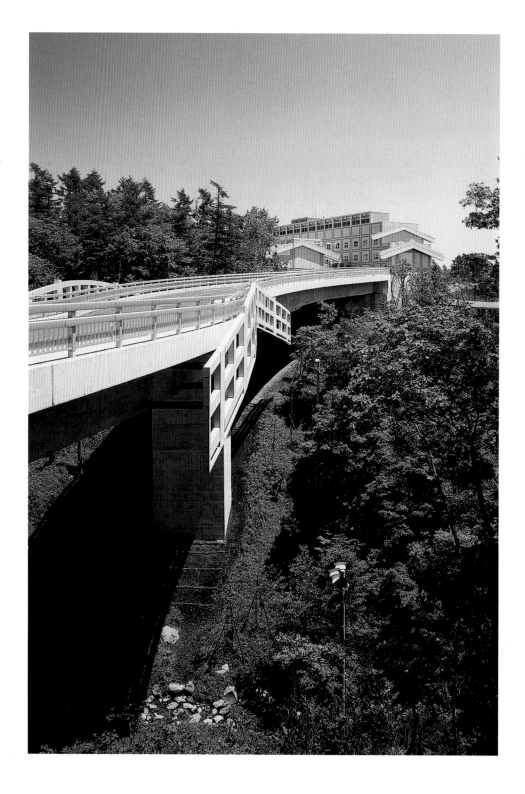

fig. 3 [opposite]
View of entrance,
Hotel Mielparque Resort
Complex, Nikko, Kirifuri
Kawasumi Architectural
Photograph Office, Tokyo

fig. 4
View of entrance,
Hotel Mielparque Resort
Complex, Nikko, Kirifuri
Photo Kosuge, Tokyo

national subculture in the West. But since then, as a result of increased opportunity for, and volume of, trade and travel and of abilities to communicate via new technological means – as well as of Japanese cultural receptiveness – since then and especially in post-World War II Japan – all hell has broken loose. And what has happened has made Japan – especially exemplified by the city of Tokyo – *the* city most relevant and revealing for our time. It's no longer Paris for its formal/spatial and symbolic unity or New York for its technical grandeur but cultural consistency or even Los Angeles for its relevance as the spatial automobile-city of today involving commercial vernacular grandeur but, again, cultural consistency. It is Tokyo exemplified by integrated chaos involving sublime relationships engaging complexities and contradictions, and juxtapositions and ambiguities of scale, space, form and especially cultural symbolisms.

There is no question concerning Japan's original genius for a cultural system, deep and broad within its dimensions, but also exclusive, and its current genius for acknowledging what we call multiculturalism – for adopting and adapting foreign influences and for juxtaposing them in creative ways that create chaos valid for today.

And there is no question concerning the relative exclusivity of an essentially single Western culture – granted that within its wide boundaries encompassing and dominating several continents via colonialism and imperialism there exist within its multiple components rich variations evolving from cultural evolutions and revolutions, regional and national – not to mention occasional exceptions like chinoiserie and japonaiserie – that prove the rule. And there are within the makeup of Western culture the recent and current aesthetic movements promoting abstraction over symbolism and iconography, and Minimalism and Purism over complexity and contradiction, all of which promote universalism as an ideal – one ideological/cultural system for all over – as in, in city planning, Le Corbusier's Ville Radieuse and Frank Lloyd Wright's Broadacre City – ultimate if contrasting simplistic impositions as universalist ideals: *à bas* pragmatism, *vive* unity!

At the same time, *we* invent the Los Angeles strip while we despise it. We are ashamed of the supposed vulgarity and materialism inherent in our commercial vernacular architecture teeming with symbolism and iconography which is disdainfully called signage – while *they* adopt it and adapt and juxtapose it with exquisite skill. We also invent Las Vegas as the ultimate commercial strip but soon turn it into 'tasteful' Disneyland while they create neon/sparkling Pachinko parlours as twentieth-century equivalents of *vitraux* sparkling cathedrals of the Gothic period.

We also invent electronic technology while reviving industrial expressionism to ornament our neo-Modern architecture while in this Post-Industrial Electronic Age and Information Age *they* employ LED to inform and ornament a vital commercial architecture. They are thereby neither afraid of iconography on architecture nor in bondage to abstraction in architecture. And they thereby adopt and adapt *the* craft art of our age as an element of our culture that we disdain and they juxtapose it joyously within their richly valid environment of chaos.

So *we* define multiculturalism as an ideal and *they* achieve it.
I end this essay with some quotations from earlier writing on the subject that highlight East is East and West is West but now the twain can meet – to create valid chaos integrated for our time.

Excerpts from 'Two Naifs in Japan'

Tokyo has its act together – though granted it is a chaotic act. The Japanese love to describe Tokyo as chaotic; the word for chaos in Japanese is adapted from the English. But is not this a convincing chaos or an order that is not yet understood? Or an ambiguity without anguish? Tokyo's chaos derives from the variety of scales, forms, symbols, and rhythms of:

- its buildings, and from its dense juxtapositions of patined village dwellings and global corporate high-rises in the latest architectural styles

- its macro and micro businesses; some in 'pencil' buildings 12 feet wide and ten storeys high, which, from 1950s Modern to the latest Decon outrage, exhibit a genius for the bold and the miniature; others at a multinational scale, set in vast urban renewal landscapes that are more used and better seamed into the city than those in America

- its juxtapositions of cultures, where the global organisation and the traditional decorative hairpin are accommodated with equal elegance; there is room for not one but many taste systems, and architecture is perhaps freer and more varied than anywhere else in the world

- its Pachinko parlours containing slot machines and outrageous blinking neon chandeliers, packed in and reflected to infinity via mirrored walls and ceilings. These are adjacent to the most sophisticated and refined high-rise office buildings, or to boutiques containing the *haute couture* of Europe and Japan, in settings designed by Japan's most distinguished architects; these in turn are next to line-ups of Coke and other dispensing machines along the sidewalks

- its small urban shrines, tucked between stores on shopping streets

- its historical temples sometimes surrounded by gardens, and served by bazaars teeming with thousands of objects, mostly miniatures, irresistible in their craftsmanship, wit, and/or beauty

- its department stores crammed with high design and luxury items from Europe and Japan

- the going range of American fast food places

fig. 5
View from exterior of
village street, lobby, Hotel
Mielparque Resort Complex,
Nikko, Kirifuri

Koji Horiuchi, Tokyo

All of these appear in cock-eyed configurations and unimaginable juxtapositions in an urban infrastructure of straight streets and wide avenues lined with trees or regiments of commercial signs; or crooked lanes lined with utility poles draped with myriad wires; or elevated highways routed along and over water canals and even over the roofs of small houses whose fenced yards enclose the highway supports.

Then there are the electronically sophisticated signs defining the architecture of the city adorning buildings and lining streets. Tokyo signs are at least as brilliant and varied as those of Fremont Street in Las Vegas. Current Japanese architecture, too, outwits its Western equivalents in its unabashed vitality and joy. Architectural frivolity in the West today is skin-deep or laborious, that of this part of the East is sophisticated or naïve; like the high-rise held together with hexagonal 'screwheads', three feet wide and 18 inches deep, on its curtain walls. There were contemporary buildings that we liked in Tokyo or Kyoto that we could not accept elsewhere. In Tokyo, in their context, they dance a jig at a lively party. In other cities they would seem irresponsible intrusions in a decaying ethos. Pride makes the kitsch OK, and spirit makes the vulgar likeable.

The layout of Tokyo is constantly referred to as chaotic. It is said that the original plan of the city was designed as a maze to confound attacking armies approaching the grounds of the Shogun's castle, now the site of the imperial palace. This park-like complex, although its buildings are hidden, is one of the few elements that intimates any hierarchy in the formal and symbolic configuration of this enormous city.

If, in the chaos, there are, beneath the surface, rules of order that whisper rather than shout their presence, these possibly derive from the early technology of the city; from the spanning capacity of the light timbers that determined the widths of the rooms of houses, and the breaks and separations mandated for fire protection, and the small-scaled building elements needed for safety from earthquakes. These requirements of the pre-industrial era probably determined the fractionated subdivision and property ownership patterns of the traditional city. Upon this destroyed city, after World War II, a new city grew in one decade. It is this city, unified by its

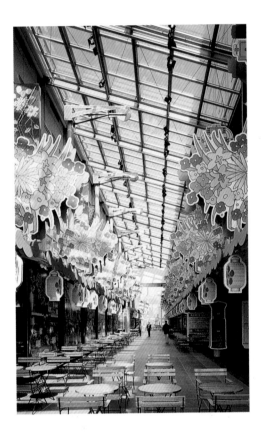

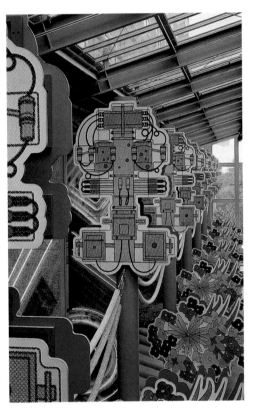

fig. 6 [opposite left]
Interior view of village street,
lobby, Hotel Mielparque
Resort Complex, Nikko,
Kirifuri

Kawasumi Architectural
Photograph Office, Tokyo

fig. 7 [opposite right]
Detail view of village street
transformers and flowers
overhead, lobby,
Hotel Mielparque Resort
Complex, Nikko, Kirifuri

Koji Horiuchi, Tokyo

1950s Googie architecture, that is now being renewed and upscaled by the demands of Japan's global economy. The results will be an overlaid pattern of different scales and types of urban configuration, reminiscent somehow of the patterns on a kimono or of the patterned and draped kimonos in a Japanese woodcut.

It is ironic that in Japan, a society known for its discipline, formality and rules of courtesy, architects are able to do things artistically that they would not be allowed to do elsewhere. The results, for example the recent Pop-Decon constructions in Tokyo, look better here than they would in Europe or America, forming, as they do, part of Tokyo's vivid and unique combination of the exotic and the familiar – and the almost familiar.

Yet, unique as Tokyo is, the architectural ethos we have described could evoke a number of cities in the world, especially prosperous trading cities with international ties, such as Venice, where an eastern-Byzantine flavour combined with 'modern' Renaissance and Baroque architecture; or nineteenth-century London, capital of a commercial empire, with an eclectic variety of architectural styles set in a medieval configuration of streets.

It is a further irony that the capitals of universal empires – imperial, commercial or financial – are not prone to universalist vocabularies in architecture, but are responsive to the multiplicity of their domains. The sublime exemplification of this tendency of mercantile empires to favour eclectic architecture is Edwin Lutyens' Viceroy's House in New Delhi. However, as the world becomes smaller, aspects of universality do evolve; today MacDonald hamburgers and Toyota cars are almost everywhere. But the combinations of universal elements may still be unique, rendered so by local conditions. In the overall, today's trends may lead to greater diversity rather than to similarity.

The Japanese are sometimes criticised for a lack of originality – their traditional art derives from that of Korea and China, many of their contemporary forms are based on Western technical and aesthetic prototypes. We do not have the knowledge to make any particular judgement of this kind, but we think the qualities we have been describing – those of care, skill, and spirit, along with an acceptance of diversity, are as much a part of artistic

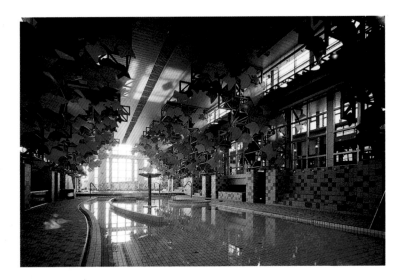

quality as is originality. And it is the combination of sophistication and naïvety, spirit and control, or 'discipline and ease' as George Santayana would have put it, that distinguishes this city and its art. It represents, perhaps, an aesthetic ethos that accompanies economic prosperity and high morale. In our reactions, we found ourselves constantly applying French words – *joie de vivre*, *jeu d'esprit*, *tour de force*, *élan*, *panache*, *arabesque*, *pastiche*, *incroyable* – to these eclectic urban juxtapositions of symbols, forms, scales, civilisations, and patterns. Our own made-up phrase, 'valid deconstructivism', seemed to define this curious urbanism.

Decon works for cities; it is more natural to cities than to buildings, because cities don't have to keep the rain out or the warmth in (or out) and because cities are not built all at once but incrementally, now that we have no princes but only individuals and committees as builders.

On only his second day in Tokyo, Robert Venturi found himself saying to an audience of architects, 'Love your city, for its spirit and reality which are immediately evident; embrace and don't resist the contradictions and tensions these elements provoke.' For us, this urban complex without hierarchy or perceptual order was perhaps the first valid manifestation of architectural,

fig. 8
View of interior of spa,
swimming pool,
Hotel Mielparque Resort
Complex, Nikko, Kirifuri
Photo Kosuge, Tokyo

fig. 9 [overleaf]
View of interior of spa,
restaurant area overlooking
swimming pool,
Hotel Mielparque Resort
Complex, Nikko, Kirifuri
Koji Horiuchi, Tokyo

or rather, urban Deconstructivism; one that represented not 'the incoherence or arbitrariness of incompetent [art] nor the precious intricacies of picturesqueness and expressionism [but] the richness and ambiguity of the modern experience…'.[1]

What you see in contemporary Tokyo and historical (and contemporary) Kyoto is an accommodation to and a celebration of the realities of our time and its tensions (we forgot to mention the monumental traffic jams); to the plurality of cultures promoted via global communication and flourishing side by side; to the diversity and quantity of overlapping taste cultures (nine symphony orchestras in Tokyo alone) – these complexities and contradictions and the resultant ambiguities lead to a richness of effect and a spirit that are the fate, and should be the glory, of the art of our time. In our art today, it should not matter if you don't like it all, if this detail isn't quite right, isn't quite to your taste: such tensions between what you like and dislike should, in the end, heighten your tolerance *and* your sensibility, and will allow the city to be 'chaotic' in its formal configuration, disciplined in the elements and maintenance of its infrastructure, overwhelming in the prominence of its detail *and* read as a capital of global business organisations.

Ultimately the remnants of those feudal street layouts, the value of the land and consequent inhibiting effects on the consolidation of land parcels, and the spirited growth of the era create real tension and evolve artful urbanism. We learn here from the combination of elemental reality in architecture and from the spirit in its craft.

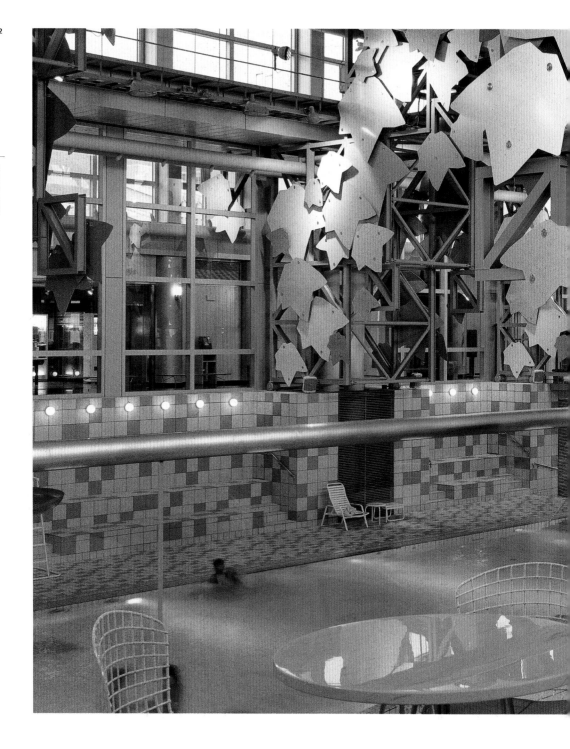

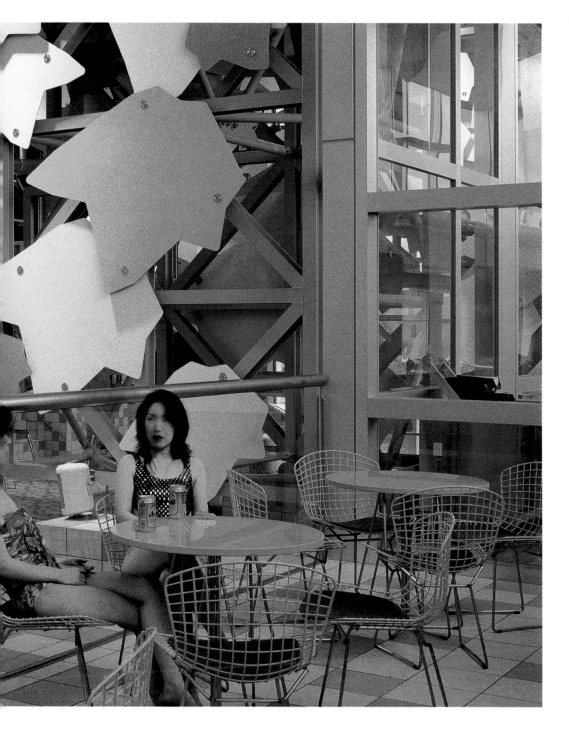

NOTES

Title credited to Philip Parsons. 'Chaotic Integration and Its Valid Aesthetic' by Robert Venturi was originally published in *Materia*, No. 28, June 1998, pp. 6–11. 'Two Naifs in Japan' by Robert Venturi and Denise Scott Brown was previously published in *Architecture and Decorative Arts: Two Naifs in Japan* (Tokyo: Kajima Institute Publishing Co., Ltd., 1991), pp. 8–24; the catalogue for the exhibition 'Venturi, Scott Brown and Associates', organised by Knoll International Japan; in *Louisiana Revy*, 35, no. 3 (June 1995), pp. 4–9, issue serving as catalogue for the exhibition 'Japan Today', Louisiana Museum of Modern Art, Denmark; and in *Iconography and Electronics upon a Generic Architecture* (Cambridge, MA and London, England, MIT Press, 1996), pp. 109–18.

1. Robert Venturi, *Complexity and Contradiction in Architecture* (New York, Museum of Modern Art, 1966; second edition 1977).

The New Centre
Architecture and Urban Planning in the Capital of the German Democratic Republic

JÖRN DÜWEL

From its establishment in the Soviet zone of occupation in October 1949 as the capital of the first 'Workers' and Peasants' State on German Soil' through the next 40 years, East Berlin was to be a socialist metropolis, redesigned through new architectural forms and urban structures to give spatial expression to the political power concentrated in the Socialist Unity Party of Germany (SED).[1] Walter Ulbricht, as General Secretary of the SED the most powerful person in the state, made this aim clear in his speech to the III Party Conference (*Parteitag*) of the SED: 'The city centre [should] acquire its characteristic image through monumental buildings and an architectural composition that [should] do justice to the significance of Germany's capital city.[2]

Ulbricht's ambition for East Berlin, though, was not a mere appeal. He envisioned the city as structured on a clear, hierarchical ordering principle, with the height of buildings increasing from the edge of the city towards the centre, like the shape of a pyramid, with a correlation between an increase in height and an increase in status. The centre itself should be reserved for prestigious state buildings and immense areas of open squares

fig. 1
Kollektivplan for
reconstructing Berlin
following the destruction
of the Second World War
developed by the
Planungskollektiv, a group
of architects headed by Hans
Scharoun in the Urban
Planning Office of the [East
Berlin] city council, 1946.

and thoroughfares in which political rallies demonstrating the people's
solidarity with the politics of the state could be held. From the beginning,
Ulbricht focused his attention on a 'Central Government Tower' – a
building to house the most important state agencies and dominate the
city. Sited on the Central Square, it would be an impressive backdrop for
mass parades.

For the construction of the 150-metre-high tower to proceed, however,
the former Royal Palace (*Stadtschloss*) of the Hohenzollerns had to be
demolished. Ulbricht believed that only after razing this culturally and
historically important building could the 'people's will to reconstruct' manifest
itself. The Palace had been damaged in the war but by no means destroyed;
it was nevertheless there and then declared a ruin. Demolition of the Palace
began the very hour that the law requisitioning the land passed on
6 September 1950.[3] Just a few months later the space needed to build the
Government Tower and ceremonial square had been created and work could
have begun. The SED decreed that 'the city centre is the *Lustgarten* (Pleasure
Garden) and the area where the ruined palace stood', and so nothing
prevented reordering the city's street plan.[4]

In the shortest time architects drew up plans for a new centre for the
capital of East Germany. In addition to the Central Building there were to be
buildings for political parties, mass organisations, nationalised industry and
embassies. The backbone of these schemes was a so-called central axis, which
ran from the Brandenburg Gate along Unter den Linden to the *Lustgarten* and
eastwards to Alexanderplatz. The core of this sequence of spaces was the
Central Square, for which a precise schedule of accommodation was drawn
up. And yet, although the designs were completed and the SED leadership
was pushing for rapid implementation, the demolition of the Palace was not
followed by the expected construction. The only thing the new leaders did
build on the extended square was a stone grandstand for 3,000 people.
Otherwise, little was realised of the ambitions to build the socialist centre
of a new capital city.

As early as autumn 1950 it was unclear whether the proposed design
would satisfy the high standards to be seen elsewhere, notably in Moscow,

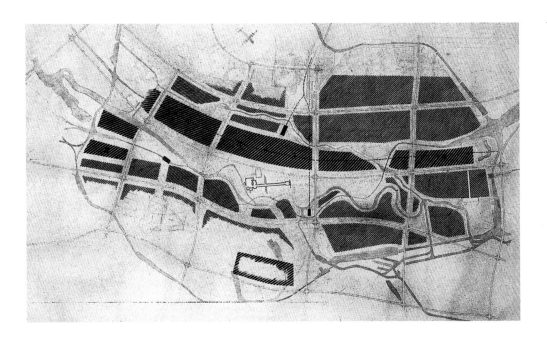

but caution in proceeding was also due to economic considerations. A major consequence of the devastation caused by the war was a housing shortage, particularly in the former capital of the German Reich which, in addition to allied air raids, suffered great losses in the 'Final Battle'. Throughout East Germany, reconstruction work began with residential buildings on the outskirts of cities. This first phase of development brought lively building activity in Berlin, but did not reach the centre until the mid-1960s. Anyone trying to track down public buildings in the centre of Berlin would have found fewest where the rousing programmes of the early years would have led them to expect the most. The area defined after the founding of the GDR as the political centre was developed very late, and even then only in fragments. The Central Building was never built.

The key institutions that were to have been concentrated in the Central Building had moved from temporary accommodation into existing buildings before the decision to build it had been taken. The SED itself took the first

step by establishing itself in the rambling complex of buildings that had formerly been the National Bank (*Reichsbank*). The 'House of Ministries' was situated in the former Aviation Ministry of the Reich (a fine example of Nazi architecture in which, incidentally, the founding ceremony of the GDR had taken place). Pragmatic considerations were paramount – only a small number of suitable office buildings had survived the War, and perhaps cultural sensitivity to the stony witnesses of the Nazi era was not very highly developed. The only new buildings constructed in the 1960s were for the Ministry for Foreign Affairs and the Council of State, neither of which achieved the symbolic power originally meant for the centre's development. It was not until the mid-1970s that the most prominent empty site in East Germany was finally built on, but instead of the Government Tower, it was the Palace of the Republic (*Palast der Republik*): a low building with a variety of uses – restaurants, entertainment facilities and cultural amenities – which became a lively, well-used meeting place. But its political programme had lost prominence.

The planning history of the centre of East Berlin is a catalogue of failed concepts and fragmentary development which reflects the development of East Germany itself. Generally little came of ambitious pronouncements and rousing promises; changes of political direction and economic restrictions often forced projects to be abandoned. None of the general urban plans passed were ever more than partially implemented, but it is possible to read different phases of policy in the halting development of the centre itself.

Moscow as a role model

The call for a separate architectural language for the reconstruction of East Berlin was made shortly after the GDR was founded. Although the Allies had given permission – just a few days after hostilities ceased in May 1945 – for German planning committees to be set up, they prohibited them from developing any binding proposals for the city's reconstruction until the status of the former capital of the Reich had been established. Nevertheless, a group

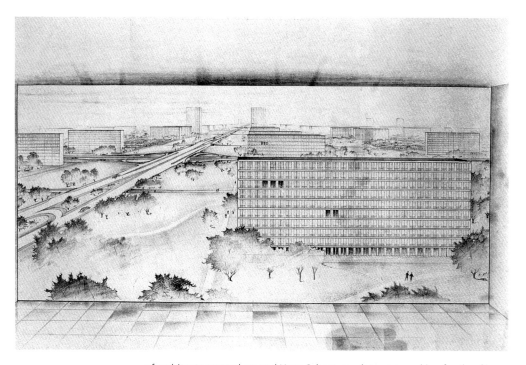

of architects centred around Hans Scharoun who were working for the city council drew up proposals for a new Berlin based on international, above all Western European models developed out of the Garden City tradition. In the summer of 1946, after 12 months of work, they presented their vision, bound to hopes of a political and moral renewal of the German people.[5] They proposed a Berlin fundamentally different from the stone tenement city of the nineteenth century, with its corridor-like streets and cramped courtyards. Instead, they would have left only a few buildings standing in the centre, as souvenirs of the past. At the opening of the exhibition, Scharoun said:

What remains after the bombing and Final Battle have carried out a process of mechanical opening up of the city, gives us the opportunity of making an urban landscape [in which] a new living system consisting of nature and buildings, high and low, closeness and distance will be created.

Landscape was the element that shaped what was in principle a new city, a 'city landscape' between the hills that stretch along both sides of the glacial valley of the River Spree. A new 'green centre' would become available to the public as a recreational space.[6]

But the chronology of the designs for Berlin's centre succinctly reflects the changes in both domestic and foreign politics. Certainly by 1948 differences between the Allies were becoming increasingly overt; unbridgeable conflicts

fig. 3
Design for the Government
Tower, the proposed Central
Building in Berlin.

between the occupying powers had led to the division of Berlin, and mutual hostility blocked any possibility of collaboration on planning the city. Just a few weeks after the GDR was founded with the connivance of the Soviet Union against agreements among the Allies, architects and politicians met in the newly established Ministry for the Reconstruction of the GDR to take over planning Berlin 'with immediate effect'. Lothar Bolz was appointed Minister for Reconstruction. He was a jurist with a Communist Party card who had fled from the Nazis to the Soviet Union, and had been active there from 1943 in the National Committee for Free Germany (*Nationalkomitee Freies Deutschland*), an organisation primarily made up of army prisoners of war that made plans for what would after the war become the Soviet zone of occupation (plans which he would have a part in implementing as East Germany's Minister of Foreign Affairs from 1953 onwards). On his return from exile Bolz founded and became leader of the NDPD (*Nationaldemokratische Partei Deutschlands*), and was under Stalin's instructions to use nationalist propaganda to gain broader-based support for the East German government's policies. In an emphatically patriotic tone, Bolz exhorted the people to see the reconstructed Berlin as the capital city 'of all Germans'. There was, however, no doubt as to the role model: 'It was suggested that we draw upon the great experience with reconstruction gained by cities such as Moscow and Warsaw'. It was decided to dispatch a German delegation to study the experiences of their Soviet and Polish colleagues, and to remove the competence of the city's local planning departments. The planning of Berlin had become a 'national matter' which was intended to influence West Germany too.[7]

The first months of 1950 were dominated by preparations for the study trip to Moscow, with increasing criticism of the plans drawn up by Scharoun and the city council: 'That kind of planning in which a suburban idyll is transposed onto the city centre is erroneous.'[8] Meanwhile, Kurt Liebknecht was sent from Moscow to Berlin with instructions to reorganise German construction along Soviet lines. A nephew of political martyr Karl Liebknecht, he had studied architecture in Berlin in the late-1920s, before going to the Soviet Union to become a specialist on the reconstruction of their cities;

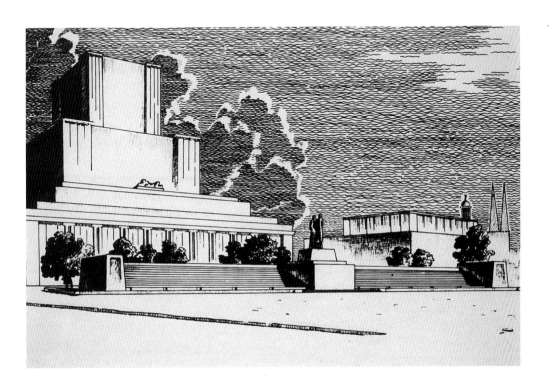

he had also worked at the architectural academy in Moscow. His criticisms therefore had particular weight. As director of the urban design and building institute at the Ministry for Reconstruction in Berlin, he wrote that the proposal drawn up in the planning department of the city council 'bears signs of downright urban design formalism'. This was tantamount to a serious contravention of the 'general line' of the party, expressed in Stalin's slogan of the 1930s, that architecture and urban design should be 'socialist in content, national in form'.

Theoretically, Socialist Realism meant preserving national, regional and local characteristics in a multiracial union of states. But calling upon history and a pan-German responsibility for the reconstruction of Berlin obscured the real political aims, foremost integrating East Germany into the Soviet sphere of influence whilst opposing West Berlin's integration into West Germany.

fig. 4
View of the grandstand under construction behind the square created by the demolition of the Royal Palace, March 1951.

Perhaps the Communists believed they could use lingering prejudices against the 'nomadic way of building' practised by the *neues bauen* movement to wage a new campaign against the 'cosmopolitanism' of post-war Modernism in West Germany. Ironically, in the campaign against modern architecture in Germany in the 1920s, the Bauhaus had been derogatorily labelled the headquarters of a culture-destroying 'Bau-bolschevism'. In the West, Modernist architecture was triumphant and – through exiles such as Marcel Breuer, Walter Gropius and Ludwig Mies van der Rohe – overtly bore witness to the continued influence of former Bauhaus members now re-imported from America. These alleged signs of 'American cultural imperialism' were firmly condemned by the East, and all 'honest architects in the West of our homeland' were invited by East Germany to put up resistance.[9]

Planning in East Berlin increasingly focused on demonstrating a state ethos. Further building on Nazi-era propaganda, the SED declared 1950 to be the year of 'cultural battle'. In mid-March 1950, 'Guidelines for the Redesign of Berlin' were drawn up by the Ministry of Reconstruction, which stated that:

… the city centre [was to be] treated as the site for institutions representing the central, political, economic and cultural life of the German Democratic Republic and should be structured in a way that [would ensure] these buildings would have an impressive effect.[10]

On the study tour of the Soviet Union the German group of experts held intense talks with high-ranking Soviet counterparts about urban design which, before they had even left Moscow, were condensed into principles for a new East Germany. The German experts noted well the Soviets diktats for the socialist city:

In the Soviet Union they are under all circumstances against the English/American theory that the 'open' city is both beneficial and economical. It is uneconomical and, what is more, it is not protected from air raids and isolates the workers from political life, making them into members of the petit bourgeoisie.

In West Germany, Nazi plans for redesigning cities were equated with parade squares and large axes (forgetting that the Nazis had also used other planning principles, including the 'structured, open city'). Consequently the

city council architects working with Scharoun had designed a city which demonstratively had no political centre marked out by buildings. In contrast to this model the Soviets stressed that they 'were in favour of monumental buildings which expressed the people's wishes and their will to build.' In accordance with this, 'the street should not only fulfil traffic functions', but should

… provide space for the people to celebrate. The street is an instrument of festive life. It must raise the consciousness of the people, it must underline the political significance of the masses. In it the idea of the time must be expressed.

The core principle of planning was thus summarised: 'Point of departure: the soul of the city is its centre! Where is the idea of the capital city located?

In the centre!' There were schematic instructions on how to design it: 'What is the centre? Where do the demonstrations go? Where is the square for parades? Where are the government institutions and the central cultural institutions? That is what the centre is about.' Soviet officials emphatically opposed any ideas that deviated from this:

The basis for thinking about the centre of a city must not be the car but people, demonstrators striding through the city. The centre and the central borough are not to be confused. In Berlin, Unter den Linden and the Tiergarten can be the centre. However, you have to take care not to look at the centre from the point of view of a trader or a tourist. The only correct point of view is the political one.[11]

These principles for the city had determined Soviet cultural policy since the 1930s, but were bound to be met initially with incomprehension, even rejection, in post-war Germany. Authoritarian choreography of state power was discredited through the memory of 12 years of Nazi dictatorship – of course most particularly in Berlin. But society's development in East Germany depended to a great extent on the SED, and was closely related to party-political decisions. Party conferences, which usually occurred every four years, were important events, taking stock of past policies and setting the course to come. The III Party Conference, which took place shortly after the return of the delegation from the Soviet Union in the summer of 1950, concentrated entirely on the stabilisation of state power within the party. The Party's General Secretary attacked Berlin's building department with unprecedented ferocity, accusing it of imitating 'cosmopolitan fantasies' instead of expressing how a new society was being created, a society that matched the greatness of the task that had begun with the five-year plan and been undertaken under 'the leadership of the working class'.[12] Ulbricht, speaking from the tribune, called upon architects and urban planners '[to ensure] that out of the rubble of the cities that were destroyed by American imperialist bombers, cities are created that are more beautiful than ever'. This applied 'especially to our capital, Berlin.' These remarks formed the prelude to an intensively waged campaign for the demonstration of a 'new German architecture' in the redesign of Berlin in order to inspire the trust of the people, to have a

demonstratively new beginning, to suggest a national self-confidence, and to gain propaganda advantages over the West. The slogan, 'national in form, democratic in content' was coined.

The new centre

Architects responded swiftly to Ulbricht's call to give the centre of the capital symbolic significance, but incorporated local or national traditions only indirectly. They made no attempt to integrate existing urban structures, they being 'societally' out of date. The historical street plan was ignored in order to be able to 'design a forum for democracy by building major buildings for the democratic mass organisations'. Even the first schemes following Ulbricht's appeal had very little to do with analysis of local history, and at best retained a number of historically and culturally important buildings as museum pieces, coarsely monumentalising their characteristics in new buildings. The architects looked more to Soviet models for inspiration, and above all to the reconstruction of Moscow, rather than (as had been called for) 'appropriating and creatively further developing the heritage'. Ulbricht had appealed to his architects 'to express in their designs for the cities the grandiose ideas' that were allegedly connected with building the new state.

A political, cultural and administrative focal point was planned for the heart of the city that pushed housing out entirely. The brief called for a monument to the victims of Fascism on the western side of the central square, and a large grandstand opposite it in front of the Government Building on the other side of the arm of the River Spree. To the south as an extension to the square an opera house was to be built. The first proposals were submitted in summer 1950, but very few architects had responded to Ulbricht's exhortations. The scheme by Helmut Hennig, though, anticipated future principles for the design of the centre. Only he, who had worked in the city architect's department without interruption since the 1930s, had understood how to condense into images the demands that had been made. His drawing shows three processions of demonstrators merging into one, moving along a

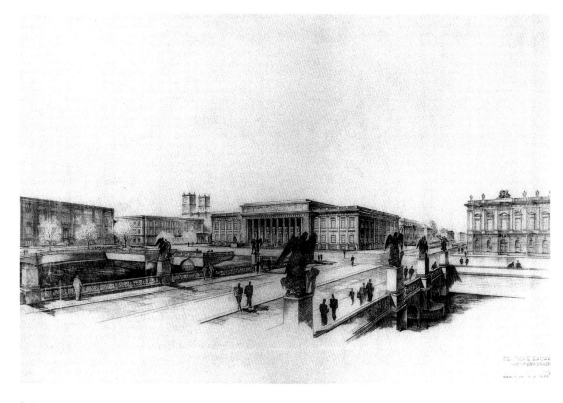

fig. 5
Sketch of the planned Haus
der Frau based on a design
by Richard Paulick. The view
is across the Schlossbrücke,
with the former Arsenal
(Zeughaus) to the right,
the Bauakademie and the
Friedrichswerder Church to
the left. The design (1952) was
meant to relate stylistically to
the neighbouring buildings
in line with the slogan
'national in form, socialist
in content'.

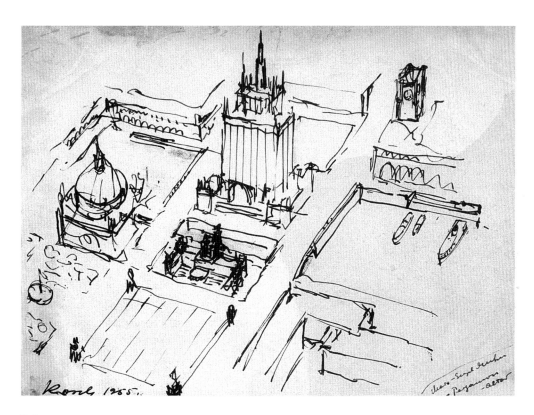

fig. 6
Design sketch by Gerhard
Kosel for the development
of Berlin's city centre, 1955.
As well as the tower building,
the form of which is based
on Moscow models, the other
significant elements are the
grandstand and the arm of
the River Spree that has been
widened into a navigable
basin. Kosel proposed
placing the Pergamon Altar
here, evidently in order to
symbolise a legitimate
sequence of power.

sequence of spacious squares past a monumental Government Building with a grandstand in front of it. It shows obvious references to local architectural culture: the central building is terminated by a colonnaded porch, like Schinkel's Altes Museum, its corner acroteria likewise indicating a neoclassical attitude.

Richard Paulick, who had returned from exile in Shanghai, developed a scheme of his own in which he did not confine himself to designing the central square and the buildings that bordered it, but designed the entire city centre, developing the idea of a central axis even more distinctly than Hennig had. In Paulick's scheme a sequence of streets stretched from Stalinallee (now Frankfurter Allee) in the east across Alexanderplatz to the central square, then continued along Unter den Linden to the Brandenburg Gate and by extension to Charlottenburger Chaussee in West Berlin. This length of about seven kilometres was envisaged as a *via triumphalis*, not open to through traffic. It had been designed according to the so-called 'demonstration plans' which envisaged a strictly controlled choreography of mass events, the positioning and size of the squares and width of the streets ensuring that the expected number of demonstrators could be accommodated. The size of the central square was calculated for two kinds of rallies, so-called static demonstrations and flowing demonstrations. Paulick assured the SED leadership: 'In the case of static demonstrations, the redesigned *Lustgarten* can accommodate approximately 330,000 people. People will be channelled in from all sides to make sure that the square fills up quickly ...' And for flowing demonstrations: 'The main approach street is Unter den Linden. Two columns of eight demonstrators, that is 16 people, arrive in front of the Schlossbrücke, so that rows of 72 demonstrators can march to the *Lustgarten* across the widened bridge. That means 125,000 people per hour.'[13]

While the extension of the axis across the *Lustgarten* to the east was a new idea, the axis to the west had been completed in the 1930s (as the first phase of an east–west axis designed by Albert Speer, whom Hitler had appointed to redesign the capital of the Reich). This section of the axis was incorporated into the demonstration plans, although it was not in the Soviet sector. Likewise, embassies for the Tiergarten district of West

Berlin, and a central railway station on the bend in the River Spree were proposed. These were but two instances when the plans for the capital city did not stop at the boundaries that had been laid down by the four victorious powers.

Not even a month had passed between the first sketch, which Paulick submitted after Ulbricht's speech at the III SED Party Conference, and the government decision to proceed. Less than two weeks later demolition of the Royal Palace began. In the following year, 1951, the May Day parade took place on the 'extended *Lustgarten*', renamed Marx-Engels-Platz for the occasion. (The SED newspaper *Neues Deutschland* proudly announced that, in an eight-hour 'demonstration parade that seemed to have no end', over a million people had passed in front of the specially built, permanent grandstand.) Central to the plan for the city centre was the restoration of historical buildings on the once magnificent Unter den Linden in order to emphasise a common national heritage. For Ulbricht, the architecture of West Germany was 'the living expression of the interventionist policies of American imperialism'.[14] Evidently he expected a wave of protest against the cultural policy of the Americans in West Germany that could be used to the benefit of East Germany.

At the beginning of the 1950s the SED leadership departed from its intention of giving the capital a new political centre for reasons that are still not entirely clear, even accepting the impact of an acute housing shortage. A lack of confidence in the designs for the centre led to the decision to use Stalinallee to gain experience for the centre's development. These ostentatious blocks of flats were within a section of the central axis, and could thus convey an initial impression of future architectural wealth. Work on planning the centre continued, although only sporadic progress reports were made public. The central building remained the dominant proposition, even when Khrushchev, Stalin's successor, introduced a new policy on building at the end of 1954. Instead of expensive, ostentatious buildings he called for simple buildings on a mass scale in order to address the needs of broad sections of society. Khrushchev explicitly called for standardisation and industrialisation of construction with the slogan 'building faster, better and more cheaply'.[15]

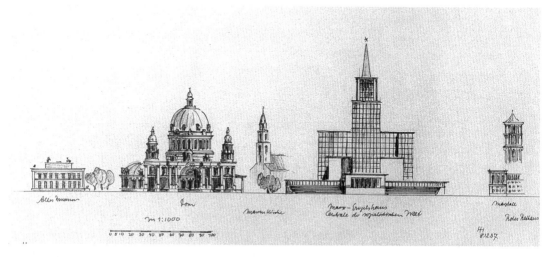

And since 'Learning from the Soviet Union means learning to be victorious', it wasn't long before Khrushchev's message arrived in Berlin.[16]

East Germans with responsibility for cultural matters must have been horrified to discover that there was now nothing to differentiate their own buildings from those that the 'class enemy' had been producing for years, and that East Germany had constantly and vehemently criticised. Thoughts of this kind may have influenced Gerhard Kosel, who had only returned from exile in the Soviet Union in 1954, in his first design for the Government Tower; based on high-rise buildings in Moscow from the Stalin era, it contradicted the new guidelines. Here, he first made the suggestion that would be repeated in abundant variations: that the arm of the River Spree should be extended to create a basin with landing stages for pleasure boats. The Pergamon Altar was to be a rostrum in front of the Government Building to symbolise an historical sequence of power. Thus the appropriation of history to make the 'heritage of world culture' into a political instrument had reached its apex. But Kosel's approach was already late.

By spring 1955 East Germany had adopted Moscow's about-turn in building policy, which would have an impact on plans for the Government Tower. Once more, architects had to translate new guidelines into concrete

fig. 7
Version of the development of the government quarter in the centre of Berlin by Gerhard Kosel, Hans Mertens and Hanns Hopp, October 1959. The planned government tower, 'Headquarters of the Socialist World', is seen in comparison with other dominant buildings in the city.

proposals. This intense search for a new architecture and the state's increasing self confidence was even reflected in the building's title: first the 'Central House of Culture' and then 'Marx-Engels House. Headquarters of the Socialist World'. Initially, the problem of keeping to traditional designs whilst using the new technologies and building procedures that had been called for seemed impossible to resolve. A series of proposals for the central building submitted in 1957 by Hanns Hopp, one of East Germany's leading architects, did take into account the special characteristics of industrialised building, but the dilemma remained acute. From 1957 onwards, Hopp worked on a scheme for the centre with Kosel, who had become deputy Minister for Building. The focus was the Government Tower, which rose from a block-like plinth reaching the standard eaves height of buildings in Berlin, its prominent quoins tapered upwards in a number of steps. Published in *Deutsche Architektur* (the official organ of the Deutsche Bauakademie and the *Bund Deutscher Architekten*) in April 1958, just after the decision had been taken to advertise a competition for the redesign of the centre of Berlin, the scheme was probably meant to indicate the direction competition entries should take. It had the character of an official pronouncement, and was bound to have met with approval from the politicians.

Competitions

At the beginning of 1958 the Politburo – in reaction to an international competition for Berlin in 1957, jointly promoted by the West German government and the West Berlin administration,[17] which had not confined itself to the West – organised a competition for the redesign of the centre of the GDR's capital. West Germany had repeatedly asserted its claim to the sole representation of German interests, ignoring the *de facto* existence of a second German state, envisaging Berlin as a cosmopolitan city and the seat of government in a reunified Germany. East Germany countered with a competition for the 'Socialist redesign of Berlin, the capital of the GDR', which seemed to have a greater chance of becoming reality. Kosel was

fig. 8
Model of a redevelopment scheme for Berlin by Hermann Henselmann outside the competition. It was submitted for the 1958 ideas competition, 'Socialist redesign of the capital of the GDR'. Here the revised version of 1968.

commissioned to draw up the competition brief – a document that is testimony to an astonishing disjointedness in ideological argumentation and which called into question previous policy. For years East Germany had earmarked funds to reconstruct Schinkel's Bauakademie, damaged during the war. Now they were saying, without further comment, that it should not be considered 'a building to be preserved': 'As the area currently occupied by Marx-Engels-Platz should not be reduced by buildings, it will be necessary to use the area to the west of the Spree canal which is occupied by ruined buildings for development proposals.'[18]

For the SED leadership, the most important purpose of the competition was to gather proposals for the central Government Building and other party and state uses for the central square: 'Marx-Engels-Platz should be able to accommodate 275,000 people at major mass events. The tribune of honour should be designed for 3,000 people.'[19] The competition was advertised on the ninth anniversary of the founding of the GDR, and only architects from socialist countries were permitted to take part. After the first round of assessment, the jury realised with disappointment that 'there was no scheme which offered an outstanding overall solution [and which] could be awarded first prize.'[20] Two proposals are worth noting, but which interestingly were outside the competition. Kosel had made minor revisions to the scheme he had already published in *Deutsche Architektur* (spring 1958), thus inviting renewed discussion. Henselmann responded to this well-known and well-received proposal with a design that bore distinct signs of modern urban planning, the kind of which was popular internationally. To a large degree he ignored the existing structure of the centre of Berlin, designing a composition of interpenetrating open spaces which would have completely altered the face of the city. Berlin's architect-in-chief, who more than anyone had given impetus to East German architecture, thus came closest to fulfilling the expectations of the competition's promoters. They, however, brusquely rejected it. The SED was visibly shocked by his suggestion to build a 'Tower of Signals' to condense the 'romantic notions of socialist society' into an architectural symbol instead of the Government Tower. Although Henselmann's design was officially rejected, it won so much approval

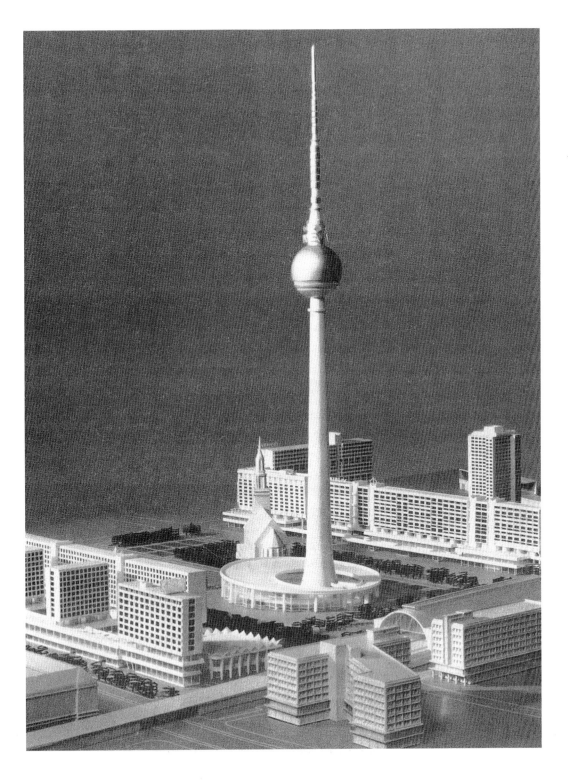

from visitors to the competition exhibition that it was removed before the exhibition ended. It was only a few years, though, before the authorities recalled his proposal and built it in the centre of Berlin.

After the building of the wall

Concepts for a comprehensively new centre were forestalled literally overnight: on 13 August 1961 construction of the Berlin Wall commenced, and all previous plans for the city were irrelevant. Only four months earlier *Neues Deutschland* had reported the 'historical decision on the reconstruction of the centre of the German Democratic Republic's capital'. However, the building of the 'anti-imperialist protective wall' removed essential elements necessary for the reconstruction's implementation. Parts of the plan passed only a few months previously had to be dropped because they would literally no longer fit into the East German capital. This included the axis planned to run to the north of and parallel to Unter den Linden, which would have involved considerable widening of Dorotheenstrasse. (This axis was laid out in a way that made the Reichstag a point of reference, a building that had otherwise played no part at all in East German propaganda.) The Wall had particularly serious consequences for the central axis itself. Any projects that would have increased the importance of the Western end of Unter den Linden were immediately shelved since it was impossible to ascertain the security risks.

The architects' co-operatives responsible for the March 1961 redesign of the centre were commissioned to submit a new proposal incorporating the 'advice' of the Party. The focus once more was the design of the central square and building; however, further demands had been added. Just as Khrushchev had introduced modernisation of building, so had he suggested other changes to bring about modernisation of society and modes of living. These included a radical modernisation of urban structures. The 'new socialist person' would have to live 'in a socialist way'. The SED tried to be at the forefront. Instead of deriving these ideas from social theory and ideological

legitimisation, the leadership concentrated pragmatically on data and prognoses: a rise in the standard of living led to expectations of a higher level of car-ownership, and a corresponding rise in traffic volume, for example.

A scientific-technological revolution having been proclaimed, architects and urban planners faced the task of designing urban spaces for the new socialist person. The 'new phase' demanded, as the Bauakademie – the leading academic institution for architecture and building in East Germany – stated in 1960, 'a rapid development of productive forces which must lead to our attaining and having a part in determining world standards including in the field of building and architecture'. Neither continuation of the traditions of national architectural culture, nor catching up with developments in West Germany were declared aims; rather, the ambition now was to determine world standards by 'overtaking without catching up' (*'Überholen ohne Einzuholen'*). This included boosting consumption as evidence of a rise in the standard of living. Improved roads for traffic and large department stores had to be accommodated in the new spatial configuration of the city. The move away from a 'new German architecture' could hardly have been formulated more clearly.[21] This trivialisation of the socialist promise is clear in the 1961 plan: immediately behind the central building, between the old Town Hall (Rotes Rathaus) and Alexanderplatz, large department stores with 'national significance' were to be built.

Other signs

When the reconstruction plan was passed, there was still confidence that the projects would already have been completed, and that construction of the central building could begin in 1965. But by the end of the 1970s only two projects had been built: the Council of State from 1964, followed by the Ministry for Foreign Affairs three years later.[22]

The Ministry for Foreign Affairs defined the western edge of Marx-Engels-Platz and is the centre's western termination. It formed a visual barrier in front of the Forum Fridericianum, and contributed to the centre's shift eastwards,

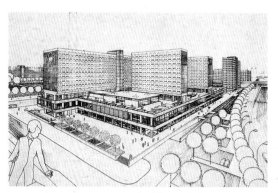

fig. 9
Development proposal for the
area around Alexanderplatz
and Rathausstrasse, 1968.

fig. 10 [opposite above]
Photograph of the Council
of Ministers building taken
in 1969.

fig. 11 [opposite below]
Photograph of the Ministry
of Foreign Affairs, taken
in 1969.

a fundamental change in the composition of
the city, which was a direct consequence of
the Wall. While providing architects some
aesthetic freedom, the question of what might
be socialist about it had been avoided: the
curtain wall made of plastic-coated aluminium
elements, for example, bears the decisive
stamp of Modernism in its geometric
abstraction. It marked the renunciation of
a commitment to the cultural heritage that
had formerly been stressed, which in Berlin was tantamount to denouncing
Schinkel's *oeuvre*. The incorporation of Portal IV from the *Lustgarten* wing of
the former Palace, placed as a spoil in front of the new building, was not only
a remnant of history but demonstrated the fulfilment of a mission: it was from
the balcony of this portal that Karl Liebknecht proclaimed the Socialist
Republic in November 1919.

Excavation works for the foundations of the Foreign Ministry had just
begun when the focus of the centre's redesign changed again. The idea arose
of halting the work on the Television Tower, begun in 1965 in the neighbouring
borough of Friedrichshain, and shifting it to the new site. Initial reservations
about placing a technical structure as the dominant feature in the centre soon
dissipated, and the Television Tower quickly became the hallmark of the city
that it still is today.[23]

Whilst the SED leadership had in the past decreed that the centre of the
capital should be kept largely free of housing, reserved instead for important
public and state institutions, they now decided that 'complex housing projects
[should] be incorporated to a greater degree into the reconstruction and
redesign of the city centre'. Multi-storey housing, a central element in urban
planning, it would 'lead to economically and architecturally effective
solutions', since it would mean that housing would be close to places of
work and 'make a significant contribution to the development of life in city
centres.'[24] What had once been envisaged as dignified spaces in the city
centre for people's celebrations and for state ceremonies was now opened

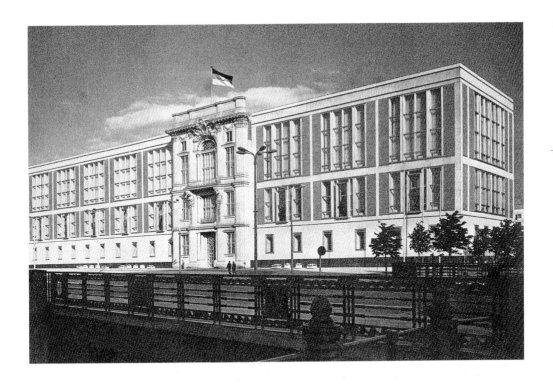

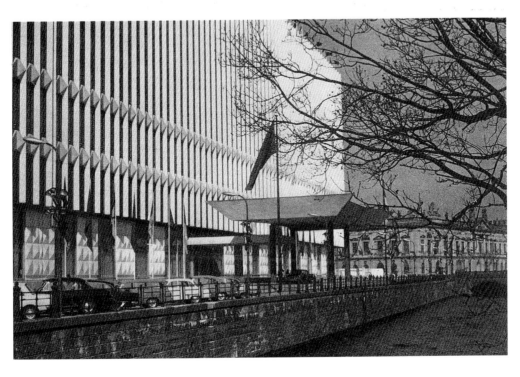

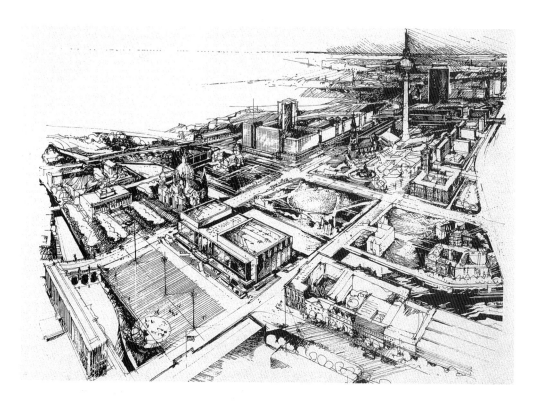

to more mundane uses. The housing on Karl-Liebknecht-Strasse and Rathausstrasse differed from other high-rise blocks of flats built en masse on greenfield sites only by a two-storey plinth accommodating shops, offices and service institutions. Otherwise, there was not a trace of the former criterion for the centre of uniqueness.

Thus, by the early 1970s, a new city began to emerge. Although it bore little resemblance to the one envisaged in earlier plans, it was proudly labelled a 'socialist achievement'. Yet despite numerous proposals, what was probably the most important site in the city centre remained empty. The leadership had clung unwaveringly to the idea of a central Government Tower Building and had not relinquished its conviction even after the radical 'turnaround in architecture and building' of 1955. But not until the early 1970s, in the wake of recognition under international law and acceptance into the UN, did the GDR once more turn to the reconstruction of its capital. At the end of 1972 it commissioned its architects to design a Palace of the Republic, and set the date for its ceremonial opening as the IX Party Conference in 1976. Instead of a concentration of all the important state and party institutions in one building as had been planned, the Palace of the Republic was envisaged as a multi-purpose building in which the People's Chamber, with its main meeting

fig. 12 [opposite]
Drawing of a proposed
redesign of the centre of
Berlin, including the Palace
of the Republic, 1974.

fig. 13
Palace of the Republic, 1976.

room, occupied relatively little space. The building's programme had shifted to a range of entertainment facilities, restaurants and cafés; the mundane use of the city centre that had been noticeable since the 1960s was thus confirmed. This programme was, in fact, the antithesis of the Government Tower, and compensated for the development of the centre that had taken place. The strict separation of offices, retail and housing had meant that in the evenings the centre of Berlin bore little resemblance to the pulsating centre of a capital city. Many people saw the Palace of the Republic as a ray of hope, a place of varied entertainment and leisure, from noisy parties in the bowling alley to quiet contemplation of paintings in the upper galleries.

The Palace of the Republic was only sporadically the political focus of East German society. The party conferences the SED held there from 1976 took place only every four years. One function happened only once. Party and state leaders took their places on the grandstand facing the parade square, a structure which had had to be specially integrated into the overall architectural concept. The occasion was a military parade and the exhaust fumes from the tanks and other heavy vehicles that swept across the grandstand made it virtually impossible for the delegates to sit there. A second attempt was never made, and thus one decisive planning criterion, to create a prestigious backdrop for demonstrations and rallies and a sense of spatial unity with Marx-Engels-Platz was vitiated. Such a use was seen once more, however, although not as those who commissioned it had ever expected. In autumn 1989, on the eve of the 40th anniversary of the founding of the GDR, when the SED leadership were gathered in the Palace of the Republic for the official celebration, the sound of open public protest rang out for the first time for decades. On that evening demonstrators had of their own accord assembled on the square in front of the Palace and were loudly demanding change.

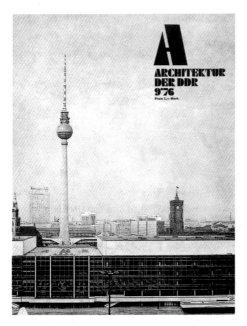

ARCHITEKTUR
DER DDR
9'76
Preis 5,— Mark

NOTES

1. For more details see Bruno Flierl, 'Rund um Marx und Engels: Berlins sozialistische Mitte', in Helmut Engel and Wolfgang Ribbe (eds), *Hauptstadt Berlin – Wohin mit der Mitte?* (Berlin, 1995); Bruno Flierl, 'Der Zentrale Ort in Berlin – Zur räumlichen Inszenierung sozialistischer Zentralität', in Günter Feist and Eckhart Gillen (eds), *Kunstdokumentation SBZ/DDR 1945–1990. Aufsätze, Berichte, Materialien* (Cologne, 1996); and Jörn Düwel, 'Am Anfang der DDR. Der zentrale Platz in Berlin', in Romana Schneider and Wilfried Wang (eds), *Moderne Architektur in Deutschland 1900–2000. Macht und Monument* (Stuttgart, 1998).

2. Walter Ulbricht, 'Die Großbauten im Fünfjahrplan', in *Zur Geschichte der deutschen Arbeiterbewegung. Aus Reden und Aufsätzen. Vol. III: 1946–1950* (Berlin, 1953).

3. Gesetz über den Aufbau der Städte in der Deutschen Demokratischen Republik und der Hauptstadt Deutschlands, Berlin (Aufbaugesetz). [Act concerning the Reconstruction of Cities in the German Democratic Republic and Berlin, the Capital of Germany (Reconstruction Act)], passed on 6 September 1950.

4. Ulbricht, 'Die Großbauten im Fünfjahrplan'.

5. On the Planungskollektiv see Johann Friedrich Geist and Klaus Kürvers, *Das Berliner Mietshaus, Vol. 3, 1945–1989* (Munich, 1989).

6. Hans Scharoun's speech at the opening of the exhibition, 'Berlin plant. Erster Bericht' ('Berlin is Making Plans. First Report'), *Der Bauhelfer*, no. 4, 1946.

7. Memorandum by Lothar Bolz on a meeting with the Prime Minister of the GDR on 18 November 1949, in BArch., Potsdam section, DH I, no. 44519, reprinted in Werner Durth and Gutschow Düwel, *Aufbau. Architektur und Stadtplanung in der DDR* (Frankfurt; New York, Campus Verlag, 1998), p. 211f.

8. Kurt Liebknecht, 'Expos, zur Stadtplanung Berlin', 23 Januar 1950, in BArch. (Federal Archives), SAPMO, ZPA IV 2/606/82.

9. From 1950 onwards the contrast between the 'West with its hostile attitude to culture' and the GDR as the 'sole guarantor of national identity' developed into a fixed topic. See for example, 'Zur Verteidigung der Einheit der deutschen Architektur. Programmerklärung der Deutschen Bauakademie und des Bundes Deutscher Architekten, 1954', in *Die nationalen Aufgaben der deutschen Architektur* (Berlin, Deutsche Bauakademie, 1954).

10. Leitsätze zur Neugestaltung Berlins (Guidelines for redesigning Berlin) vom 23. März 1950, in BArch., Potsdam section, DH I, unsigned.

11. All quotations from the trip to Moscow. See Werner Durth and Gutschow Düwel, *Ostkreuz / Aufbau. Architektur und Stadtplanung in der DDR*, 2 vols (Frankfurt; New York, 1998).

12. Ulbricht, 'Die Großbauten im Fünfjahrplan'.

13. 'Planung Berlin, 14. August 1950' (Plans for Berlin, 14 August 1950), paper prepared for the Politburo meeting of 15 August 1950, in BArch., Potsdam section, DH II, A 21.

14. Walter Ulbricht, 'Das Nationale Aufbauwerk und die Aufgaben der deutschen Architektur' ('The National Reconstruction Work and the Tasks Facing German Architecture'), speech at the opening of the Deutsche Bauakademie on 8 December 1951, in *Das Nationale Aufbauwerk und die Aufgaben der deutschen Architektur* (Berlin, Deutsche Bauakademie, 1952).

15. Speech by Khrushchev at the conference of the building workers trades unions, Über die Einführung industrieller Methoden im Bauwesen, die Verbesserung der Qualität und die Senkung der Selbstkosten der Bauarbeiten' ('On the Introduction of Industrial Methods of Construction, Improvements in Quality and Reduction of Total Production Costs in Building Projects'), Moscow, 30 November 1954, in Sammlung Kurt Liebknecht, Berlin.

16. Resolution of 22 July 1955 of the executive committee of the Deutsche Bauakademie to introduce a construction method using large prefabricated slabs, in BArch., Potsdam section, DH I, bundle 1298.

17. See *Hauptstadt Berlin. Internationaler städtebaulicher Ideenwettbewerb 1957/58* (Berlin, Berlinische Galerie, 1990).

18. See paper prepared for the meeting of 9 September 1958 of the Politburo of the SED's Central Committee, in BArch., SAPMO, I IV 2/2/A; and paper prepared for the meeting of 30 September 1958 of the Politburo of the SED's Central Committee, in BArch., SAPMO, I IV 2/2/A-657.

19. Ibid.

20. Jury's evaluation of the award-winning designs submitted for the competition for ideas for the 'Socialist re-design of Berlin', 29 September 1959, in Sammlung Hans Gericke, Berlin.

21. *Probleme des Städtebaus und der Architektur im Siebenjahrplan* ('Problems of Urban Design and Architecture in the Seven-Year Plan'), theory conference held at the Deutsche Bauakademie, October 1960 (Berlin, Deutsche Bauakademie, 1960).

22. See Irma Leinauer, *Das Ministerium für Auswärtige Angelegenheiten in Berlin* (Berlin, 1997).

23. See Peter Müller, *Symbol mit Aussicht. Der Berliner Fernsehturm* (Berlin, Huss-Medien, 1998).

24. From vol. 6, p. 110 of Dokumente der SED, vol. 1–21, Berlin 1948–1989.

The Permanent Side
Wishful Thinking about the City of the Telematic Age

VITTORIO MAGNAGO LAMPUGNANI

The development, gradual merging and networking of new communication technologies means that more and more functions that to date were tied to particular objects and particular places are moving into the invisible realm of data streams. Consequently, our social, economic and cultural structures, as well as public and private life, are being shaken to the core.

It is cities that will be particularly affected by this. For some time now our urban centres, which have already lost a number of locational advantages and have had to give up part of their leading role, have been in a crisis that cannot be overlooked. This crisis will worsen, take on undreamt-of dimensions and possibly lead to a paroxysm that will cause the very nature of what we today call the city to be fundamentally changed. Even now, there is talk of cities disappearing altogether and, even now, we have meaningful names at the ready for what will replace them: telepolis, cyber city, digital city, city of bits.

Now the presumed 'dissolution of the cities' is something which has been haunting the entire recent history of urban design worldwide, from Charles Fourier to Bruno Taut and from Ebenezer Howard to the Soviet 'Desurbanists'

of the 1920s. And for that which will succeed the city, and which will probably be something quite different, the contemporary Desurbanists chose of all things urban metaphors, which is at least cause for reflection. Should our cities really be written off, since the future belongs not to real places but to virtual ones? Will the metropolis and everything that characterises its architecture – historical centre, nineteenth-century extensions, garden suburbs and industrial periphery – be replaced by the telepolis?

Making suppositions about the future is a risky business. Prognoses are subject to the test of reality: if they come true they cause mild surprise, although this is by no means proof of their correctness; if, on the other hand, they prove to be false, their failure is complete and definitive. Nevertheless, beyond the clichés that people like to air whenever there is uncertainty about the immediate future, the attempt to conjecture what impact new communications technology will have on our cities is worthwhile. If such conjectures are mingled with wishes then we preserve them, in a sense, from the threat of being disproved: a future that is predicted not in a quasi-scientific or even know-all way but is subjectively conjured into existence can, if it does not happen, only be a disappointment.

Living, working, recreation, transport: Prognoses about the four urban functions

Living, one of the most important dimensions of the city *per se*, will barely be touched in any significant way by the telematic revolution. The telephone, which is increasingly fulfilling a new and more sophisticated range of functions and in the near future will have advanced to a veritable electronic secretary, will play an increasingly important role in contact with the outside world. Television, which will soon work digitally and serve us a great deal more, will take on the role of providing information and services to an extent that it has never done before. The computer, which has already gained entry into our personal living space, will, through its link into different service networks, increasingly become a subservient domestic companion and,

through its connection to the Internet, will become a tool for communication, exchange, education and entertainment. But all this will have an infinitely greater effect on people's daily lives than on their homes. In a way that is analogous to the spread of the telephone after the turn of the century, or of radio in the thirties and of television in the fifties, the new telematic instruments (or the old ones used telematically) will become an established feature of people's homes and change them in individual areas but not really revolutionise them. The essence of home life will coexist alongside telecommunications.

This will not be the case in the world of work. The advance of computer technology is automating and simplifying administrative work across the board, so that much of this work no longer needs to be done by people. But the advance in computer technology does a lot more than this: it removes the necessity for the different stages in the work process to be spatially connected. In post offices, government agencies and banks, back offices no longer have to be directly behind the counters which, as their name suggests, is where they always were; they can be accommodated more conveniently elsewhere, and possibly centralised. But, above all, many people will no longer have to go to the office but will be able to work, at least part of the time, in their own homes. They will have the same infrastructure there that in the past was only available in the workplace, and in this way they will acquire a new independence, in terms of both workspace and time. For centuries now it has been possible to carry out some work outside the workplace, thanks to those wonderful tools that are pen, paper and books, as well as nowadays tape recorders, telephones and computers, which means that it is even possible to control and manage small service businesses remotely. The initial euphoria over teleworking may have died down and it has become obvious that not everything can be split up and outsourced, but nevertheless industrialised society is on the threshold of a completely new organisation of work.

The picture is not much different when it comes to recreation. Even in recent decades, television has swallowed up a large portion of people's free time, and done so at the cost of the cinema and the theatre. But they have not been entirely superseded, merely cast in a marginal role. Now that

television is becoming high-resolution, digital and interactive, and now that the computer, through the Internet and World Wide Web, is also opening up alternatives for education and entertainment, many things point to this marginalisation increasing, unless the amount of leisure time our society has at its disposal becomes even greater than it already is. Other traditional options for filling free time will remain: from having a cup of tea with your friends to spending the night in a club, from a walk in the park to a weekend outing, from reading a book to going to a concert or lecture. But, particularly in the case of leisure activities which try to convey experiences, there will be a great temptation to seek those experiences not in reality – where, despite relevant facilities, they are still associated with difficulty and sometimes with effort – but in the virtual world of the computer screen. It is easier to get artificial adventures there whenever you desire them, they can be exchanged for others more quickly when you are bored with them, and they are easier to interrupt when the entertainment value threatens to wear off. And, above all, you can have it all delivered to your home, where you can sit comfortably in your armchair in dressing gown and slippers with no need whatsoever to face the real world outside with all its vagaries and risks – even if it is only on the short journey from your front door to the newsagent or cinema round the corner.

The consequences for traffic, the fourth and last central dimension of the city, are obvious. Very briefly: there will be a reduction in traffic. Many things that at present still have to be transported as an object from one place to another will be conveyed as pure information via cable or radio waves. Countless people who still have to go to their place of work to use the infrastructure there will stay at home because they will have the same infrastructure in their own living rooms. Other journeys will become totally redundant: if you do all your correspondence via e-mail, you no longer have to go to the post office to buy stamps; if you do your shopping by selecting items on a screen and ordering them by telephone or modem, you no longer have to walk or drive to the shops or supermarket; if you can transfer money by telephone or computer, you no longer have to go to the bank.

Effects on the city

What does all this mean for the city? For its residential buildings, not a great deal: they will continue to be needed, new cables might have to be installed and they may be used slightly differently than they are now, but no fundamental changes will have to be made to the buildings themselves.

For city offices, it will mean a development that we can see beginning to happen already: they will stand empty. A great number of institutions and corporations which had their headquarters in the city centre will, if not completely disappear, become smaller; only a few new ones will move in. Generally speaking, less office space will be needed, and, in particular, less office space will be needed in the city. Large units will be used less and less,

and smaller, more manageable buildings will be required. Counters and areas dealing directly with the public will stay where they are, namely, easily visible and reachable in the centre of the city. By contrast, back offices will be accommodated elsewhere and linked to the counters and offices dealing with customers. This will free-up built space in the city.

As far as large factory complexes are concerned: if they have not already been abandoned, they soon will be, at least by the industries that created them. Above all in Europe, industrial locations in cities are unprofitable, unnecessary and obsolete, not least because automation means that human labour is required less and less, which cancels out the advantages of being in a city. The new telematic instruments will decouple the monitoring of production processes from the production locations themselves, so that there will be absolutely no reason to keep them in inner-city areas. This will also free up space in the city.

Leisure amenities will be used by fewer people, particularly in certain areas. They will perhaps have to undergo fundamental restructuring, but on

the whole they will be able to continue as they are now. The same applies to education structures.

Finally, traffic and transport facilities, underground and overground urban railway systems, and, above all, the streets and squares of a city will be markedly emptier; urban motorways with their huge viaducts and tunnels might even become obsolete. But will this not make the city itself obsolete? The large conurbations in which we live today – with their factories, office blocks, housing for blue- and white-collar workers, their infrastructure – were primarily created by the industrial revolution. If the premises that engendered them cease to exist, the city as such is called into question. The replacement of primary industries by service industries has already shaken cities to the core. Will people in the future want to live in cities anyway? Or might they not roam the countryside like nomads, bearing mobile phones, fax cards, laptops, PCs and modems, keeping in touch with other nomads kitted out with the same equipment?

There is little to indicate that this wonderfully radical prediction will actually come true: after all, cities existed before the industrial revolution and their origins cannot be explained in one-dimensional terms. They were affected primarily by political, economic and cultural factors; although in the meantime politics happen elsewhere, trade and industry have become global, production has been relocated to countries with low-wage economies, and culture is also created in the countryside and villages, the city is nevertheless not merely an empty shell. Cities have always had the central, overarching task of facilitating and promoting rapid and diverse forms of communication and interaction through spatial proximity. If some of these functions are now being absorbed by the telematic webs which we are spinning between us with increasing density, this means that the borders between leisure and work, the public and the private, and also between the city and the country are shifting. But it does not mean that spatial density in the city as such is superfluous. Numerous kinds of communication, numerous kinds of interaction, cannot be banished to a cable or frequency. They are the more intense, more complex and subtle human relationships in which not only pure facts, but also nuances, tones of voice, moods and atmospheres are

important. And for these relationships, for this kind of communication, for this kind of interaction, the city is still the predestined place.

Refitting historical building fabric

The telematic capacity and communicative efficiency – in short, the modernity – of a building can no longer be deduced from its external form. The new technologies are invisible: they have not developed an architectural expression, but materialise in software and hardware that for the most part consist of relatively small machines and hidden cables. So, for example, a city which, to judge from its skyline, would seem to be one of the most future-friendly in Europe – Frankfurt am Main – is in telematic terms actually not up-to-date because its cables are still copper. By contrast, the museum city *par excellence* – Venice – behind its historical façades, its alleys and maze of canals and its monuments, which are both wonderful and for contemporary circumstances a-functional, hides glass fibre cables, making it one of the most modern cities in Europe. Another, perhaps even more significant, example is an old village in Liguria, Colletta di Castelbianco: the modernisation study that was carried out by none other than Giancarlo De Carlo (an architect who can definitely not be accused of having a penchant for nostalgia) revealed that the old architectural structure was beautifully suited to accommodating new uses. The refurbishment scheme confined itself to consolidating the existing walls, carefully modifying some room sequences, functionally fitting out the flats, and laying cables throughout the buildings. It was primarily the latter modification that transformed a village in its death throes into a (admittedly exclusive) centre for experiments in combining efficient management with high quality of life.

Examples like this show that the old city is well suited to meeting the demands of the telematic age. They are not, however, intended to suggest that everything should remain as it is. The old city is not something which, as the avant-garde of the twenties were still proclaiming, must be wiped out to make way for the new; on the contrary, it is the basis, indeed the very

substance, of the new. Nevertheless, it has to be redesigned to ensure that it is in a position to carry out its new tasks as well as possible.

The conditions for a redesign of this kind are already in place. If the demands on housing remain largely unchanged, we can concentrate on refining their types and interior fittings better to meet the needs of the people who use them, including their need to work at home, ability to concentrate there and, above all, their comfort in doing so. As an office block becomes empty it can be converted into residential units (there are models for this in cities like London and Paris, where it is already happening) and the process of pushing dwellings out of the city centres, which began in a particularly virulent way in the post-war years, can be halted or even reversed. When large factory buildings are vacated, large tracts of land can be acquired to create more homes, and recreational and educational amenities in the middle of the city (not, as has been common practice since the seventies, on the fringes of the city or even on greenfield sites), and also to open up the city by laying out new public parks in places that are too densely populated. A drop in traffic levels will not only provide an opportunity for greater mobility for everyone; the streets and squares on which fewer vehicles will rumble and roar, emitting noise and noxious odours, will be at the same time available for pedestrians to use.

All this could but will not necessarily happen. The new state of empty office space will not necessarily mean that the city centre will be reclaimed by the people who live there: it could also smooth the path for a gentrification process in which only the extremely rich return to the city, people who could have afforded to live there anyway, whilst poorer people continue to be relegated, and increasingly so, to the fringes of the cities. The large empty factory sheds do not necessarily have to be reserved for new public places: they could just as well – at far greater profit – be left to private speculation of the most unchecked kind. The reduction in traffic will not necessarily bring an improvement in general mobility and quality of life in the city: it could just as well lead to a drastic reduction in, or even abolition of, public transport, which will have become completely unprofitable, in favour of a grimly liberalised private motor traffic. The fate of the city of the telematic age will be decided

not only in the arena of urban design and architecture but also, in fact primarily, in the economic and political arena.

The city as a book

In his novel *Notre-Dame de Paris*, Victor Hugo has his hero Claude Frollo prophecy that the machine-printed book, as it had been invented by Johannes Gensfleisch zum Gutenberg, would mean the death of architecture as the great memory bank of mankind. Pointing with one hand to a book printed using lead type and with the other to his immense cathedral, which he is able to decipher like a piece of built writing, the archdeacon proclaims his damning judgement with a degree of regret: '*Ceci tuera cela.*' The book will kill architecture; printed paper, light and cheap to reproduce, will from now on record and propagate people's thoughts.

Hugo wrote his novel in 1831, just after the July Revolution which had brought the citizen king Louis-Philippe to power and in the midst of the architectural discussion which Heinrich Hübsch had got to the heart of three years previously in his book *In welchem Style sollen wir bauen? (In what style should we build?)*. The crisis predicted by Frollo had happened. Architecture was no longer the sole and infallible means of recording and conveying universally valid thoughts acknowledged by everyone but was merely one option; furthermore it reflected the same linguistic confusion with which the upper classes had maintained their grip on society.

Today, at the epicentre of the telematic revolution, whose profound consequences for our society and for our daily life we can only guess at, it would seem appropriate to hold up not a book, as once Archdeacon Frollo did, but a diskette, and to venture, with a meaningful glance at our bookcase, the same prognosis as the one he made for the grandiose Gothic cathedral of Paris. The storage and passing on of thoughts that humanity has produced, and continues to produce, now happens on hard disks, diskettes, modem connections and data highways; the book, since photocomposition made Gutenberg's invention obsolete a few decades ago, recedes into the

background. And architecture has lost a little more of its role as conveyor of information.

This loss has happened primarily and most obviously in the city. In the Middle Ages and the Renaissance, the city was acknowledged as a vehicle for conveying messages to such an extent that Pope Nicholas V, for example, used specific building schemes to try to transform quattrocento Rome into a *biblia pauperum*, whose magnificence he thought would convince the people who were unable to read of the existence and power of God (and of the Catholic Church). Even in the nineteenth century, the city was the most intentional and relatively faithful image of a society that did not balk at cultural artifice and social segregation in order to present a picture of education and respectability. It was not until the twentieth century that the city exploded into the peripheries that parodied, if not totally ignored, the models presented by the architectural culture of their time. Cities were thus created that no one wanted, and that no one will admit to having created: no politician, no civil servant, no client, no architect. The story they tell is nothing other than the sum of the individual interests and egoism which underpinned

their particular elements; in that, they present a picture of our society that is even more gloomy than it actually is. They have subsequently been labelled urban sprawl and on occasion even upgraded in literature, but this has done nothing at all to mitigate the fact that they are inhospitable and desolate. And yet each city, even the most horrendous, is and remains a didactic formation, which tells a story, composed of its own memories. It is an artificial geological layer, whose sediments document and evoke the past. In them the events that have destroyed or built up the city, damaged it or healed it, shaken it or strengthened it – in other words shaped it in whatever way – have been architecturally processed. The built deposits make it possible to see and imagine the city's political, social, economic and cultural life. The city is a monument to itself and thus a piece of didactic theatre.

Away from the city as an advertisement and back again

But the city is more than that. The symbolic character that has been a characteristic of public buildings in the city since time immemorial is increasingly spreading to private buildings. An increasing number of building owners are displaying their identity in residential complexes and, particularly in office buildings, having an emblem of themselves created on an urban scale. The buildings become gigantic billboards, tirelessly endeavouring to stand out from their neighbours by ambitiously cultivating spectacular and frenetic sculptural ostentation.

This book of stone has a different overlay. There are the inscriptions that testify to certain events, be they floods or street battles. There are also the epigrams that describe the monuments or buildings as works of art or keepsakes. There are the signs that draw attention to cafés, restaurants, hotels and shops and others that point the way to public amenities. There are yet other signs indicating destinations and traffic regulations. And finally there are banners and posters advertising all kinds of things, including events and products that have nothing to do with the place itself. The city has become a

book again after all, albeit bearing a closer resemblance to a coloured picture book or a comic than to a Gutenberg folio.

And now all this is to become obsolete. Soon advertising will come directly into the home, through radio and television (which we are already witnessing to satiety) as well as via the data highway; teleshopping, telekiosking, telebanking and other tele-activities will take away the burden (and also deprive us of the pleasure) of wandering around the city, running errands. And the urban realm through which we once strolled, including its places of memory, will be offered to us as cyberspace. The euphoria with which this development is being greeted in certain quarters is no more justified than the panic that sometimes leads to its rejection. The telematic revolution is a fact and has been for some time. It is common knowledge that it will have immense consequences for our cities. The real question is, in what direction should these consequences be guided?

First of all, a misunderstanding that is as naïve as it is persistent must be cleared up: the belief that more information is fundamentally better than less. What matters is the quality of the information that technology transmits and the way people process it. The fact that it is possible to select carefully and use means of communication for manipulative purposes has been demonstrated not only by every modern totalitarian regime but also by consumer society. And many a jungle of traffic signs reveals the fact that unmanageable volumes of information engender not education but satiety, helplessness and confusion.

Therefore, when it comes to the communicative dimension of the city, it is a matter not of boundlessly extending it but, on the contrary, of setting appropriate limits and achieving a qualitative improvement. The new telematic instruments certainly offer an opportunity to do that. They relieve the city of numerous functions – including many of communication – that are currently still being heaped upon it. Why bother using buildings for advertising when the message is far more effective on the computer screen? Why have thousands upon thousands of traffic signs when the mobility of information means that there is far less need to move from one place to another in the city, which in turn means that traffic chaos could solve itself?

Why the billboards and adverts competing brashly with one another when you look on the screen at home to decide where to go for the evening? And why the symbolic buildings wildly gesticulating and clamouring for attention when corporate presence is more intensive and effective on the data highway?

Discreet information technologies and places of stillness

Alongside the nightmare of a cyber city that is a pure surrogate for the material city and does nothing other than mingle its stimuli with other borrowed images and increase them, there is on the horizon a vision of a city of the near future in which the new information technologies will establish themselves in a way that is both discreet and helpful. And in doing so they neither overload the city with relentlessly flickering media screens nor ape it with their virtual spaces, but rather liberate the city from functions and missions that are becoming increasingly difficult to marry with it, and at the same time enrich it with others that will make the city more viable and improve the quality of life it offers. Having become to a great degree commercially uninteresting because telematic instruments have superseded and marginalised it, the city will consequently be able to become a place of collective memory once more. It will have less to say, but what it does say will be impartial, selfless and not manipulative. It will once more relate its own history, tell the story of the people who shaped it, their culture, their ideas, their dreams, their hopes; and in doing so it will inspire other people – the people who live in the city and use the city – to dream, to hope, to think. It will not bombard an anonymous crowd with its wares, hustling for their spending power or votes, but will remind politically mature citizens of their own past and give them the hope of a better future. It will offer them places that are stimulating, places that hold memories, and also places of stillness.

If Archdeacon Frollo were to look at the city today, he would no doubt have even more reason than he did five hundred years ago to proclaim that "*ceci tuera cela*". He would recall the fact that vulgar corporate-identity

architecture has already become obsolescent, that the bright, glitzy lights of Piccadilly Circus or Times Square are about to fade, and that the failure of the digital city as an urban alternative is imminent. And yet maybe he would have a confident, or even downright amused, look on his face.

Virtual and real: the solid part of things

'… it is the people, not the walls, who make the community', is how the commander Nicias encouraged and consoled the beaten Greek army on the run in Thucydides' *History of the Peloponnesian War*. It is true that the built

city is only the outer shell surrounding what is vital for the principle of urbanity: the people who live in the city and live together in it as a community. However, this community needs a place in which to be active, a place with which it can identify. And, particularly in a world in which the promises of immateriality are seductive and sometimes even dazzling, it will become increasingly necessary to think seriously about the solid part of things. For just as we must not forget that information constantly needs more powerful machines (which therefore use more energy) to be able to fly through the air or whizz down a cable, similarly we must not overlook the fact that people still need tangible objects for certain tasks. In order to sit down, you need a chair. In order to live, you need a living space. In order to enjoy a stroll, you need a street or a square. Against a background of such simple facts, the scorn with which the trendy telepolis inhabitants look down upon those of us who still want to change things in the real city, the city built in stone and iron and wood and glass, becomes unfounded. The new city that is created in the data networks will not replace the traditional one, but at best complement it. And the traditional city will remain, will even become more important than it already was and is. And therefore it is all the more important to look after it: by means of intelligent urban design measures and good architecture.

It is not only tangible, practical reasons that speak in favour of a commitment to the solid, permanent aspect of the city. The computer's capacity to simulate things and situations is without question useful; but it must not mean that the actual experience of reality is superseded. Reality and its surrogate can and will coexist, as they have already started to. But their boundaries must not become blurred, their different possibilities and areas of application must not be confused. And against the background that the surrogate is spreading, reality with its incomparable wealth of information and irreplaceable quality of authenticity deserves to be more highly valued. This is also true, in fact particularly true, in the city.

The principle of substitution, the dictate of 'as if' did not begin with the breakthrough of the computer. Even the late nineteenth century had raised the masquerade to a method of urban composition, lending an external appearance of noble aristocratic palaces to common blocks of flats that were

usually built with only profit in mind. Our age has taken the game much further, and sometimes it seems that a building can be anything it likes – except itself: a house has to look like the backdrop for a fairy tale, an office building like a space station, a railway station like a shopping centre. But a shopping centre must imitate nothing less than the city itself: with bars, restaurants, cinemas, theatres, a market-place, and the inevitable galleria planted with artificial palm trees, in which – as prescribed by the operators – that very same urban life has to pulsate, which this whole crudely staged simulation has had a decisive role in destroying.

If now, thanks to the new communication technologies, there are no longer boundaries to the universe of the stand-in and the substitute action, a new process is not triggered in the city but rather an old one is carried to its utmost extremes. *Ad absurdum*. The result is that there are so many surrogates that the real thing becomes attractive again: not as a rarity with mere snob value, but as the vital antidote to deception and manipulation.

But what is the authentic in the city? Buildings that present themselves as they really are and do not believe they have to look like the trademark of themselves, their architects or their owners. Buildings whose function and structure are understandable and make sense, whose materials serve a purpose, have a name and are not an arbitrary costume. Streets which do not have loud and brash choreography but create unobtrusive and familiar-feeling places for movement, spending time, or sauntering, and are equipped with the attractions of the city such as cafés and shops. Squares which do not with their overpowering furniture become large, plush and unnecessarily exclusive living rooms, but which provide inviting, indeed stimulating, open spaces where the unplanned and unexpected can happen. And then trees; trees in parks, trees lining avenues, trees delimiting and framing squares, trees showing the changing seasons and weather. Expanses of water in which the city they are opening up and decorating is reflected, refracted and transfigured.

Return of the vehicle that can refine people

Reflections of this kind bear no trace of nostalgia. The drastic change into which the whirlpool of the telematic revolution has dragged us is unstoppable. Yet, just because it effects a general shift from the material to the immaterial it places a new value on the material, this gives it a new freedom. In its solid aspect, the city finds itself free of the utilitarian with which it has struggled since the industrial revolution. It also finds itself free from the commercial, which now, if we want it to or allow it to, comes directly into our living room. For many of the things which created the city, shaped it and sometimes formed a crust over it, the city is no longer suitable.

Exactly this, however, opens up an epochal opportunity for the city: to reflect upon its own most inherent functions and to try to fulfil these to the best of its ability. These include: giving people a dignified and friendly home with efficient infrastructure to match, a pleasant place to work, attractive places for recreation, and the possibility of moving quickly and freely between them.

And yet the responsibility the city has borne since it came into existence, which in fact forced it to come into existence, goes beyond pure usefulness and mere purpose-driven rationality. We do not want simply to live, shop, learn, work, go to the cinema and go for a walk. We want more. David Hume put his finger on this in his essay 'On Refinement in the Arts':

… Nor is it possible that, when enriched with science, and possessed of a fund of conversation, that [men] should be content to remain in solitude … they flock into cities … love to receive and communicate knowledge … to shew [sic] their wit or their breeding; their taste in conversation or breeding, in clothes or furniture, particular clubs and societies are everywhere formed: both sexes meet in an easy and sociable manner, and the tempers of men, as well as their behaviour, refine apace.

In line with the European Enlightenment, of which he represents one of the most prominent protagonists, Hume evokes the city as the vehicle that can improve and refine humankind; and he discovers the driving force of this

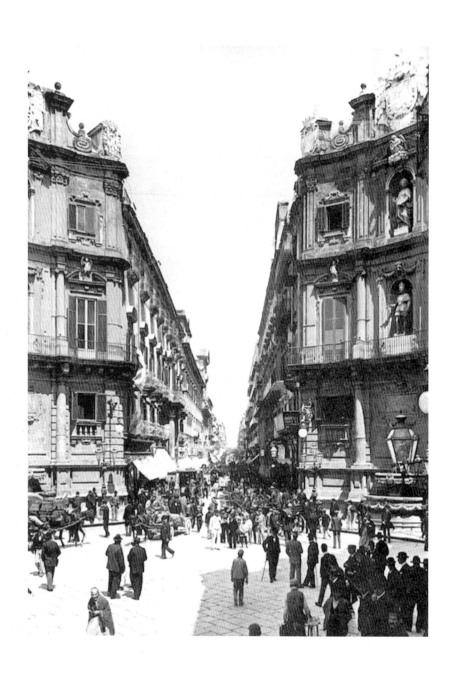

vehicle in the tendency, indeed passion, 'to receive and communicate knowledge'.

New spaces for a new *res publica*

This kind of exchange of knowledge and insight can, of course, take place to some extent in the data networks, but only to some extent. It is the very increase in options for virtuality that not only gives rise to a new yearning for the authentic but which reveals the centrality and the irreplaceability of real human relationships. No data highway, no matter how broad, is able to convey their richness. And, for human relationships of that kind, the city in the course of its history has created congenial places: the Greek agora, the Roman forum, the medieval market-place, the system of public spaces of the Renaissance, Baroque and neo-Classical periods, the boulevard and glazed arcades of the nineteenth century. The stoa, basilica, loggia. And, of course, the theatre, the pub, the café, the market-hall, the railway station, the bar. The city has to be able to provide more of these places, these types of buildings, these particular spaces – and invent new ones as well.

Nothing would be more erroneous than to see this as a purely hedonistic plea. The idea that friendly, human-scale streets and squares would be for the sole benefit of the nostalgic lady or gentleman of leisure or the *nouveau riche* shopping fanatic is a product, both typical and grotesque, of the era of the endless urban motorways and pedestrian precincts with their homely furniture. In truth, before it was occupied by technocrats and dedicated to commerce, the urban realm was the place of the *res publica per se* – the place in which it was born, discovered, cherished and administered.

In her book *Vita activa*, Hannah Arendt writes:

The public and private realm, as the world that is common to all of us, gathers people together and at the same time prevents them, as it were, from falling over one another and into one another. What makes things so difficult to bear in a mass society is actually not, or at least not primarily, to be found in the mass scale itself; it is far more that in it the world has lost its power to gather together, that is to separate and connect.

Of course, the telematic revolution cannot and will not evoke again the 'power to gather together'. However, what it can do, if used intelligently, is to create in the city the space in which citizens can rediscover this power; that public space that connects and separates both people and things, creates community and a sense of identity.

In this way the city of the telematic age could escape the nightmare of isolated individuals cut off from one another, each barricaded in his or her own living room, isolated from reality by its display and drifting in panic down the commercialised and manipulated data highway. Instead, it could become a place in which the same individuals who naturally possess the most up-to-date telematic appliances and enjoy their blessings shut them off and go out onto the street to get involved with their neighbours and fellow citizens, engage with them and work with them to create a community in which something better, more just and more joyful is alive than the society in which we live today.

'The Map is not the Territory'
The Unfinished Journey of the Situationist International

ANDREW HUSSEY

It is not by chance that the history of the Situationist International reads like an account of a military campaign. During their first, artistic phase (roughly speaking the period from 1957 to 1962), the Situationists declared a war of secession against what they contemptuously termed 'the civilisation of the image'.[1] They identified their enemies, in ascending order of importance, as work, leisure, boredom, advertising, modern art and, above all, the tendency of the present age to turn real life into an endless series of meaningless, frozen gestures or 'spectacles'. Their originality lay in the claim, delineated by the group's leading strategist Guy Debord, that 'the society of spectacle' could only be fought and defeated on its own terms.

Although the iconoclastic fury of the texts of this first period has remained undiminished by either the passage of time or academic scrutiny, it is the second, political phase, which has contributed most to the Situationists' legendary status. This period culminated in the 'revolutionary game' played out by the Situationists on the rue Gay-Lussac and in the Sorbonne during the events of May 1968. For a fleeting moment, as they engaged the enemy in the streets of Paris, the Situationists seemed to live up to their own expectations

as avatars of the high point of post-war revolutionary theory. It is, therefore, a cruel irony that since 1968 the Situationist International has largely been considered no more than a footnote in the cultural history of post-war France and that, since his death in 1994, Guy Debord has been hailed in France less as a revolutionary thinker than as a master of French prose.[2]

What I want to propose here, however, is that the theses of the Situationist International still represent, more than any other revolutionary force this century, the potential to disrupt the organisation of society in a way which would be irreversible. For the Situationists following from Henri Lefebvre argue that pleasure, technology, and everyday life are in themselves transformative agents which can and should be used as weapons against the society of the spectacle, even in a world where – as Guy Debord emphasises in his later writings – real political activity has been inexorably and inevitably replaced by integrated spectacle (*spectacle integré*).[3] Most importantly, the Situationists sought to separate their activity from the dead language of classical French Marxism by privileging method and action over historical process. In this way the Situationist project can be read as not simply an attack on the shibboleths of Marxist orthodoxy, but also as a critical method which reintroduces a Hegelian vocabulary – negativity, labour, alienation – into debates about the theory and representation of revolution. In this sense, the Situationists offer a critique of the language of modern politics as well as of its essential content.

The first question to ask, therefore, is how Situationist theory, and in particular the Situationist critique of urbanism, emerges out of the development of practice or a series of practices which offer a concrete, non-metaphorical form of analysis. Secondly, what importance does this process have on the status of Situationist theories of urbanism within the framework of a larger critique which is founded on principles of negation rather than the logic of contradiction?

Finally, it is crucial for my argument to note that the demands made by the Situationists were not only political but aesthetic. Situationist politics emerged directly out of a preoccupation with reintegrating an aesthetic system into daily life. It is therefore of great significance that the opening shots fired by

the Situationists in their war against culture were in the form of a critique of urbanism, and that the first site of Situationist guerrilla activity was the city itself.

'Strategies against architecture':
the theory of the *dérive* and the fall of Paris

In some cases, the city meant London where, following the footsteps of their hero De Quincey and guided by a drug-addicted fellow traveller, the Scots writer Alex Trocchi, the Situationist International reported on the 'unitary ambience' of Limehouse and protested against the planned destruction of Chinatown. It also meant Amsterdam, where the Dutch architect Constant Nieuwenhuys, who had originally coined the term 'situationist', collaborated with Guy Debord and experimented with an imaginary city he called New Babylon. It was also Venice, much admired by the Situationists for the dream-like quality of its architecture, where the English Situationist Ralph Rumney stalked Alan Ansen, Beat poet and intimate of William Burroughs, in a series of photographs which as a collage also form a map of the city. (Rumney returned to this theme for his major 1980s series 'The map is not the territory', also made in Venice.) Most importantly and most frequently, however, the city meant Paris.

Like Walter Benjamin, the Surrealists, or indeed Baudelaire, the Situationists saw Paris as a *topos*, which contained both poetic and political possibilities in its margins as well as at its centre. Unlike their precursors, however, the Situationists also saw the city as a future battleground for the conflict over the meaning of modernity. It is this battle for urban space, in a literal and metaphorical sense, which is in many ways the defining moment in the development of Situationist strategy.

Importantly, this battle was fought in real, practical terms as well as being a theoretical, speculative abstraction. The Situationists devoted a great deal of energy to developing techniques of 'psychogeography', varieties of what Iain Sinclair has recently termed ambulatory vandalism, which aimed at

fig. 1
Guy Debord and Asger Jorn
*The Naked City: illustration
de l'hypothèse des plaques
tournantes en
psychogéographie*
(reproduced in *Documents
rélatifs à la fondation de
l'internationale situationniste,*
Paris, Allia, 1985)

destabilising the spectacular organisation of the city. The most important of these techniques was the well-known practice of the drift, or *dérive*, in the course of which groups of Situationists would float across Paris in the pursuit of anarchy, play and poetry: Paris without spectacle. Their favoured places were those which, like the rue du Xavier-Privas, Square des Missions Étrangères, and the Canal Saint-Martin, moved observers, such as Michèle Bernstein, to 'salutary states of awe, melancholy, joy or terror'.[4]

The above is a well-documented version of Situationist practice and taken to be what is meant by 'Situationism'. For example, in *The Painting of Modern Life: Paris in the art of Manet and his followers*, the art historian T. J. Clark – now a Professor at Berkeley and briefly, in 1967, a member of the English Section of the Situationist International – argues, in strict Situationist terms, that what is termed Modern Art had its origins in the encounter between a newly consumerist society of late nineteenth-century Paris and a generation of artists who were deeply sceptical of the new city's Haussmannisation and pleasures. The ultimate situation for those who called themselves Situationists had been the Paris Commune, a moment when ordinary people seized control of their own lives in a revolutionary festival which actively negated the controlling principles of capital and consumerism. The failure of the Commune, the Situationists argued, and with which Clark agrees, was the moment when Paris began to be strangled by the demands of modernity.[5]

The *flânerie* which Clark describes in this book, and which he parallels to Situationist activity, is essentially, however, an ironic practice: the *flâneur* is a subject who remains at a fixed distance from the pleasures he (and it is always he) observes or consumes. The Situationist practice of *dérive*, on the other hand, is characterised by an active hostility to the representation of urban experience. The *dérive*, defined by the drunkenness of the subject and his relation to an environment which has lost shape, meaning or form, is a negation of the city as a site which invites the subject to remain detached from the object of its gaze. Unlike the intoxicated wanderings of Baudelaire, de Musset or Martin du Gard, Situationist practices are political acts which aim to reinstate lived experience as the true map of a city.

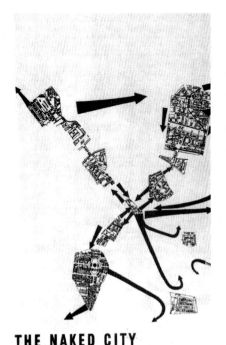

THE NAKED CITY

The theory of the *dérive* is indeed, as Patrick ffrench puts it, a '*détournement* of *flânerie* and its politicisation'. It reveals that 'the *flâneur* is at the mercy of reified social conditions without being aware of it and without any analysis'.[6] 'Haussmann's Paris', writes Debord, 'is a city built by an idiot, full of sound and fury, signifying nothing.' It is a city, which, in the name of rational organisation, has lost all sense of itself as a site for poetry, play, situations.

The *dérive*, as a practice that disorders and disorients the subject in the city, reveals for the Situationists the collision between poetry and its opposite. *Dérive* is an exercise in spatial projection, a rediscovery of the city as a labyrinth. Like Surrealist poetry, it is a collective practice which separates objects from their functions; as a fundamentally poetic game it reveals its opposite in an urban topography of fragmentation and dispersal. Paris, revealed in the analytic practice of *dérive*, is a fortress museum (*ville-musée gardée*). The fall of Paris as a spectacular city is therefore the necessary prelude to its reinvention as the *locus* of real creativity.[7]

The Naked City

The Situationists argue not only for an attack on the theory of urbanism, but most importantly for a defence of the meaning of Paris as a site which carries metaphorical and metonymic significance. This point is best demonstrated by one of the most well-known images associated with them, a screenprint by Guy Debord and Asger Jorn entitled *The Naked City: illustration de l'hypothèse des plaques tournantes en psychogéographie*.[8] The title of the piece, faithful to the Situationist practice of kidnapping (*détournement*), has been kidnapped from the famous American documentary of 1948 which portrayed hard-boiled cops at work in New York City. This film is particularly distinguished for the camera-work in its opening shot which swoops across

the cityscape at night, focusing on incidental details before returning to the broad cinematic sweep of panoramic vision.

In their own version of *The Naked City* Debord and Jorn draw a picture of Paris which borrows from this technique and which negates it. This psycho-geographical map is an attempt to capture the movement of the city in time without freezing it into spectacle. It is therefore necessarily fluid, continuous and opposed to the static language and principles of conventional map-making. It is a map of experience rather than of activity.

The map which Debord and Jorn drew traverses the section of Paris which was designated for redevelopment in the late 1950s. *The Naked City* is the negative visual corollary of de Gaulle's programme – the so-called 'reconquest of Paris' – which aimed to evacuate the working classes from Saint-Lazare, Gare du Nord, and Place de la République and move them to the neo-Corbusian barracks of Sarcelles. It is a map of a city which is being emptied of human activity and which is in the process of becoming a dead site, a city without a *telos*.

Across this map, which runs roughly from the Gare de Lyon, on the right, to a limit marked by the Palais Royal and the Jardins du Luxembourg on the left, is a movement which designates sites which are absent – Rue Sauvage, the Halle aux Vins, rue du Xavier-Privas. The Situationists protested at the destruction of these places, which they identified as having magical or poetic significance and which were therefore essential to the metaphorical meaning of the city. (Many of these sites would disappear shortly after the map was drawn.) The map comes to function for the Situationists as a metonymic echo of the absence of those sites which first defined the city of Paris as metaphor and experience. With time the cliché of *The Naked City* has not only been *détourné* but also *détraqué*, that is to say upset, unhinged and broken down. *The Naked City* is a metaphor which undoes itself.

A metaphor which cannot sustain itself, by definition, functions no longer in the literal sense of the term but rather as an ironic comment on the possibility of its original meaning; it is an absolutely negative form of discourse. The Situationist critique of urbanism, founded on the negative principles of the *dérive*, which actively opposes the possibility of meaning in

urbanism, is just such a form of discourse. This is how, I think, *The Naked City* and much of the Situationist critique of urbanism comes to be not only a map or series of maps which inform the development of a broader critique, but also a premonition.

Territory and city

In the section of *The Society of the Spectacle* devoted to 'Environmental Planning', Debord quotes two main sources, apart from Marx and Hegel, to support his theses. The first is Lewis Mumford, whose famous book *The City in History* was totemic for the Situationists. The second source is Machiavelli, whom Debord quotes as the *envoi* to this section:

And he who becomes master of a city used to being free and does not destroy her can expect to be destroyed by her, because always she has as pretext in rebellion the name of liberty and her old customs, which through either length of time or benefits are forgotten, and in spite of anything that can be done or foreseen, unless citizens are disunited or dispersed, they do not forget that name and those institutions.[9]

Machiavelli represents for Debord an ideal of intellectual action and political reasoning. For Machiavelli politics and morality are inextricably linked and are, moreover, the defining criteria for the organisation of the state. This is not to say that morality must shape political life, or vice versa, but that there can be no divorce between the ethical imperatives of political behaviour and social existence. Machiavelli terms the coexistence of these conflicting demands *virtù*, and says that this principle is, in fact, the highest form of political morality.

Also important for Debord is Machiavelli's insistence that there should be no conflict between 'the morality of the souls and the morality of the city'. *Virtù* is, moreover, 'the quality of mind and action that creates, saves or maintains cities'. The opposite of *virtù* is *ozio*: indolence, stupidity or corruption, a quality which implies not only weakness but a dangerous lack of civic culture which destroys the soul of a people or citizenry.[10] It is important to

note that *virtù,* although it comes from the Latin *vir* (man) and *virtus* (what is proper to a man), cannot be translated as virtue but as virtuosity. *Virtù* is not only a theory of action but a technique.

Virtù is the key concept which Debord applied to the map of his own life which he drew in two volumes of memoirs called *Panégyrique.* In the first volume, Debord presents us with an account of his life, art and politics with a series of quotations and references from Cardinal de Retz, Machiavelli, François Villon and Castiglione. In the second volume, the same account is given in a series of drawings, photographs and maps which correspond to or match the original text of the first volume.[11] Some of these have a clear meaning: 1953, for example, is represented by a photograph of Debord's graffiti from a wall on the rue de Seine in that year, 'Ne Travaillez Jamais' – a famous and ubiquitous slogan taken up in May 1968. Similarly, the year 1968 is announced by way of a detail from a press photograph showing Debord in charge of a Situationist delegation in the occupied Sorbonne. Other images celebrate the group of hooligans (*bande de voyous*) – Asger Jorn, Ivan Chtcheglov, Michèle Bernstein, Alice Becker-Ho – who were the lovers, friends and comrades who formed Debord's entourage during the heroic years of the Situationist adventure. There are maps of *Paris habité* and photographs of bars, cafés and apartments where a life was lived. There is also, most importantly, a photograph of the author's hand (*la main de l'auteur*); like his literary hero Laurence Sterne, Debord privileged the imprint of the author on his work as having an extra-literary value which marked the essential relation between life, art and subjectivity. Debord emphasised above all that these images have not been mediated by the commodity-spectacle and separated from their real meaning: they exist, instead, as iconographic proof of the Situationist notion that in the twentieth century life can be lived as an adventure within the city, outside of the all-pervasive, controlling narrative of the society of the spectacle.

It is, then, especially significant that the 'Environmental Planning' section of *Society of the Spectacle* is called in French *l'aménagement du territoire.* In French, and in Italian, *territoire* (territory) has a political meaning, which has not been fully translated into English. As Lewis Mumford notes, *territoire* is

separate from the city in the sense that it is land, an area or a zone, which belongs to the state or government and not to its inhabitants. This makes it distinct from a political entity which makes the citizenry owners of the city. *Le territoire Français* refers not to land or people but is an abstraction defined by the organising administration to which the individual citizen stands in opposition. In *The City in History* Mumford describes the end of the Middle Ages and the onset of an early modern capital economy as emblematic of such an opposition: 'The age of free cities, with their widely diffused cultures and their relatively democratic modes of association, gave way to an age of absolute cities.'[12]

It is this tension between city and territory, says Mumford, which is the defining feature of the early modern world. In the same way for Debord it is the tension between the clandestine nature of private life (*la clandestinité de la vie privée*) and the spectacular society of surveillance and control which is the defining feature of the city in our age. If, however, as we infer from Debord, the Situationist city has already existed in the labyrinths and passages of the city-state of late medieval Italy, what chance can there be of its return in an era where the technology of separation – as the Situationists describe the occult powers of media hypnosis – reinforces daily what they call the powers of spectacular domination? The answer is that for Debord the Situationist city, like Thomas More's Amaraute, the city-state which lies at the heart of Utopia, is a city of the mind. This does not mean, however, that it does not exist: the maps of Barcelona, Florence and *Paris habité* are maps of cities defined by Debord and his *virtù,* that is to say historical life as opposed to historical lack. Debord quotes Paul deGondi, also known as Cardinal de Retz, active in the troubles of the Fronde, and follower of Machiavelli, improvising desperately his own panegyric before the Parlement de Paris: 'In bad times, I did not abandon the city; in good times, I had no private interests; in desperate times I feared nothing.'[13]

fig. 2
Guy Debord
Paris Habité
(reproduced in *Panégyrique*,
volume two, Paris, Fayard, 1997)

Historical life

In the film *Guy Debord son art et son temps*, Debord asserts his relationship to his time by quoting Baudelaire's famous poem *Le Cygne* in a scene which precedes his account of the final catastrophe unleashed by the technology of separation:

*Le Vieux Paris n'est plus (La forme d'une ville
change plus vite, hélas, que le cœur d'un mortel)*

Old Paris is no more (the form of a city
changes faster, alas, than the heart of mortal man)

Debord here compares himself to Baudelaire's swan, cut out of history and time by the relentless sweep of Haussmann's Boulevards, constructed not only to ease the movement of troops and arms across Paris in times of insurrection, but also to erase the historical memory of the proletariat. Debord thus places himself and his art, again like Baudelaire's swan, against a modernity which has been evacuated of historical sense.

Although Debord in his later years wrote as if the revolutionary moment had passed, I do not think that the Situationist critique of urbanism is in any sense anachronistic. Indeed, as debate about the structural meaning as well as the structural function of cities intensifies, the Situationist notions of history, space and subjectivity in the city are increasingly valid. The occupation of cities by historical absence is defined by Debord as the central fact of contemporary urbanism: 'Obviously, it is precisely because the liberation of history, which must take place in the cities, has not happened that forces of historical absence have set about their own exclusive landscape there.' Contemporary urbanism's main problem, therefore, is the movement of people, vehicles and commodities across a cityscape in which nothing happens and, as Debord writes, 'human movement is something to be consumed and deprived of its temporal aspect.'[14] Debord sees this as an abstract negativity which orders the controlling narrative of the spectacle: 'This society eliminates distance only to reap distance internally in the form of spectacular separation.'[15] Paul Virilio's assertion that 'social space is now

Haussmann. It is an apt metaphor for the journey, without map or compass, of the Situationist International: 'Our life is a journey in winter and night / We search for a way where there is no light.'[19]

The military metaphors used by the Situationists have a political as well as a poetic meaning. For Debord, in particular, it was significant that Carl von Clausewitz was a contemporary of Hegel and that von Clausewitz's critique of the shock waves sent round Europe by the French Revolution was founded in practical knowledge of the battlefield. The essential nature of combat, as described by von Clausewitz and defined by the Situationists, is that in war, as in politics, there can be no isolated act. It is this aspect of Situationist thinking which makes them our contemporaries rather than mere legends. In a world where a lack of ideology is the dominant value, the demand made by the Situationists for a political language which can express negation as well as contradiction is not anachronistic but rather an ever more relevant appeal for a return to real communication.

It may well be true, as the Situationists themselves believed, that the Situationist International offers the only authentic political language of the age, in fact the only living language of the century. It may even be true, as Guy Debord told us in his earliest works, that the time of the Situationist International has yet to come, in which case the Situationist adventure is literally an unfinished journey without maps.

NOTES

1. This objective is indeed first delineated in the text 'La ligne générale', signed by Michèle Bernstein, M. Dahou, Véra and Gil J. Wolman in no. 14 of the 'pre-Situationist' journal *Potlatch*. See *Potlatch 1954/1957* (Paris, Allia, 1997), p. 51.

2. For accounts of Debord's current literary reputation in Paris see Andrew Hussey, 'Saint Guy de Paris', *Times Literary Supplement*, 4 October 1996, p. 10; Jacques-Emile Mireil, 'Les situs, précurseurs de mai 68', 'Éloge de la révolte', *Magazine littéraire* 365, May 1998, pp. 64–67; Francis Marmande, 'L'aube de l'internationale situationnniste', *Le Monde*, 22 June 1998, p. 12. An interesting perspective on Debord's legacy can be found in a text by Philippe Sollers, Debord's most prominent literary champion. See Philippe Sollers, 'La Guerre selon Guy Debord', in *La Guerre du Goût* (Paris, Gallimard, 1997), pp. 442–45.

3. Guy Debord, *Commentaires sur la société du spectacle* (Paris, Gallimard, 1992), p. 21.

4. The clearest delineation of a Situationist urban aesthetic as formulated by Bernstein can be found in the letter sent to *The Times* and reprinted in *Potlatch 23*, p. 107.

5. See T. J. Clark, *The Painting of Modern Life: Paris in the Art of Manet and his followers* (London, Thames & Hudson, 1996), pp. 68–69.

6. Patrick ffrench, 'Dérive: The détournement of the flâneur', in Andrew Hussey and Gavin Bowd (eds), *The Hacienda Must Be Built: On the Legacy of Situationist Revolt* (Manchester: AURA, 1997), p. 44.

7. Guy Debord, 'La Chute de Paris', *L'internationale situationniste* 4, 1960 (Paris, Éditions Gérard Lebovici, 1975), p. 7.

8. For a full description and account of this illustration see Simon Sadler, *The Situationist City* (Cambridge, MA, MIT Press, 1998), pp. 20–21.

9. Guy Debord, *The Society of the Spectacle*, translated by Donald Nicholson-Smith (New York, Zone, 1994), p. 119.

10. This fundamental distinction is described in Bernard Crick (ed.), *Machiavelli: The Discourses* (London, Penguin, 1970), pp. 41–45

11. See *Panégyrique, tome premier* (Paris, Gallimard, 1993), and Patrick Mosconi (ed.), *Panégyrique, tome second*, (Paris, Fayard, 1997).

12. Lewis Mumford, *The City in History* (London, Duckworth, 1960), p. 134.

13. *Panégyrique, tome premier*, p. 32.

14. Debord, *The Society of the Spectacle*, p. 126.

15. Debord, *The Society of the Spectacle*, p. 120.

16. This is a reading of Virilio's relation to Situationism made by Patrick ffrench in 'Dérive', pp. 42–43. See also Paul Virilio, *L'Inertie Polaire* (Paris, Christian Bourgeois, 1990), p. 9.

17. ffrench, 'Dérive', p. 42.

18. Debord, *The Society of the Spectacle*, p. 126.

19. Guy Debord, *Mémoires* (Paris, Jean-Jacques Pauvert au Belles Lettres, 1993), unpaginated.

All translations are by the author unless otherwise noted.

Extract from 'Max Ferber' in *The Emigrants* *

W. G. SEBALD

They come when night falls
to search for life

Until my twenty-second year I had never been further away from home than a
five- or six-hour train journey, and it was because of this that in the autumn of
1966, when I decided, for various reasons, to move to England, I had a barely
adequate notion of what the country was like or how, thrown back entirely on
my own resources, I would fare abroad. It may have been partly due to my
inexperience that I managed to weather the two-hour night flight from Kloten
airport to Manchester without too many misgivings. There were only a very
few passengers on board, and, as I recall, they sat wrapped up in their coats,
far apart in the half-darkness of the cold body of the aircraft. Nowadays,
when usually one is quite dreadfully crammed in together with one's fellow
passengers, and aggravated by the unwanted attentions of the cabin crew, I
am frequently beset with a scarcely containable fear of flying; but at that time,
our even passage through the night skies filled me with a sense (false, as I

* This excerpt is from the final part of W.G. Sebald's *The Emigrants*, translated by Michael Hulse
(London, The Harvill Press, 1997).

now know) of security. Once we had crossed France and the Channel, sunk darkness below, I gazed down lost in wonder at the network of lights that stretched from the southerly outskirts of London to the Midlands, their orange sodium glare the first sign that from now on I would be living in a different world. Not until we were approaching the Peak District south of Manchester did the strings of street lights gradually peter out into the dark. At the same time, from behind a bank of cloud that covered the entire horizon to the east, the disc of the moon rose, and by its pale glow the hills, peaks and ridges which had previously been invisible could be seen below us, like a vast, ice-grey sea moved by a great swell. With a grinding roar, its wings trembling, the aircraft toiled downwards until we passed by the strangely ribbed flank of a long, bare mountain ridge seemingly close enough to touch, and appearing to me to be rising and sinking like a giant recumbent body, heaving as it breathed. Looping round in one more curve, the roar of the engines steadily increasing, the plane set a course across open country. By now, we should have been able to make out the sprawling mass of Manchester, yet one could see nothing but a faint glimmer, as if from a fire almost suffocated in ash. A blanket of fog that had risen out of the marshy plains that reached as far as the Irish Sea had covered the city, a city spread across a thousand square kilometres, built of countless bricks and inhabited by millions of souls, dead and alive.

Although only a scant dozen passengers had disembarked at Ringway airport from the Zurich flight, it took almost an hour until our luggage emerged from the depths, and another hour until I had cleared customs: the officers, understandably bored at that time of the night, suddenly mustered an alarming degree of exactitude as they dealt with me, a rare case, in those days, of a student who planned to settle in Manchester to pursue research, bringing with him a variety of letters and papers of identification and recommendation. It was thus already five o'clock by the time I climbed into a taxi and headed for the city centre. In contrast to today, when a continental zeal for business has infected the British, in the Sixties no one was out and about in English cities so early in the morning. So, with only an occasional traffic light to delay us, we drove swiftly through the not unhandsome

suburbs of Gatley, Northenden and Didsbury to Manchester itself. Day was just breaking, and I looked out in amazement at the rows of uniform houses, which seemed the more rundown the closer we got to the city centre. In Moss Side and Hulme there were whole blocks where the doors and windows were boarded up, and whole districts where everything had been demolished. Views opened up across the wasteland towards the still immensely impressive agglomeration of gigantic Victorian office blocks and warehouses, about a kilometre distant, that had once been the hub of one of the nineteenth century's miracle cities but, as I was soon to find out, was now almost hollow to the core. As we drove in among the dark ravines between the brick buildings, most of which were six or eight storeys high and sometimes adorned with glazed ceramic tiles, it turned out that even there, in the heart of the city, not a soul was to be seen, though by now it was almost a quarter to six. One might have supposed that the city had long since been deserted, and was left now as a necropolis or mausoleum. The taxi driver, whom I had asked to take me to a hotel that was (as I put it) not too expensive, gave me to understand that hotels of the kind I wanted were rare in the city centre, but after driving around a little he turned off Great Bridgewater Street into a narrow alleyway and pulled up at a house scarcely the width of two windows, on the soot-blackened front of which was the name AROSA in sweeping neon letters.

 Just keep ringing, said the driver as he left. And I really did have to push the bell long and repeatedly before there was a sign of movement within. After some rattling and shooting of bolts, the door was opened by a lady with curly blonde hair, perhaps not quite forty, with a generally wavy, Lorelei-like air about her. For a while we stood there in wordless confrontation, both of us with an expression of disbelief, myself beside my luggage and she in a pink dressing gown that was made of a material found only in the bedrooms of the English lower classes and is unaccountably called candlewick. Mrs Irlam – Yes, Irlam like Irlam in Manchester, I would later hear her saying down the phone time and again – Mrs Irlam broke the silence with a question that summed up both her jolted state, roused from her sleep, and her amusement at the sight of me: And where have you sprung from? – a question which she promptly

answered herself, observing that only *an alien* would show up on her
doorstep at such an hour on a blessed Friday morning with a case like that.
But then, smiling enigmatically, Mrs Irlam turned back in, which I took as a
sign to follow her. We went into a windowless room off the tiny hall, where a
roll-top desk crammed to bursting with letters and documents, a mahogany
chest stuffed with an assortment of bedclothes and candlewick bedspreads,
an ancient wall telephone, a keyrack, and a large photograph of a pretty
Salvation Army girl, in a black varnished frame, all had, it seemed to me, a
life entirely of their own. The girl was in uniform, standing in front of an ivy-
covered wall and holding a glistening flugelhorn in the crook of her arm.
Inscribed on the slightly foxed *passe-partout,* in a flowing hand that leant
heavily to one side, were the words: *Gracie Irlam, Urmston nr Manchester,
17 May 1944.* Third floor, she said, and, nodding across the hall, her eyebrows
raised, added: the lift's over there. The lift was so tiny that I only just fitted in
with my case, and its floor was so thin that it sagged beneath the weight of
even a single passenger. Later I hardly used it, although it took me quite some
time before I could find my way around the maze of dead-end corridors,
emergency exits, doors to rooms, toilets and fire escapes, landings and
staircases. The room that I moved into that morning, and did not move out of
until the following spring, was carpeted in a large floral pattern, wallpapered
with violets, and furnished with a wardrobe, a washstand, and an iron
bedstead with a candlewick bedspread. From the window there was a view
onto semi-derelict slate-roofed outbuildings below and a back yard where
rats thronged all that autumn until, a week or so before Christmas, a little
ratcatcher by the name of Renfield turned up several times with a battered
bucket full of rat poison. He doled the poison out into various corners, drains
and pipes, using a soup spoon tied to a short stick, and for a few months the
number of rats was considerably reduced. If one looked out across the yard,
rather than down into it, one saw the many-windowed deserted depot of the
Great Northern Railway Company, a little way beyond a black canal, where
sometimes lights would flit about erratically at night.

The day of my arrival at the Arosa, like most of the days, weeks and
months to come, was a time of remarkable silence and emptiness. I spent

the morning unpacking my suitcase and bags, stowing away my clothing and
linen, and arranging my writing materials and other belongings; then, tired
after a night of travelling, I fell asleep on my iron bed, my face buried in the
candlewick bedspread, which smelled faintly of violet-scented soap. I did not
come to till almost half past three, when Mrs Irlam knocked at my door.
Apparently by way of a special welcome, she brought me, on a silver tray, an
electric appliance of a kind I had never seen before. She explained that it was
called a *teas-maid*, and was both an alarm clock and a tea-making machine.
When I made tea and the steam rose from it, the shiny stainless steel
contraption on its ivory-coloured metal base looked like a miniature power
plant, and the dial of the clock, as I soon found as dusk fell, glowed a
phosphorescent lime green that I was familiar with from childhood and which

I had always felt afforded me an unaccountable protection at night. That may be why it has often seemed, when I have thought back to those early days in Manchester, as if the tea maker brought to my room by Mrs Irlam, by Gracie – you must call me Gracie, she said – as if it was that weird and serviceable gadget, with its nocturnal glow, its muted morning bubbling, and its mere presence by day, that kept me holding on to life at a time when I felt a deep sense of isolation in which I might well have become completely submerged. Very useful, these are, said Gracie as she showed me how to operate the teas-maid that November afternoon; and she was right. After my initiation into the mysteries of what Gracie called an *electrical miracle*, we went on talking in a friendly fashion, and she repeatedly emphasised that her hotel was a quiet establishment, even if sometimes in the evenings there was (as she put it) a certain commotion. But that need not concern you. It's travelling gentlemen that come and go. And indeed, it was not until after office hours that the doors would open and the stairs creak at the Hotel Arosa, and one would encounter the gentlemen Gracie had referred to, bustling characters clad almost without exception in tattered gabardine coats or macs. Not until nearly eleven at night did the toings and froings cease and the garish women disappear – whom Gracie would refer to, without the slightest hint of irony, with a hold-all phrase she had evidently coined herself, as *the gentlemen's travelling companions*.

Every evening of the week, the Arosa was bustling with salesmen and clerks, but on Saturday evening, as in the entire rest of the city centre, there was no sign of life. Interrupted only occasionally by stray customers she called *irregulars*, Gracie would sit at the roll-top desk in her office doing the books. She did her best to smooth out the grey-green pound notes and brick-red ten-shilling notes, then laid them carefully in piles, and, whispering as if at some mystical rite, counted them until she had come up with the same total at least twice. She dealt with the coins no less meticulously; there was always a considerable quantity, and she stacked them in even columns of copper, brass and silver before she set about calculating the total, which she did partly by manual and partly by mathematical means, first converting the pennies, threepenny bits and sixpences to shillings and then the shillings, florins and

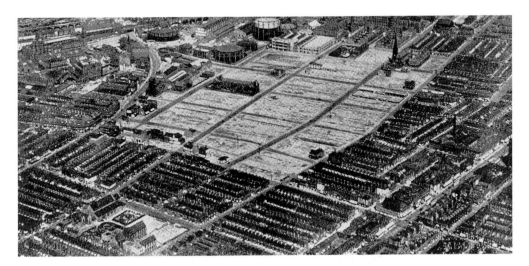

half crowns into pounds. The final conversion that then followed, of the pound total thus arrived at into the guineas which were at that time still the customary unit in better business establishments, always proved the most difficult part of this financial operation, but without a doubt it was also its crowning glory. Gracie would enter the sum in guineas in her ledger, sign and date it, and stow the money in a Pickley & Patricroft safe that was built into the wall by the desk. On Sundays, she would invariably leave the house early in the morning, carrying a small patent leather case, only to return, just as unfailingly, at lunchtime on the Monday.

As for myself, on those Sundays in the utterly deserted hotel I would regularly be overcome by such a sense of aimlessness and futility that I would go out, purely in order to preserve an illusion of purpose, and walk about amidst the city's immense and time-blackened nineteenth-century buildings, with no particular destination in mind. On those wanderings, when winter light flooded the deserted streets and squares for the few rare hours of real daylight, I never ceased to be amazed by the completeness with which anthracite-coloured Manchester, the city from which industrialisation had spread across the entire world, displayed the clearly chronic process of its impoverishment and degradation to anyone who cared to see. Even the

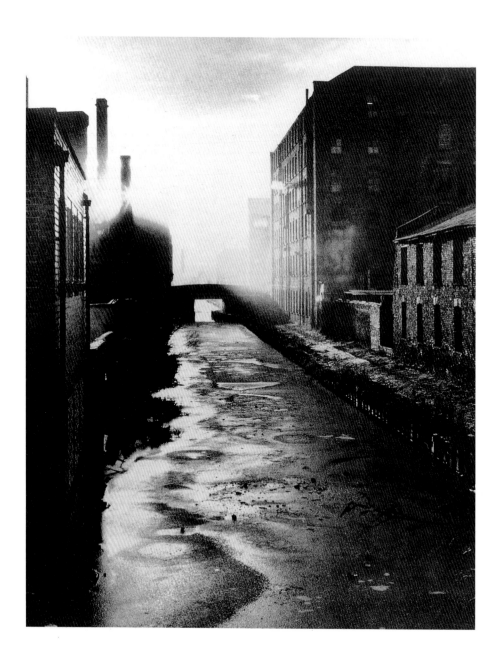

grandest of the buildings, such as the Royal Exchange, the Refuge Assurance Company, the Grosvenor Picture Palace, and indeed the Piccadilly Plaza, which had been built only a few years before, seemed so empty and abandoned that one might have supposed oneself surrounded by mysterious façades or theatrical backdrops. Everything then would appear utterly unreal to me, on those sombre December days when dusk was already falling at three o'clock, when the starlings, which I had previously imagined to be migratory songbirds, descended upon the city in dark flocks that must have numbered hundreds of thousands, and, shrieking incessantly, settled close together on the ledges and copings of warehouses for the night.

Little by little my Sunday walks would take me beyond the city centre to districts in the immediate neighbourhood, such as the one-time Jewish quarter around the star-shaped complex of Strangeways prison, behind Victoria Station. This quarter had been a centre for Manchester's large Jewish community until the inter-war years, but those who lived there had moved into the suburbs and the district had meanwhile been demolished by order of the municipality. All I found still standing was one single row of empty houses, the wind blowing through the smashed windows and doors; and, by way of a sign that someone really had once been there, the barely decipherable brass plate of a one-time lawyers' office, bearing names that had a legendary ring to my ear: Glickmann, Grunwald and Gottgetreu. In Ardwick, Brunswick, All Saints, Hulme and Angel Fields too, districts adjoining the centre to the south, whole square kilometres of working-class homes had been pulled down by the authorities, so that, once the demolition rubble had been removed, all that was left to recall the lives of thousands of people was the grid-like layout of the streets. When night fell upon those vast spaces, which I came to think of as the Elysian Fields, fires would begin to flicker here and there and children would stand around them or skip about, restless shadowy figures. On that bare terrain, which was like a glacis around the heart of the city, it was in fact always and only children that one encountered. They strayed in small groups, in gangs, or quite alone, as if they had nowhere that they could call home. I remember, for instance, late one November afternoon, when the white mist was already rising from the ground, coming across a little boy at a crossroads

in the midst of the Angel Fields wasteland, with a Guy stuffed with old rags on a hand-cart: the only person out and about in the whole area, wanting a penny for his silent companion.

It was early the following year, if I remember correctly, that I ventured further out of the city, in a southwesterly direction, beyond St George and Ordsall, along the bank of the canal across which, from my window, I could see the Great Northern Railway Company depot. It was a bright, radiant day, and the water, a gleaming black in its embankment of massive masonry blocks, reflected the white clouds that scudded across the sky. It was so strangely silent that (as I now think I remember) I could hear sighs in the abandoned depots and warehouses, and was frightened to death when a number of seagulls, squawking stridently, all of a sudden flew out of the shadow of one of the high buildings, into the light. I passed a long-disused gasworks, a coal depot, a bonemill, and what seemed the unending cast-iron palisade fence of the Ordsall slaughterhouse, a Gothic castle in liver-coloured brick, with parapets, battlements, and numerous turrets and gateways, the sight of which absurdly brought to my mind the name of Haeberlein & Metzger, the Nuremberg *Lebkuchen* makers; whereupon that name promptly stuck in my head, a bad joke of sorts, and continued to knock about there for the rest of the day. Three quarters of an hour later I reached the port of Manchester, where docks kilometres in length branched off the Ship Canal as it entered the city in a broad arc, forming wide side-arms and surfaces on which one could see nothing had moved for years. The few barges and freighters that lay far apart at the docksides, making an oddly broken impression, put me in mind of some massive shipping disaster. Not far from the locks at the harbour mouth, on a road that ran from the docks to Trafford Park, I came across a sign on which TO THE STUDIOS had been painted in crude brush-strokes. It pointed in to a cobbled yard in the middle of which, on a patch of grass, an almond tree was in blossom. At one time the yard must have been part of a carriage business, since it was enclosed partly by stables and outbuildings and partly by one- or two-storey buildings that had formerly been living quarters and office premises. In one of these seemingly deserted buildings was a studio which, in the months to come, I visited as often as I

thought acceptable, to talk to the painter who had been working there since the late Forties, ten hours a day, the seventh day not excepted.

When one entered the studio it was a good while before one's eyes adjusted to the curious light, and, as one began to see again, it seemed as if everything in that space, which measured perhaps twelve metres by twelve and was impenetrable to the gaze, was slowly but surely moving in upon the middle. The darkness that had gathered in the corners, the puffy tidemarked plaster and the paint that flaked off the walls, the shelves overloaded with books and piles of newspapers, the boxes, work benches and side tables, the wing armchair, the gas cooker, the mattresses, the crammed mountains of papers, crockery and various materials, the paint pots gleaming carmine red, leaf green and lead white in the gloom, the blue flames of the two paraffin heaters: the entire furniture was advancing, millimetre by millimetre, upon the central space where Ferber had set up his easel in the grey light that entered through a high north-facing window layered with the dust of decades. Since he applied the paint thickly, and then repeatedly scratched it off the canvas as his work proceeded, the floor was covered with a largely hardened and encrusted deposit of droppings, mixed with coal dust, several centimetres thick at the centre and thinning out towards the outer edges, in places resembling the flow of lava. This, said Ferber, was the true product of his continuing endeavours and the most palpable proof of his failure. It had always been of the greatest importance to him, Ferber once remarked casually, that nothing should change at his place of work, that everything should remain as it was, as he had arranged it, and that nothing further should be added but the debris generated by painting and the dust that continuously fell and which, as he was coming to realise, he loved more than anything else in the world. He felt closer to dust, he said, than to light, air or water. There was nothing he found so unbearable as a well-dusted house, and he never felt more at home than in places where things remained undisturbed, muted under the grey, velvety sinter left when matter dissolved, little by little, into nothingness. And indeed, when I watched Ferber working on one of his portrait studies over a number of weeks, I often thought that his prime concern was to increase the dust. He drew with vigorous abandon,

frequently going through half a dozen of his willow-wood charcoal sticks in the shortest of time; and that process of drawing and shading on the thick, leathery paper, as well as the concomitant business of constantly erasing what he had drawn with a woollen rag already heavy with charcoal, really amounted to nothing but a steady production of dust, which never ceased except at night. Time and again, at the end of a working day, I marvelled to see that Ferber, with the few lines and shadows that had escaped annihilation, had created a portrait of great vividness. And all the more did I marvel when, the following morning, the moment the model had sat down and he had taken a look at him or her, he would erase the portrait yet again, and once more set about excavating the features of his model, who by now was distinctly wearied by this manner of working, from a surface already badly damaged by the continual destruction. The facial features and eyes, said Ferber, remained ultimately unknowable for him. He might reject as many as forty variants, or smudge them back into the paper and overdraw new attempts upon them; and if he then decided that the portrait was done, not so much because he was convinced that it was finished as through sheer exhaustion, an onlooker might feel that it had evolved from a long lineage of grey, ancestral faces, rendered unto ash but still there, as ghostly presences, on the harried paper.

As a rule, Ferber spent the mornings before he began work, and the evenings after he left the studio, at a transport café near Trafford Park, which bore the vaguely familiar name Wadi Halfa. It probably had no licence of any kind, and was located in the basement of an otherwise unoccupied building that looked as if it might fall down at any moment. During the three years I spent in Manchester, I sought out Ferber at least once a week at that curious hostelry, and was soon as indifferent as he was to the appalling dishes, a hybrid of the English and the African, that were prepared by the Wadi Halfa's cook, with an incomparable stylish apathy, in a set-up behind the counter that resembled a field kitchen. With a single, sweeping, seemingly slow-motion movement of his left hand (his right was always in his trouser pocket) the cook could take two or three eggs from the box, break them into the pan, and dispose of the shells in the bin. Ferber told me that this cook, who was almost

two metres tall, had once been a Maasai chieftain. Now close to eighty, he had travelled (said Ferber), by which highways and byways he could not say, from the south of Kenya to the north of England, in the post-war years. There he soon learnt the rudiments of local cooking, and, giving up the nomadic life, had settled in to his present trade. As for the waiters, noticeably more numerous than the customers, who stood or sat around at the Wadi Halfa wearing expressions of the utmost boredom, Ferber assured me that they were without exception the chieftain's sons, the eldest probably somewhat over sixty, the youngest twelve or thirteen. Since they were each as slim and tall as the other, and all displayed the same disdain in their fine, even features, they were scarcely distinguishable, especially as they would take over from each other at irregular intervals, so that the team of waiters currently on duty was continuously changing. Nonetheless, Ferber, who had observed them closely and used the differences in their ages as an aid to identification, was of the opinion that there were neither more nor less than a dozen waiters, all told, whereas I for my part could never manage to picture those not present at any given moment. It is also worth mentioning that I never once saw any women at the Wadi Halfa, neither family or companions of the boss or his sons nor indeed customers, the clientele being chiefly workmen from the demolition companies then busy throughout Trafford Park, lorry divers, refuse collectors and others who happened to be out and about.

At every hour of the day and night, the Wadi Halfa was lit by flickering, glaringly bright neon light that permitted not the slightest shadow. When I think back to our meetings in Trafford Park, it is invariably in that unremitting light that I see Ferber, always sitting in the same place in front of a fresco painted by an unknown hand that showed a caravan moving forward from the remotest depths of the picture, across a wavy ridge of dunes, straight towards the beholder. The painter lacked the necessary skill, and the perspective he had chosen was a difficult one, as a result of which both the human figures and the beasts of burden were slightly distorted, so that, if you half shut your eyes, the scene looked like a mirage, quivering in the heat and light. And especially on days when Ferber had been working in charcoal, and the fine powdery dust had given his skin a metallic sheen, he seemed to have

just emerged from the desert scene, or to belong in it. He himself once remarked, studying the gleam of graphite on the back of his hands, that in his dreams, both waking and by night, he had already crossed all the earth's deserts of sand and stone. But anyway, he went on, avoiding any further explanation, the darkening of his skin reminded him of an article he had recently read in the paper about silver poisoning, the symptoms of which were not uncommon among professional photographers. According to the article, the British Medical Association's archives contained the description of an extreme case of silver poisoning: in the 1930s there was a photographic lab assistant in Manchester whose body had absorbed so much silver in the course of a lengthy professional life that he had become a kind of photographic plate, which was apparent in the fact (as Ferber solemnly informed me) that the man's face and hands turned blue in strong light, or, as one might say, developed.

One summer evening in 1966, nine or ten months after my arrival in Manchester, Ferber and I were walking along the Ship Canal embankment, past the suburbs of Eccles, Patricroft and Barton upon Irwell on the other side of the black water, towards the setting sun and the scattered outskirts where occasional views opened up, affording an intimation of the marshes that extended there as late as the mid nineteenth century. The Manchester Ship Canal, Ferber told me, was begun in 1887 and completed in 1894. The work was mainly done by a continuously reinforced army of Irish navvies, who shifted some sixty million cubic metres of earth in that period and built the gigantic locks that would make it possible to raise or lower ocean-going steamers up to 150 metres long by five or six metres. Manchester was then the industrial Jerusalem, said Ferber, its entrepreneurial spirit and progressive vigour the envy of the world, and the completion of the immense canal project had made it the largest inland port on earth. Ships of the Canada & Newfoundland Steamship Company, the China Mutual Line, the Manchester Bombay General Navigation Company, and many other shipping lines, plied the docks near the city centre. The loading and unloading never stopped: wheat, nitre, construction timber, cotton, rubber, jute, train oil, tobacco, tea, coffee, cane sugar, exotic fruits, copper and iron ore, steel, machinery, marble

and mahogany – everything, in fact, that could possibly be needed, processed or made in a manufacturing metropolis of that order. Manchester's shipping traffic peaked around 1930 and then went into an irreversible decline, till it came to a complete standstill in the late Fifties. Given the motionlessness and deathly silence that lay upon the canal now, it was difficult to imagine, said Ferber, as we gazed back at the city sinking into the twilight, that he himself, in the post-war years, had seen the most enormous freighters on this water. They would slip slowly by, and as they approached the port they passed amidst houses, looming high above the black slate roofs. And in winter, said Ferber, if a ship suddenly appeared out of the mist when one least expected it, passed by soundlessly, and vanished once more in the white air, then for me, every time, it was an utterly incomprehensible spectacle which moved me deeply.

I no longer remember how Ferber came to tell me the extremely cursory version of his life that he gave me at that time, though I do remember that he was loath to answer the questions I put to him about his story and his early years. It was in the autumn of 1943, at the age of eighteen, that Ferber, then a student of art, first went to Manchester. Within months, in early 1944, he was called up. The only point of note concerning that first brief stay in Manchester, said Ferber, was the fact that he had lodged at 104 Palatine Road – the selfsame house where Ludwig Wittgenstein, then a twenty-year-old engineering student, had lived in 1908. Doubtless any retrospective connection with Wittgenstein was purely illusory, but it meant no less to him on that account, said Ferber. Indeed, he sometimes felt as if he were tightening his ties to those who had gone before; and for that reason, whenever he pictured the young Wittgenstein bent over the design of a variable combustion chamber, or test-flying a kite of his own construction on the Derbyshire moors, he was aware of a sense of brotherhood that reached far back beyond his own lifetime or even the years immediately before it. Continuing with his account, Ferber told me that after basic training at Catterick, in a God-forsaken part of north Yorkshire, he volunteered for a paratroop regiment, hoping that that way he would still see action before the end of the war, which was clearly not far off. Instead, he fell ill with jaundice,

and was transferred to the convalescent home in the Palace Hotel at Buxton, and so his hopes were dashed. Ferber was compelled to spend more than six months at the idyllic Derbyshire spa town, recovering his health and consumed with rage, as he observed without explanation. It had been a terribly bad time for him, a time scarcely to be endured, a time he could not bear to say any more about. At all events, in early May 1945, with his discharge papers in his pocket, he had walked the roughly forty kilometres to Manchester to resume his art studies there. He could still see, with absolute clarity, his descent from the fringes of the moorlands after his walk amidst the spring sunshine and showers. From a last bluff he had had a bird's eye view of the city spread out before him, the city where he was to live ever after. Contained by hills on three sides, it lay there as if in the heart of a natural amphitheatre. Over the flatland to the west, a curiously shaped cloud extended to the horizon, and the last rays of sunlight were blazing past its edges, and for a while lit up the entire panorama as if by firelight or Bengal flares. Not until this illumination died (said Ferber) did his eye roam, taking in the crammed and interlinked rows of houses, the textile mills and dyeing works, the gasometers, chemicals plants and factories of every kind, as far as what he took to be the centre of the city, where all seemed one solid mass of utter blackness, bereft of any

further distinguishing features. The most impressive thing, of course, said Ferber, were all the chimneys that towered above the plain and the flat maze of housing, as far as the eye could see. Almost every one of those chimneys, he said, has now been demolished or taken out of use. But at that time there were still thousands of them, side by side, belching out smoke by day and night. Those square and circular smokestacks, and the countless chimneys from which a yellowy-grey smoke rose, made a deeper impression on me when I arrived than anything else I had previously seen, said Ferber. I can no longer say exactly what thoughts the sight of Manchester prompted in me then, but I believe I felt I had found my destiny. And I also remember, he said, that when at last I was ready to go on I looked down once more over the pale green parklands deep down below, and, half an hour after sunset, saw a shadow, like the shadow of a cloud, flit across the fields – a herd of deer headed for the night.

As I expected, I have remained in Manchester to this day, Ferber continued. It is now twenty-two years since I arrived, he said, and with every

year that passes a change of place seems less conceivable. Manchester has taken possession of me for good. I cannot leave, I do not want to leave, I must not. Even the visits I have to make to London once or twice a year oppress and upset me. Waiting at stations, the announcements on the public address, sitting in the train, the country passing by (which is still quite unknown to me), the looks of fellow passengers – all of it is torture to me. That is why I have rarely been anywhere in my life, except of course Manchester; and even here I often don't leave the house or workshop for weeks on end. Only once have I travelled abroad since my youth, two years ago, when I went to Colmar in the summer, and from Colmar via Basle to Lake Geneva. For a very long time I had wanted to see Grünewald's Isenheim paintings, which were often in my mind as I worked, and especially the *Entombment of Christ*, but I never managed to master my fear of travelling. So I was all the more amazed, once I had taken the plunge, to find how easily it went. Looking back from the ferry at the white cliffs of Dover, I even imagined I should be liberated from that moment; and the train ride across France, which I had been particularly afraid of, also went very well. It was a fine day, I had a whole compartment, indeed the entire carriage to myself, the air rushed in at the window, and I felt a kind of festive good spirits rising within me. About ten or eleven in the evening I arrived in Colmar, where I spent a good night at the Hotel Terminus Bristol on the Place de la Gare and the next morning, without delay, went to the museum to look at the Grünewald paintings. The extreme vision of that strange man, which was lodged in every detail, distorted every limb, and infected the colours like an illness, was one I had always felt in tune with, and now I found my feeling confirmed by the direct encounter. The monstrosity of that suffering, which, emanating from the figures depicted, spread to cover the whole of Nature, only to flood back from the lifeless landscape to the humans marked by death, rose and ebbed within me like a tide. Looking at those gashed bodies, and at the witnesses of the execution, doubled up by grief like snapped reeds, I gradually understood that, beyond a certain point, pain blots out the one thing that is essential to its being experienced – consciousness – and so perhaps extinguishes itself; we know very little about this. What is certain, though, is that mental suffering is effectively without

end. One may think one has reached the very limit, but there are always more torments to come. One plunges from one abyss into the next. When I was in Colmar, said Ferber, I beheld all of this in precise detail, how one thing had led to another and how it had been afterwards. The flood of memory, little of which remains with me now, began with my recalling a Friday morning some years ago when I was suddenly struck by the paroxysm of pain that a slipped disc can occasion, pain of a kind I had never experienced before. I had simply bent down to the cat, and as I straightened up the tissue tore and the *nucleus pulposus* jammed into the nerves. At least, that is how the doctor later described it. At that moment, all I knew was that I mustn't move even a fraction of an inch, that my whole life had shrunk to that one tiny point of absolute pain, and that even breathing in made everything go black. Until the evening I was rooted in one place in a semi-erect position. How I managed the few steps to the wall, after darkness had fallen, and how I pulled the tartan blanket that was hanging on the back of the chair over my shoulders, I no longer remember. All I now recall is that I stood at that wall all night long with

my forehead against the damp, musty plaster, that it grew colder and colder, that the tears ran down my face, that I began to mutter nonsense, and that through it all I felt that being utterly crippled by pain in this way was related, in the most precise manner conceivable, to the inner constitution I had acquired over the years. I also remember that the crooked position I was forced to stand in reminded me, even in my pain, of a photograph my father had taken of me in the second form at school, bent over my writing. In Colmar, at any rate, said Ferber after a lengthy pause, I began to remember, and it was probably those recollections that prompted me to go on to Lake Geneva after eight days, to retrace another old memory that had long been buried and which I had never dared disturb. My father, said Ferber, beginning anew, was an art dealer, and in the summer months he regularly put on what he called special exhibitions in the lobbies of famous hotels. In 1936 he took me with him to one of these exhibitions at the Victoria Jungfrau in Interlaken and then to the Palace at Montreux. Father's shows usually consisted of about five dozen salon pieces in the Dutch manner, in gold frames, or Mediterranean genre scenes in the style of Murillo, and deserted German landscapes – of these, I remember a composition that showed a gloomy heath with two juniper trees, at a distance from each other, in the blood-red glow of the setting sun. As well as I could, at the age of twelve, I helped Father with the hanging, labelling and despatch of these exhibition pieces, which he described as artistic merchandise. By way of a reward for my efforts, Father, who loved the Alps passionately, took me up the Jungfraujoch in the mountain railway, and from there he showed me the largest glacier in Europe, gleaming snow-white in the midst of summer. The day after the exhibition at the Palace closed, we drove out of Montreux in a hired car, some way along the Rhône valley, and presently turned off to the right, up a narrow and twisting road to a village with a name that struck me as distinctly odd, Miex. From Miex it was a three-hour walk, past the Lac de Tanay, to the summit of Grammont. All the noontide of that blue-skied day in August I lay beside Father on the mountaintop, gazing down into the even deeper blue of the lake, at the country across the lake, over to the faint silhouette of the Jura range, at the bright towns on the far bank, and at St Gingolph, immediately

below us but barely visible in a shaft of shadow perhaps fifteen hundred metres deep. On my train journey through Switzerland, which truly is amazingly beautiful, I was already remembering these scenes and images of thirty years before, said Ferber; but they were also strangely threatening, as I saw with increasing clarity during my stay at the Palace, so that in the end I locked the door of my room, pulled down the blinds, and lay in bed for hours at a stretch, which only worsened my incipient anxiety. After about a week it somehow occurred to me that only the reality outside could save me. But instead of strolling around Montreux, or going over to Lausanne, I set off to climb Grammont a second time, regardless of my condition, which by now was quite frail. The day was as bright as it had been the first time, and when I had reached the top, utterly exhausted, there below me was the country around Lake Geneva once again, seemingly completely unchanged, and with no trace of movement but for the one or two tiny boats that left their white wakes on the deep blue water as they proceeded, unbelievably slowly, and the trains that went to and fro at intervals on the far bank. That world, at once near and unattainably far, said Ferber, exerted so powerful an attraction on him that he was afraid he might leap down into it, and might really have done so had not a man of about sixty suddenly appeared before him – like someone who's popped out of the bloody ground. He was carrying a large white gauze butterfly net and said, in an English voice that was refined but quite unplaceable, that it was time to be thinking of going down if one were to be in Montreux for dinner. He had no recollection of having made the descent with the butterfly man, though, said Ferber; in fact the descent had disappeared entirely from his memory, as had his final days at the Palace and the return journey to England. Why exactly this lagoon of oblivion had spread in him, and how far it extended, had remained a mystery to him however hard he thought about it. If he tried to think back to the time in question, he could not see himself again till he was back in the studio, working at a painting which took him almost a full year, with minor interruptions – the faceless portrait *Man with a Butterfly Net*. This he considered one of his most unsatisfactory works, because in his view it conveyed not even the remotest impression of the strangeness of the apparition it referred to. Work on the

picture of the butterfly man had taken more out of him than any previous painting, for when he started on it, after countless preliminary studies, he not only overlaid it time and again but also, whenever the canvas could no longer withstand the continual scratching-off and re-application of paint, he destroyed it and burnt it several times. The despair at his lack of ability which already tormented him quite enough during the day now invaded his increasingly sleepless nights, so that soon he wept with exhaustion as he worked. In the end he had no alternative but powerful sedatives, which in turn gave him the most horrific hallucinations, not unlike those suffered by St Anthony on the temptation panel of the Isenheim altarpiece. Thus, for instance, he once saw his cat leap vertically into the air and do a backward somersault, whereupon it lay where it fell, rigid. He clearly remembered placing the dead cat in a shoebox and burying it under the almond tree in the yard. Just as clearly, though, there was the cat at its bowl the next morning, looking up at him as if nothing had happened. And once, said Ferber in conclusion, he dreamt (he could not say whether by day or by night) that in 1887 he had opened the great art exhibition in the purpose-built Trafford Park, together with Queen Victoria. Thousands of people were present as, hand in hand with the fat Queen, who gave off an unsavoury odour, he walked through the endless halls containing 16,000 gold-framed works of art.

Almost without exception, said Ferber, the works were items from his father's holdings. In amongst them, however, there were one or two of my own paintings, though to my dismay they differed not at all, or only insignificantly, from the salon pieces. At length, continued Ferber, we passed through a painted *trompe-l'oeil* door (done with astounding skill, as the Queen remarked to me) into a gallery covered in layers of dust, in the greatest possible contrast to the glittering crystal palace, where clearly no one had set foot for years and which, after some hesitation, I recognised as my parents' drawing room. Somewhat to one side, a stranger was sitting on the ottoman. In his lap he was holding a model of the Temple of Solomon, made of pinewood, papier-maché and gold paint. Frohmann, from Drohobycz, he said, bowing slightly, going on to explain that it had taken him seven years to build the temple, from the biblical description, and that he was now travelling from ghetto to ghetto exhibiting the model. Just look, said Frohmann: you can see every crenellation on the towers, every curtain, every threshold, every sacred vessel. And I, said Ferber, bent down over the diminutive temple and realised, for the first time in my life, what a true work of art looks like.

Bibliography on the Contributors and Seminal Texts

SIGRID WEIGEL

Ingeborg Bachmann. Hinterlassenschaft unter Wahrung des Briefgeheimnisses (Vienna, Zsolnay, 1999).

Body- and Image-Space. Re-reading Walter Benjamin (London, Routledge, 1996).

'Reading/Writing the Feminine City: Calvino, Hessel, Benjamin', in Gerhard Fischer (ed.), *'With the Sharpened Axe of Reason'. Approaches to Walter Benjamin* (Oxford, Berg, 1996), pp. 85–98.

'Aby Warburg's *Schlangenritual.* Reading Culture and Reading Written Texts', in *New German Critique* no. 65, summer 1995, pp. 135–53.

Bilder des kulturellen Gedächtnisses (Imen-Hiddingsee, Tende, 1994).

Topographien der Geschlechter. Kulturgeschichtliche Studien zur Literatur (Reinbek bei Hamburg, Rowholt, 1990).

Die Stimme der Medusa. Schreibweisen in der Gegenwartsliteratur von Frauen (Imen-Hiddingsee, Tende, 1987).

'Contemporary German Women's Literature' (in two parts), *New German Critique* no. 31, winter 1984, pp. 53–94, and no. 32, spring 1984, pp. 3–22.

OTHER READINGS

Walter Benjamin, *Charles Baudelaire. A Lyric Poet in the Era of High Capitalism* (London, Verso, 1976).

Berliner Kindheit um Neunzehnhundert (Frankfurt am Main, Rolf Tiedemann, 1987).

Walter Benjamin, 'Theses on the Philosophy of History' in Hannah Arendt (ed.), *Illuminations* (London, Fontana, 1968; 1973; 1992).

Sigmund Freud, 'Beyond the Pleasure Principle', in *On Metapsychology: The Theory of Psychoanalysis: Beyond the Pleasure Principle, The Ego and the Id, and Other Works* (London, Penguin, 1984).

Pierre Missac (ed.), *Walter Benjamin's Passages* (Massachusetts, MA, MIT Press, 1995).

MARSHA MESKIMMON

The Art of Reflection: Women Artists' Self-Portraiture in the Twentieth Century (London, Scarlet Press; New York, Columbia University Press, 1996).

Engendering the City: Women Artists and Urban Space, vol. 1 in the series *Nexus: Theory and Practice in Contemporary Women's Photography* (London, Scarlet Press, 1997).

'We Weren't Modern Enough': Women Artists and the Limits of German Modernism (London, I. B. Tauris; Berkeley, University of California Press, 1999).

(with Shearer West, eds) *Visions of the Neue Frau: Women and the Visual Arts in Weimar Germany* (Aldershot, Scolar Press, 1995).

OTHER READINGS

Renate Bridenthal, Atina Grossmann and Marion Kaplan (eds), *Destiny: Women in Weimar and Nazi Germany* (New York, Monthly Review Press, 1984).

Andreas Huyssen, *After the Great Divide: Modernism, Mass Culture, Postmodernism* (London and New York, Macmillan Press, 1986).

Anton Kaes, Martin Jay and Edward Dimendberg (eds), *The Weimar Republic Sourcebook* (Berkeley, University of California Press, 1994).

Elga Kern, *Wie Sie dazu Kamen: 35 Lebensfragmente bordellierte Mädchen nach Untersuchungen in badischen Bordellen* (Munich, Verlag von Ernst Reinhardt, 1928).

Anna Pappritz, *Einführung in das Studium der Prostitutionsfrage* (Leipzig, 1921).

Patrice Petro, *Joyless Streets: Women and Melodramatic Representation in Weimar Germany* (Princeton, NJ, Princeton University Press, 1989).

Alice Rühle-Gerstel, *Das Frauenproblem der Gegenwart: Eine Psychologische Bilanz* (Leipzig, Verlag von S. Hirzel, 1932).

THOMAS STRUTH

Thomas Struth, Portraits (Munich, Schirmer/Mosel Verlag 1998).

Still: Thomas Struth (Munich, Schirmer/ Mosel Verlag 1995).

Thomas Struth's Strasson (Art Data, 1995).

Thomas Struth: Strangers and Friends (Cambridge, MA, MIT Press, 1995)..

Thomas Struth: Landschaften: Photographien 1991–1993, exhibition catalogue (Dusseldorf, Achenbach Kunsthandel; Berlin, Galerie Max Hetzler, 1994).

Thomas Struth: Portraits, exhibition catalogue, interview with Benjamin H. D. Buchloh (New York, Marion Goodman Gallery, 1990).

Invisible Cities, exhibition catalogue (Leeds, Leeds City Art Gallery, 1989).

OTHER READINGS

Roland Barthes, *Camera Lucida, Reflections on Photography* (London, Vintage, 1982).

Norton Batkin, 'The Museum Exposed', in *Exhibited*, exhibition catalogue (Annandale-on-Hudson, NY, Bard College, Center for Curatorial Studies, 1994).

Hans Belting, *Thomas Struth: Museum Photographs*, exhibition catalogue, (Munich, Schirmer/ Mosel Verlag; Hamburg, Hamburger Kunsthalle, 1993).

Walter Benjamin, 'A Small History of Photography', in *One Way Street and Other Writings*, translated by Edmund Jephcott and Kingsley Shorter (London, Verso, 1985).

Markus Bruderlin, Wolfgang Kemp, Lucius Burckhardt, Guido Mangold, Ulf Wuggenig, and Vera Kockot, *Das Bild der Ausstellung/The Image of the Exhibition*, exhibition catalogue (Vienna, Hochschule fur angewandte Kunst, 1993).

Norman Bryson, 'Not Cold, Not Too Warm: The Oblique Photography of Thomas Struth', in *Parkett* 50/51, December 1997, pp. 156–65.

Susan Butler, 'The Mis-en-Scène of the Everyday', in *Art and Design* 10, nos 9/10, September–October 1995, pp. 16–32.

Jean Francois Chevrier and James Lingwood, *Une autre objectivite/Another Objectivity*, exhibition catalogue (Paris, Centre national des artes plastiques; Prato, Italy, Centro per l'Arte Contemporanea Luigi Pecci, in association with Milan, Idea Books, 1989).

Graham Clarke, *The Photograph* (Oxford, 1997).

Ralph Hyde, *Panoramania* (London, 1988).

Ulrich Loock, 'Thomas Struth: "Unconscious Places"', in *Parkett* 23, spring 1990, pp. 28–31.

Hans Rudolf Reust, 'Backdrop' in *Artscribe International* no. 68, March–April 1998, pp. 58–59.

Susan Sontag, *On Photography* (London, Penguin, 1977).

Trudy Wilner Stack, *Art Museum: Sophie Calle, Louise Lawler, Richard Misrach, Diane Neumaier, Richard Ross, Thomas Struth*, exhibition catalogue (Tucson, AZ, Center for Creative Photography/University of Arizona, 1995).

THOMAS BENDER

(with Carl E. Schorske, eds) *Budapest and New York: Studies in Metropolitan Transformation, 1870–1930* (New York, Russell Sage, 1994).

'Metropolitan Life and the Making of Public Culture', in John Mollenkopf (ed.), *Power, Culture and Place: Essays in New York City History* (New York, Russell Sage, 1988), pp. 261–71.

'The Culture of the Metropolis', *Journal of Urban History* 14, 1988, pp. 492–502.

(with William R. Taylor) 'Culture and Architecture, Some Aesthetic Tensions in the Shaping of Modern New York City', in William Sharpe and Leonard Wallock (eds), *Visions of the Modern City* (Baltimore, Johns Hopkins University Press, 1987), pp. 185–215.

New York Intellect: A History of Intellectual Life in New York City, from 1750 to the Beginnings of Our Own Time (New York, Knopf, 1987).

Community and Social Change in America (Baltimore, Johns Hopkins University Press, 1982).

'The Making of Lewis Mumford', *Skyline*, December 1982, pp. 12–14.

OTHER READINGS

Berenice Abbott, *New York in the Thirties* (New York, Dover Publications, 1973).

Marshall Berman, *All That Is Solid Melts Into Air* (New York, Simon & Shuster, 1982).

Sidney H. Bremer, *Urban Intersections: Meetings of Life and Literature in American Cities* (Urbana and Chicago, University of Illinois Press, 1992).

Robert Caro, *The Power Broker: Robert Moses and the Fall of New York* (New York, Knopf, 1974.)

Michel de Certeau, *The Practice of Everyday Life*, translated by Steven Rendell (Berkeley, University of California Press, 1984).

Hugh Ferriss, *The Metropolis of Tomorrow* [1929] (Princeton, NJ, Princeton Architectural Press, 1986).

Robert Fitch, *The Assassination of New York* (London, Verso, 1993).

David Frisby, *Fragments of Modernity* (Cambridge, MA, MIT Press, 1986).

William Innes Homer, *Alfred Stieglitz and the American Avant-Garde* (Boston, New York Graphic Society, 1977).

Jane Jacobs, *The Death and Life of Great American Cities* (New York, Random House, 1961).

Angel Roma, *The Lettered City*, translated by John Charles Chasteen (Durham, NC, Duke University Press, 1996).

Merrill Schleier, *The Skyscraper in American Art, 1890–1931* (New York, Da Capo, 1986).

Carl E. Schorske, *Fin de Siècle Vienna* (New York, Knopf, 1979).

James Sleeper, *The Closest of Strangers: Liberalism and the Politics of Race in New York* (New York, Norton, 1991).

William R. Taylor (ed.), *Inventing Times Square* (New York, Russell Sage, 1991).

Caroline F. Ware, *Greenwich Village, 1920–1930: A Comment on American Civilization in the Postwar Years* [1935] (Berkeley, University of California Press, 1994).

Rebecca Zurier, Robert W. Snyder, and Virginia M. Mecklenburg, *Metropolitan Lives: The Ashcan Artists and Their Work*, (New York, Norton, 1995).

PAUL DAVIES

'Indiana Jones and Robert Venturi: America's Enduring Principles', *The Journal of Architecture*, vol. 4, no. 1 (London, E. and F. N. Spon, spring 1999). Issue guest edited by Ed Winters and Paul Davies.

'Just add Water: Lake Las Vegas Resort', in Rowan Moore (ed.), *Vertigo: The Strange New World of the Contemporary City* (London, Lawence King Publishing, February 1999).

'Tourism, Transportation and Bedtime Reading', chapter in *Clues* journal (Ohio, Bowling Green University Press, 1998).

'The Landscape of Luxury', in Jonathan Hill (ed.), *Occupying Architecture* (London, Routledge, 1998).

Contributor to *The Fontana Dictionary of Modern Thought* (3rd edition) 1998.

Profile: 'Learning from Paul Davies', in *Architects Journal*, 23 April 1998.

'Tales of Vicarious Consumption: Hollywood's (Living Room) History' *AD Magazine; Consuming Architecture*, John Wiley, London, February 1998.

'From Model to Simulation: Scale in the Architecture of Tourism', *The Journal of Architecture*, vol. 1, no. 1 (London, E. & F. N. Spon, 1996).

(with Sean Griffiths) 'Archigram: Experimental Architecture 1961–74', *AA Files* (Annals of the Architectural Association School of Architecture) no. 28, March 1995.

OTHER READINGS

Deke Castleman, *Las Vegas* (Fodor's Compass America Guides, 1995).

John Hannigan, *Fantasy City* (London, Routledge, 1998).

Alan Hess, *Viva Las Vegas* (San Francisco, Chronicle Books, 1993).

Dave Hickey, *Air Guitar, Essays on Art and Democracy* (Los Angeles, Art Issues Press, 1997).

Michael Sorkin (ed.), *Variations on a Theme Park* (New York, Noonday Press, 1992).

Hunter S. Thompson, *Fear and Loathing in Las Vegas* (New York, Random House, 1972).

Mike Tronnes (ed.), *Literary Las Vegas* (Edinburgh, Mainstream, 1996).

Robert Venturi, Denise Scott Brown and Steven Izenour, *Learning from Las Vegas* (Cambridge, MA, MIT Press, 1972).

Tom Wolfe, *The Kandy Kolored Tangerine Flake Streamline Baby* (New York, Farrar, Straus and Giroux, 1965).

MALCOLM MILES

'A Game of Appearance: Public Art and Urban Development—Complicity or Sustainability?', in T. Hall and P. Hubbard (eds), *The Entrepreneurial City* (Chichester, Wiley, 1998), pp. 203–224.

'Something Strange has to be Eaten or Drunk' in *Point* No. 5, Spring 1998.

Art, Space & the City (London, Routledge, 1997).

'Another Hero?—public art and gender', *Parallax* no. 5, September 1997, pp. 125–35.

'Art and craft in urban design—the possibilities for collaboration' in *Urban Design International* vol. 1, no. 1, 1996, pp. 81–88.

Health Buildings in the Community (London, HMSO, 1994).

OTHER READINGS

Stephen Barber, *Fragments of the European City* (Reaktion, London, 1995).

Ivan Illich, *H_2O and the Waters of Forgetfulness* (London, Marion Boyars, 1986).

Henri Lefebvre, *The Production of Space* (Oxford, Blackwell, 1991).

Doreen Massey, *Space, Place & Gender* (Cambridge, Polity, 1994).

Martha Rosler, 'Place, Position, Power, Politics' in C. Becker (ed.), *The Subversive Imagination* (London, Routledge, 1994), pp. 55–76.

Leonie Sandercock, *Making the Invisible Visible: a multicultural planning history* (Berkeley, University of California Press, 1998).

Ken-ichi Sasaki, *Aesthetics on non-Western Principles. Version 0.5* (Maastricht, Jan Van Eyck Akademie, 1998).

Richard Sennett, *The Uses of Disorder* (London, Faber & Faber, 1996), p. 102.

Marina Warner, *Monuments and Maidens* (London, Pan, 1987).

Elizabeth Wilson, *The Sphinx and the City* (Berkeley, University of California Press, 1991).

ROBERT VENTURI and DENISE SCOTT BROWN

Robert Venturi, *Iconography and Electronics Upon a Generic Architecture, A View from the Drafting Room* (Cambridge, MA, MIT Press, 1996).

Denise Scott Brown, *Urban Concepts* (London, Architectural Design, 1990).

Robert Venturi and Denise Scott Brown, *A View from the Campidoglio: Selected Essays, 1953–1984* (New York, Harper & Row, 1984).

Robert Venturi, Denise Scott Brown and Steven Izenour, *Learning from Las Vegas* (Cambridge, MA, MIT Press, 1972; revised edition 1977). Published also in French, Spanish, German, Japanese, Italian and Serbo-Croat.

Robert Venturi, *Complexity and Contradiction in Architecture* (New York, Museum of Modern Art, 1966; second edition 1977). Published also in French, Spanish, German, Japanese, Italian, Serbo-Croat, Greek, Chinese, Hungarian, Czech and Turkish.

For a more detailed bibliography go to their website at www.vsba.com

JÖRN DÜWEL

'Am Anfang der DDR. Der zentrale Platz in Berlin', in Romana Schneider and Wilfried Wang (eds), *Moderne Architektur in Deutschland 1900–2000. Macht und Monument* (Stuttgart, 1998).

(with Werner Durth and Niels Gutschow) *Ostkreuz/Aufbau. Architektur und Städtebau der DDR*, 2 volumes (Frankfurt; New York, 1998).

Baukunst voran! Architektur und Städtebau in der SBZ/DDR (Berlin, 1995).

(with Werner Durth, Niels Gutschow and Jochen Schneider) *1945. Krieg—Zerstörung—Aufbau. Architektur und Stadtplanung 1940–1960* (Berlin, 1995).

OTHER READINGS

Bruno Flierl, 'Rund um Marx und Engels: Berlins sozialistische Mitte', in Helmut Engel and Wolfgang Ribbe (eds), *Hauptstadt Berlin—Wohin mit der Mitte?* (Berlin, 1995).

Bruno Flierl, 'Der Zentrale Ort in Berlin—Zur räumlichen Inszenierung sozialistischer Zentralität', in Günter Feist and Eckhart Gillen (eds), *Kunstdokumentation SBZ/DDR 1945–1990. Aufsätze, Berichte, Materialien* (Cologne, 1996).

Irma Leinauer, *Das Ministerium für Auswärtige Angelegenheiten in Berlin* (Berlin, 1997).

Peter Müller, *Symbol mit Aussicht. Der Berliner Fernsehturm* (Berlin, 1998).

Dieter Vorsteher (ed.), *Parteiauftrag: Ein neues Deutschland. Bilder, Rituale und Symbole der frühen DDR* (Berlin, 1996).

VITTORIO LAMPUGNANI

The Architecture of the Contemporary City: Theories and Projects (Tokyo, YKK Architectural Products Inc., 1999).

Die Modernitat des Dauerhaften (Frankfurt am Main, Fischer, 1998).

An Urban Experiment in Central Berlin, Planning Potsdamer Platz, exhibition catalogue (Frankfurt am Main, Deutsches Architektur-Museum, Hatje, 1997).

Le citta immaginate, exhibition catalogue (Mailand, Electa, 1987).

Architektur als Kultur. Die Idee und die Form. Aufsatze 1970–1985 (Cologne, DuMont, 1986).

L'avventura delle idee nell'architettura 1750–1980 (Mailand, Electa, 1985).

Das Abenteuer der Ideen 1750–1980 (Berlin, Frohlich & Kaufmann, 1984).

Modelle fur eine Stadt (Berlin, Siedler, 1984).

Lexikon der Architektur des 20. Jahrhunderts (Stuttgart, Hatje, 1983; second edition, Stuttgart, 1998); [*Encyclopaedia of 20th Century Architecture* (London: Thames & Hudson, 1986)].

Architektur unseres Jahrhunderts in Zeichnungen (Stuttgart, Hatje, 1982); [*Architecture of the 20th Century in Drawings* (New York, Rizzoli international, 1982)].

Architektur und Stadtebau des 20. Jahrhunderts, (Stuttgart, Hatje, 1980); [*Architecture and City Planning in the 20th Century* (New York, Van Nostrand Reinhold, 1985)].

OTHER READINGS

Walter Kiess, *Urbanismus im Industriezeitalter. Von der klassizistischen Stadt zur Garden City* (Berlin, 1991).

La ville. Art et Architecture in Europe 1870–1993, exhibition catalogue (Paris, Centre Pompidou, 1994).

ANDREW HUSSEY

'Elision and paradox', *Times Literary Supplement*, 22 May 1998, p. 31.

'Fanatics of the Apocalypse: Traces of the End in Debord and Bataille', *Space and Culture*, 2, 1998, pp. 110–26.

'Tempête de Flammes: Surrealism, Bataille and the Perennial Philosophy of Heraclitus' *Parallax* no. 4, 1997, pp. 151–66.

(with Gavin Bowd) *The Hacienda must be built: On the legacy of Situationist revolt* (Manchester, AURA, 1996).

'Beau comme une guêpe: Cruelty and Illumination in Bataille's mystical writings', in *Literature and Cruelty*, (New York, Columbia University, 1996), pp. 62–81.

'Saint Guy de Paris', *Times Literary Supplement*, 4 October 1996, p. 10.

'The Wreckers of Civilisation', *The Sunday Telegraph Review*, 4 August 1996, p. 7.

'From Being to Nothingness', *Independent on Sunday Review*, 10 December 1995, pp. 16–22.

'Esprit de Mort', *Harper's Magazine*, New York, September 1995, pp. 18–19.

'Au revoir cruel world', *The Modern Review*, London, May 1995, p. 27.

'Bile en tête', *Les Inrockuptibles*, Paris, April 1995, pp. 43–44.

OTHER READINGS

T. J. Clark, *The Painting of Modern Life: Paris in the art of Manet and his followers* (London, Thames & Hudson, 1996).

T. J. Clark and Donald Nicholson-Smith, *The Revolution of Modern Art: The Modern Art of Revolution* (London, Chronos, 1996).

Guy Debord, *Panégyrique, tome second* (Paris, Fayard, 1997).

The Society of the Spectacle, translated by Donald Nicholson-Smith (New York, Zone, 1994).

Mémoires (Paris, Jean-Jacques Pauvert au Belles Lettres, 1993).

Panégyrique, tome premier (Paris, Gallimard, 1992).

Commentaires sur la société du spectacle (Paris, Gallimard, 1992).

La société du spectacle (Paris, Buchet et Chastel, 1967).

Johan Huizinga, *Homo Ludens* (Paris, Gallimard, 1999).

Anselm Jappe, *Guy Debord* (Marseille, Via Valeriano, 1995).

L'internationale situationniste, *Documents rélatifs à la fondation de l'international situationniste 1948–1947* (Paris, Allia, 1985).

L'internationale situationniste (Paris, Fayard, 1997).

Gianfranco Marelli, *L'amère victoire du situationnisme* (Paris, Sulliver, 1998).

Jean-Michel Mension, *La Tribu* (Paris, Allia, 1998).

Lewis Mumford, *The City in History* (London, Duckworth, 1960).

Simon Sadler, *The Situationist City* (Cambridge, MA, MIT Press, 1998).

Frédéric Schiffter, *Guy Debord l'atrabilaire* (Paris, Édition de la Distance, 1997).

Paul Virilio, *L'Inertie Polaire* (Paris, Christian Bourgeois, 1990).

Die Beschreibung des Unglücks. Zur österreichischen Literatur von Stifter bis Handke (Salzburg, Residenz Verlag, 1985).

Austerlitz, (Munich, Carl Hanser Verlag, 2001).

Available in English:

Vertigo, translated by Michael Hulse (London, The Harvill Press, 1999).

The Rings of Saturn, translated by Michael Hulse (London, The Harvill Press, 1998).

The Emigrants, translated by Michael Hulse (London, The Harvill Press, 1997).

Austerlitz, translated by Anthea Bell (London, Hamish Hamilton, 2001).

W. G. SEBALD

Luftkrieg und Literatur (Munich, Carl Hanser Verlag, 1999).

Logis in einem Landhaus. Über Gottfried Keller, Johann Peter Hebel, Robert Walser und andere (Munich, Verlag Carl Hanser, 1998).

Die Ringe des Saturn (Frankfurt am Main, Vito von Eichenborn, GmbH & Co. Verlag KG, 1992).

Die Ausgewanderten (Frankfurt am Main, Vito von Eichenborn, GmbH & Co. Verlag KG, 1992).

Unheimliche Heimat. Essays zur österreichischen Literatur (Salzburg, Residenz Verlag, 1991).

Schwindel. Gefühle (Frankfurt am Main, Vito von Eichenborn, GmbH & Co. Verlag KG, 1990).

Notes on Contributors

STEVEN SPIER

Steven Spier has a degree in philosophy from Haverford College near Philadelphia and worked in book publishing and television production before attaining a masters degree in architecture from the Southern California Institute of Architecture. He has practised in Los Angeles, Berlin, and occasionally in London. He has taught at the ETH-Zurich, at SCI-Arc in Ticino, and at South Bank University, London. He has recently been appointed Professor at the University of Strathclyde in Glasgow. His areas of research in addition to the city include topics in contemporary Swiss and German architecture, and in organisational and notational issues in the work of William Forsythe and the Ballett Frankfurt.

SIGRID WEIGEL

Sigrid Weigel, born 1950 in Hamburg, is professor of literary history and cultural theory at Zurich University, in 1998/99 director of the Einstein Forum, Potsdam, and 1990–93 member of the directory board of *Kulturwissenschaftliches Institut*, Essen. She writes on literature, memory, psychoanalysis, Jewish philosophy, gender and cultural differences, and city images. The article in this volume is translated from her book *Ingeborg Bachmann. Hinterlassenschaft unter Wahrung des Briefgeheimnisses* (Vienna, Zsolnay, 1999).

MARSHA MESKIMMON

Marsha Meskimmon teaches art history in the School of Art and Design at Loughborough University. Current projects include work on feminist aesthetics and cross-cultural perspectives on women's art practices.

ANNE MACPHEE

Anne MacPhee is a lecturer in art history at the University of Liverpool and a coordinator of Tate Liverpool Critical Forum

THOMAS BENDER

Thomas Bender teaches cultural history at New York University, where he is University Professor of the Humanities. His scholarship and writing focuses mainly on two themes: intellectuals and cities. He is the author of several books, including *Toward an Urban Vision* (1975), *New York Intellect* (1987), and *Intellect and Public Life* (1993). With Carl Schorske he has edited *Budapest and New York* (1994) and *American Academic Culture in Transformation* (1988). His essays have appeared in *The New York Times*, *The Los Angeles Times*, *The Nation*, *Dissent*, *The Design Book Review*, and *Harvard Design Magazine* as well as in scholarly journals. He also directs the 'Project on Cities and Urban Knowledges' at New York University.

PAUL DAVIES

Paul Davies is senior lecturer in the architecture of tourism at South Bank University and at the Architectural Association, London. He visits Las Vegas, his favourite city, as a matter of habit, or perhaps addiction, whenever possible. He lectures widely, and has written for *AD*, *Architect's Journal*, *Building Design*, *Blueprint*, and *FX* magazines, and the academic *Journal of Architecture*.

MALCOLM MILES

Malcolm Miles teaches at the University of Plymouth. His most recent book is *Art, Space & the City* (London, Routledge, 1997). He is co-editor of the *City Cultures Reader* (with Iain Borden and Tim Hall, London, Routledge, 1999), and has contributed to journals including *Urban Design International*, *Urban History*, *Parallax*, and *Point*.

ROBERT VENTURI and DENISE SCOTT BROWN

Robert Venturi, FAIA, Hon. FRIBA, and Denise Scott Brown, RIBA, are principals in Venturi, Scott Brown and Associates, Inc. of Philadelphia. Venturi and Scott Brown have had a decisive influence on architects through the work of their firm and their teaching, writing and lecturing. Under their guidance the firm has been recognised internationally. During the 1990s, VSBA projects have included: the Sainsbury Wing at the National Gallery; the Mielparque Nikko Kirifuri hotel and resort in Japan;

a Hôtel du Département for the Haute Garonne in Toulouse, France; academic and research buildings at UCLA, Yale, Princeton, Harvard, Dartmouth and the University of Pennsylvania; and master planning for various universities and institutions, including six campuses at the University of Michigan, where they are designing a Life Sciences complex.

JÖRN DÜWEL

Jörn Düwel was born in Rostock in 1965. He studied art history and German literature in Greifswald, and was awarded a doctorate in 1994. From 1994 to 1996 he was lecturer at the institute, Foundations of Modern Architecture, at the University of Stuttgart. In 1997 he received a grant from the *Deutsche Forschungsgemeinschaft* (German Research Council). Since 1998 he has been assistant professor in the history and theory of architecture at the Technical University of Darmstadt. He lives in Wiesbaden.

VITTORIO MAGNAGO LAMPUGNANI

Vittorio Magnago Lampugnani was born in Rome in 1951 and graduated in architecture at the Universities of Rome and Stuttgart. He runs a practice in Milan and teaches history of town planning in the Faculty of Architecture at the Swiss Federal Institute of Technology Zurich (ETH), where he is currently also dean.

Between 1990 and 1995 he was director of the

German Museum of Architecture in Frankfurt am Main, between 1991 and 1996 editor of *Domus*. Among the major international exhibitions which he has curated are, 'The Adventure of Ideas in Architecture 1950–1980', and (with Henry Millon) 'Renaissance. From Brunelleschi to Michelangelo. The Representation of Architecture'.

He was one of the protagonists of the Berlin IBA (1980–84), and his office building (with Marlene Dörrie) on a corner of Friedrichstrasse in Berlin is conceived as an urban insert. Currently he is completing a small social housing complex in Maria Lankowitz near Graz (with Marlene Dörrie), and designing the entrance square of the Audi factory in Ingolstadt.

His teaching experience includes Stuttgart University, the Städelschule Academy of Art in Frankfurt am Main, and the GSD at Harvard University. He has been a research fellow at the School of Architecture, Planning and Preservation at Columbia University, and at the Wissenschaftskolleg zu Berlin.

His most important architectural publications have been translated into several languages.

ANDREW HUSSEY

Andrew Hussey is lecturer in French at the University of Wales, Aberystwyth, and taught previously at the universities of Huddersfield, Manchester and Dijon. He is currently preparing *The Game of War*, a biography of Guy Debord, for publication by Jonathan Cape.

W. G. SEBALD

W. G. Sebald was born in Wertach in Allgäu, Germany, in 1944. He studied German language and literature in Freiburg, French-speaking Switzerland and Manchester. In 1966 he took up a position an assistant lecturer at the University of Manchester, and settled in England in 1970. He taught at the University of East Anglia from that date, becoming Professor of European Literature in 1987, and from 1989 to 1994 he was the first Director of the British Centre for Literary Translation at UEA. W. G. Sebald was killed in a car crash in December 2001. In addition to *Die Ausgewanderten*, which won the Berlin Literature Prize, the Literatur Nord Prize and the Johannes Bobrowski Medal, Sebald wrote three other works of fiction: *Schwindel. Gefühle* (1990), *Die Ringe des Saturn* (1992) and *Austerlitz* (2001). He was awarded the Joseph Breitbach and the Heinrich Heine prizes in 2000.

Michael Hulse is a translator and award-winning poet who has translated Sebald's *The Emigrants*, *The Rings of Saturn*, and *Vertigo*. He is the author of *Eating Strawberries in the Necropolis* (London, The Harvill Press, 1991).

TEXT TRANSLATIONS

Düwel and Lampugnani translated from the German by Chris Charlesworth, London.
Weigel translated from the German by Dr Georgina Paul, University of Warwick.

Index